ICELAND

PHOTOGRAPHS BY PATRICK DESGRAUPES

ESSAYS BY EINAR MÁR JÓNSSON
AND GUILLAUME CANNAT

TRANSLATED FROM THE FRENCH BY MARK GETLEIN

HARRY N. ABRAMS, INC., PUBLISHERS

To Iceland, which enchanted me in my sleep
only to lead me to other dreams.

CONTENTS

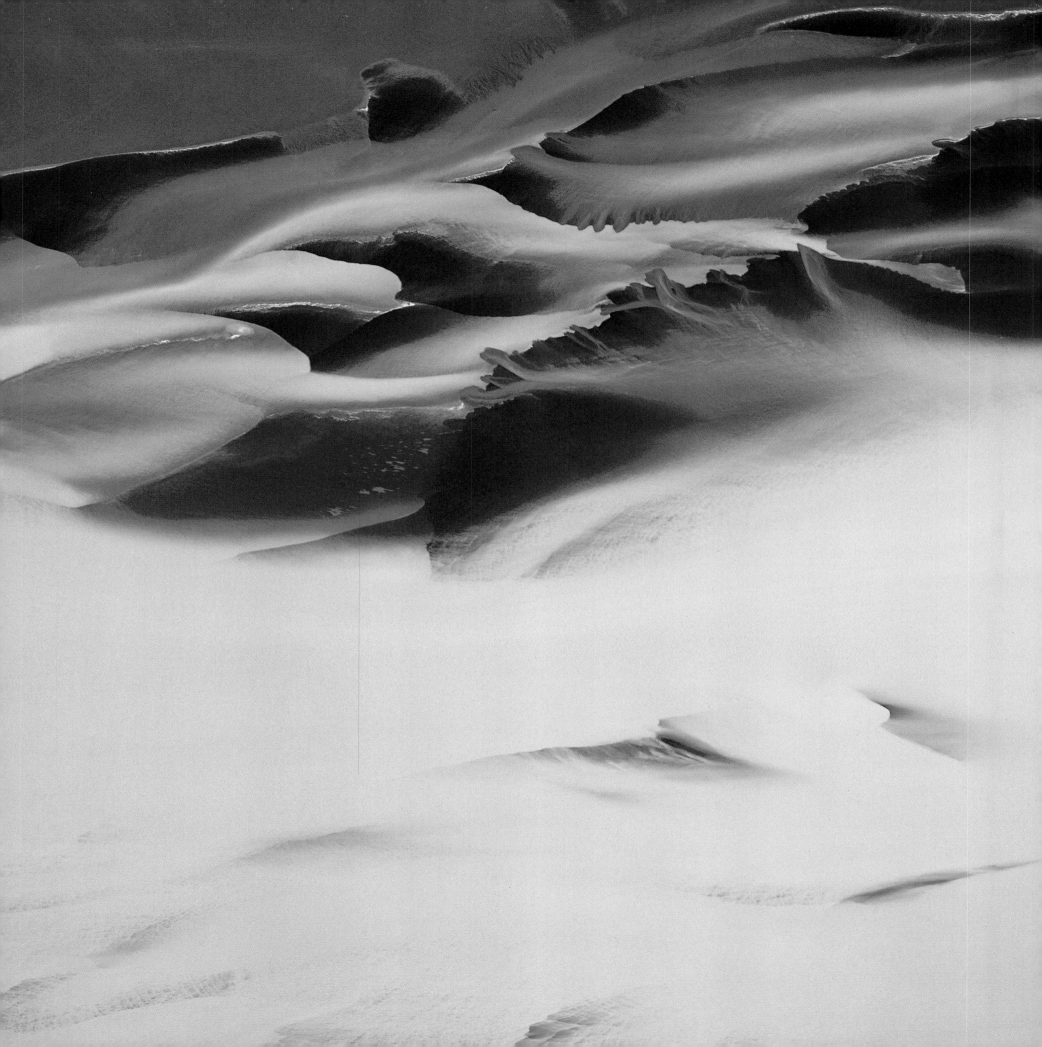

PREFACE

The origins of my work on Iceland go back to 1987. I awoke one night with a name lodged in my still sleep-clouded brain: Iceland. At dawn I absolutely had to look at a map to locate this country, about which I knew nothing, but which already drew me.

I arrived in Iceland the following year and was stunned by what I saw: deserts of black sand stretching into infinity, multicolored rhyolite massifs, the lights of the aurora borealis moving as though enchanted. A feeling came over me, immediate and strong, that my own story was intimately bound up with this land. Its wild beauty, now violent, now romantic, overwhelmed me. I felt as though I were going back in time, approaching the origin of life. I decided to undertake a long project involving the country, following the rhythms of its passing seasons, to render it a worthy homage. I began then to work out a method that became definitively my own. I started shooting in a medium format, 6 x 6 (centimeters), but soon switched to a 4 x 5 (inches) view camera, a large format. The advantages of the large format are, of course, the size of the original transparency (twelve times the size of a 35-millimeter transparency, four times the size of a 6 x 6), which provides unrivaled sharpness of detail and fullness of modeling. In addition, the front and rear parts of the camera can be manipulated—"tilted," "swung," "twisted," "raised," and "dropped down"—in order to increase depth of field, to change the viewpoint without moving, or to correct receding perspective lines. The inconveniences are the weight (thirty-three to forty-four pounds), the lengthy setup time (five to twenty minutes), the upside-down and backwards viewing, and the expense (the cost of a single negative in this format is the equivalent of thirty-six exposures of 35mm film). The entire technical aspect necessitates a rigorous and systematic approach. It may seem tedious, and at first quite daunting, but once the process is mastered, the work is uniquely and intensely pleasurable.

I collaborated with my guides and drivers, friends with a passion for traveling, who helped me

search out new locations. I proceeded to research each site meticulously, armed with a compass to pinpoint the precise position of the sun (at the summer or winter solstice). I studied the vegetation in order to determine the most promising season, whether spring, summer, or autumn. All of this information I transferred to a notebook, together with sketches. Some photographs were made a mere week later, whereas others had to wait for months or even years.

In any case, it was rare that I made a photograph immediately upon arriving at a site. I spent a lot of time without going near the camera, looking, exploring my subject. I waited until the space felt fully mine, until I sensed myself at one with it, until I found its essence. I returned several times to experience it in full sun and under a cover of clouds. Once I had decided on the view, I positioned my camera, adjusted the settings, and waited for the light. Sometimes I waited for quite a while; I have lost track of the number of times that, after patiently making my preparations, I left after an hour or two, the film still unexposed! I had to accept the idea that I might have to let days go by without shooting a single image, only to shoot two or three on a single miraculous day. For all of that, there are images I still haven't been able to realize. For a landscape photographer, the weather forecast is always a concern. In Iceland, this aspect takes on truly insane proportions; it is best to stay calm and not let it get to one. Here, even more than elsewhere, there is no question of mastering the elements, only of adapting to them. A good measure of luck and perseverance is indispensable. I didn't hesitate, moreover, to completely change my itinerary on the spur of the moment in order to take advantage of exactly the right light. Thus it was that I had to wait for seven years to get one image, which could only be made during the winter and unfortunately during a severe cold spell. There were incredible gusts of wind that day, which kept sweeping along my tri-

pod, even though it was well weighted down. Equipment, too, was put to the test during all the moving about in 4-wheel drives and snowmobiles, on foot and on skis, not to mention the combination of rain, sand, and wind, the mud of the solfataras, the sulfurous steam, and the winter cold that made all manipulations problematic.

I still dream, some nights in Paris, of the ice caves I never got to. The ones I photographed at Hrafntinnusker (pages 124 and 154) required sixteen hours of trekking with over forty pounds of equipment on my back. Such caves last only a few weeks on the average, and they are often difficult and dangerous to get to. Each of the two photographs of Svartifoss (pages 33 and 134) required two hours of work, because after each exposure I had to wipe off the bellows, the lens, and the chassis before beginning again, and all that beneath a waterproof cape. For the two views of the Hekla erupting (pages 64 and 65), the organization of the expedition was so fragile and uncertain that I had to wait around for six days. Besides the two images, I brought back with me a pair of singed shoes and a partially burned foot.

The particular style of my photographs is the result of a number of influences (I would name more painters than photographers) and my training. I have worked as much in the studio as in the laboratory. In the first, I acquired an understanding of light; in the second, a knowledge of emulsions and what could be done with them. I am often asked whether my images are filtered or retouched by computer. The answer to this question is: absolutely not. My photographs are the result of a series of combined choices of format, lens, photographic emulsion, and light. I am haunted by light and color, and I track them to their climax. I seek almost obsessively those fleeting, magical moments in order to show reality elevated to the sublime.

—PATRICK DESGRAUPES

ICELAND, MAN, AND NATURE

One spring day, long ago, a Norwegian navigator sailed west across the Atlantic to found a new home on a vast, uninhabited island. Shortly before, an earlier would-be colonist of this island had named it Iceland, in a final act of revenge on its inhospitality before he gave up and returned home.

On his boat, the navigator carried his family, servants, slaves, and livestock, and all the tools he would need to make a home in an untamed land. Behind him, he had left everything he thought of as civilized society, and in the immense solitude that stretched before him, he could count only on himself and his household and what they had brought with them. He was not obliged to obey what would later become the first article of Icelandic written law, written when the leaders of the new country met to establish their constitution. Then, it would be strictly forbidden to approach Iceland's coast with a dragon-headed prow, for such a prow would frighten the *land-vættir,* the supernatural beings that lived on and protected the land. But the ancestral beliefs that would later inspire this law were certainly rooted in his conscience, for, perhaps reflexively and out of caution and respect for the supernatural world, he veiled his ship's figurehead when his first vision of his future country rose up before him in the northwest, the immense glacier now known as Vatnajökull.

Various medieval Icelandic texts give us the name of this first colonist, Ingólfur Arnarson, as well as the date he settled definitively in Iceland, 874. To what extent can we believe these writings? The oldest, the *Book of the Icelanders,* by Ari the Learned, was written some 250 years after the event, so we may well wonder whether the author could have had a solid knowledge of facts that were already so ancient. Modern science, however, has sources of information unimagined by earlier generations. Owing to these, we now know that just before the settlement of Iceland, two violent eruptions in the volcanic system of Veidivötn, in the south of the country, spewed clouds of ash across the greater part of the island. Every layer of volcanic ash has a sort of chemical signature all its own, making it easy to identify. The layers deposited by the Veidivötn eruptions have thus served as reference

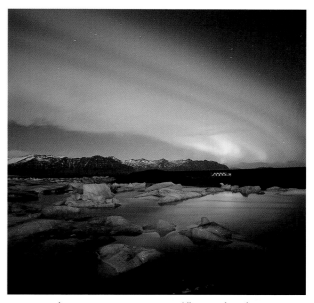

AURORA BOREALIS, JÖKULSÁRLÓN

NEAR THINGVELLIR

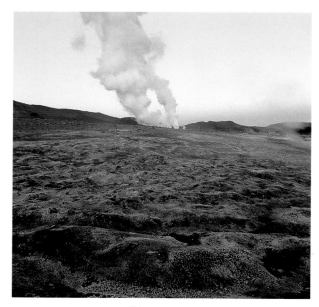

NÁMASKARD

COTTONGRASS

points for archaeologists: below them, there is no trace of human activity, but immediately above them appear the remains of rudimentary buildings, along with changes to the soil brought about by human exploitation of the land, with its consequent deforestation and erosion. This rain of ashes did not fall exclusively on Iceland, but spread as far as Greenland, where its traces have been found in ice cores extracted by drilling. By counting the annual layers of snow, just as we count the rings of a tree, it is possible to date what archaeologists call occupation layers, which contain evidence of human settlement. The earliest layers point to a date of 871, with a margin of error of two years.

This agreement between parchment and ash is impressive. Among other things, it indicates that we can have a certain confidence in the vision of the past set down by medieval Icelandic authors. But above all it marks the start of a long history—the complex, dramatic, and occasionally tragic tale of the relationship between Icelanders and the unique country in which their ancestors chose to live more than eleven centuries ago.

The first colonists encountered a land that was both very similar to and very different from the one that greets today's travelers. Its landscape was certainly far richer and more welcoming. Today, in Iceland's swift streams and in the middle of its isolated lakes, small islands can be found covered with dense vegetation characterized by clumps of very tall angelica. Naturally protected from the ravages of grazing sheep, these areas show us how much of the island must have looked at the time of the first human settlements. Iceland, in fact, was one of the rare large islands—and the first discovered by Norwegian explorers—that had no population of large herbivorous animals. Thus, plant life had been allowed to develop freely, hindered by nothing other than the climate, since the end of the Ice Age thousands of years earlier. The first settlers, on the other hand, came from western Norway, a mountainous region that had been under cultivation since time immemorial. The sight that rose before their eyes was one of almost unbelievable abundance. In the

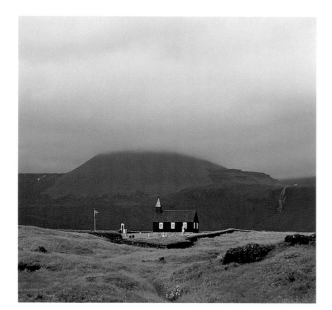
CHURCH, SNÆFELLSNES

valleys and on the plains, the soil was rich and often deep, and vegetation covered some 15,600 square miles or more—at least twice the area it covers today. Plant life thrived then even on some of the mountainous plateaus that today are barren. The most cautious scientists estimate that almost half of this area, around 7,020 square miles, was covered with birch scrub, which had largely disappeared by the beginning of the twentieth century. Others believe that area was even larger.

Historians have sometimes wondered how it was that Norwegian country people, attached to their farms despite their Viking expeditions (which in any case only occupied men during a portion of their youth), could tear themselves away from the place where they had been rooted for centuries—where they knew each stone and stream, where the sanctuaries and tombs of their fathers and ancestors lay, where they formed part of a society rich in tradition and united by manifold ties of family and friendship—to settle in a faraway place, separated from their former land by more than 600 miles of turbulent ocean. In his magisterial novel *The Sworn Brothers,* the Icelandic writer Gunnar Gunnarsson suggests an answer: in order for such a migration to begin, there had to be an unusual combination of an adventuresome spirit and attachment to the land. Closely tracking the medieval texts, the novelist tells the story of the first colonist, Ingólfur Arnarson, and his sworn brother,

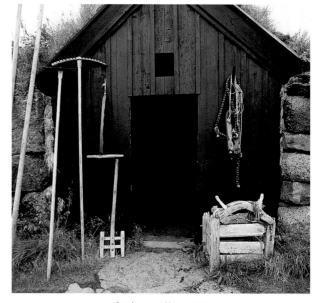
SKÓGAR MUSEUM

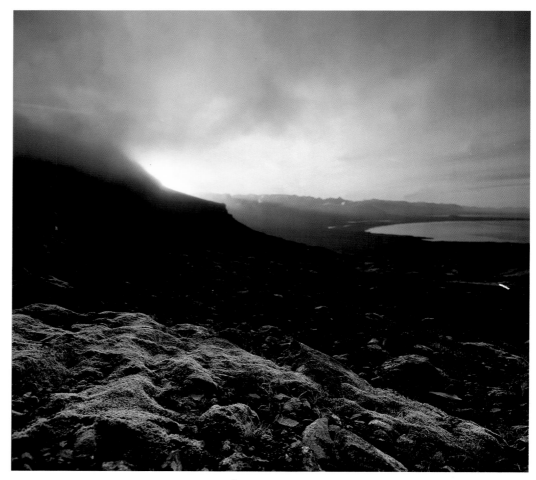

SNÆFELLSNES

Hjörleifur, exiles from Norway. Gunnarsson makes much of one particular detail mentioned in the sources: Ingólfur was very pious, whereas Hjörleifur refused to believe in the gods and to offer sacrifices to them. With his love of the land and the ancestral deities, the novelist concludes, Ingólfur alone would never have been capable of leaving for a far-off land, whereas Hjörleifur, a restless and unquiet soul, would have been capable of going anywhere but not of putting down permanent roots. Together the two decide to settle in Iceland, but once there, Hjörleifur is killed by slaves he had rounded up in Ireland. His role in the story is over, and he dies as he has lived. Ingólfur understands this in his own way: his friend's death was a necessary sacrifice to the gods so that human life could begin to flourish in the new country. During their adventures, Ingólfur had acquired a deeper understanding of the ties that bind man to the earth, and he was from thenceforth rooted in Iceland with his family. Others could now follow him to found a new society.

Brought to life for us by a writer thoroughly familiar with both medieval texts and modern historians (the novel was published in 1918), this story is extremely interesting, especially for its novelistic take on the Viking mentality. But we should also bear in mind that the richness of Iceland's soil and vegetation must have exerted a powerful pull on the Norwegians of that time, even those who were not forced into exile. It is certainly this richness that explains the scale of the subsequent migration, which brought at least ten thousand people to Iceland in a little over fifty years. According to the medieval sources—thoroughly reliable, as we have seen—the country was fully occupied by the time its leaders decided to create political institutions, which happened around 930.

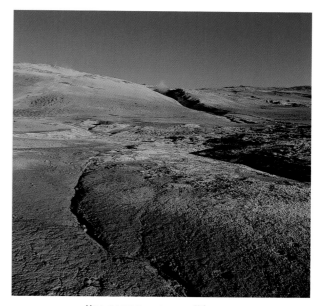

However attractive, the vegetation of Iceland was set in a landscape that must have appeared rather strange, and occasionally even worrisome, to those who saw it for the first time. In fact, below its surface lurked dark and threatening forces that would soon make themselves felt, even as they do today: volcanoes. That there were volcanoes on Iceland had already been recorded, although in a somewhat fantastic form. This was in the Irish text known as *The Voyage of Saint Brendan,* a compilation of stories handed down orally from the sixth century A.D. and committed to writing sometime between 700 and 1,000 A.D. The Voyage relates that Brendan, a monk later canonized as Saint Brendan the Navigator, discovered a mountain of fire on a North Atlantic island, where, according to legend, the gates of Hell are located.

While Iceland is entirely volcanic in origin—a fact attested to by the hot springs that occur everywhere except in the extreme east and southeast—only in part of the land are these volcanoes active. (Scientists consider a volcano to be active if it has erupted since the end of the Ice Age some ten thousand years ago). The principal volcanic region of Iceland extends in a broad belt from the northeast to the southwest. Divided in two in its southern portion, the country resembles an upside-down, slanted *Y.* In the north, the region extends to the area around Lake Mývatn and the lands north of Vatnajökull; in the south, the western branch covers the peninsula

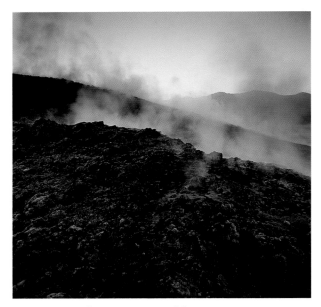

SOLFATARAS, NÁMASKARD

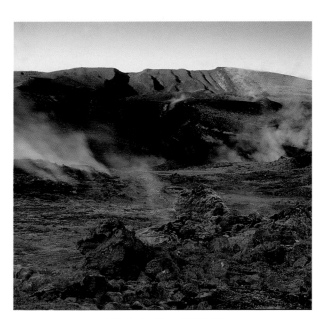

FUMAROLES, MÝVATN

of Reykjanes, to the south of Reykjavík, while the eastern branch embraces the volcanoes Hekla and Katla before continuing to the Vestmann Islands. In this broad belt are found numerous volcanoes of various types, some extinct, others active: shield volcanoes, with their circular, gently sloping form; fissure volcanoes, which appear as rows of craters; strato volcanoes; spatter cones; and others. On the surrounding plateaus and plains can be found vast fields of lava, their generally rough surfaces covered with gray moss that changes color when it rains. Dotting the landscape are hot springs and solfataras—fissures that emit sulfurous vapors, steam, and at times, hot mud—which represent the last stages of volcanic activity. Commonly called "mudpots," they are in many ways more disconcerting than the springs found in more ancient volcanic regions, for here it is the earth itself that boils and spits.

Volcanic activity has also left its mark on a second zone. Extending in the west over the peninsula of Snæfellsnes and its border region, this zone was very active for a long time after the Ice Age. Its principal volcano lay beneath the Snæfellsjökull glacier. Made famous by Jules Verne and his novel, *Journey to the Center of the Earth*, it can be seen from as far away as Reykjavík, weather permitting; its last eruption was about 2,000 years ago. There were many other volcanoes of various types in the area as well, and collectively they have created the unique landscape of Snæfellsnes, one of the most beautiful regions of Iceland, where tertiary mountains made of basalt and rhyolite, sometimes violently eroded, are juxtaposed with a recent volcanic relief of lava flows and numerous small craters.

The Norwegian colonists, pagans for the most part, had certainly not read the fantastic tales of Saint Brendan's voyage, but there can be no doubt that they very quickly discovered the troubling reality of the volcanoes. While volcanic activity is irregular and unpredictable, there is said to be an average of one major eruption somewhere in Iceland every five years. Immigration was at its height when the most recent event in the western volcanic region occurred: the eruption of the Eldborg crater around the year 900. Situated in the present-day district of Myrar, just south

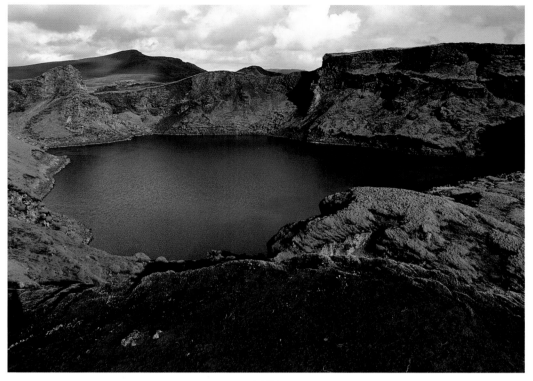

LAKI

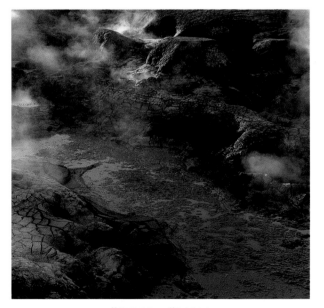

MUDPOT, KRAFLA

of Snæfellsnes, Eldborg's distinctive form can be seen from far away. We can imagine the stupefaction of the colonists, who had never seen anything like this before. In fact, that eruption marked the end of volcanic activity in that region, which geologists now believe to be extinct. Around the same time, the volcano Katla awoke in the south. This was far more serious, for Katla is not a simple crater like Eldborg but an immense caldera located beneath the Mýrdalsjökull glacier. Its eruptions produce the violent, destructive landslides and mudflows known as lahars. Echoes of Katla's eruption can be found in texts from the Middle Ages, where its story becomes the stuff of legend and fantasy: the lahar is attributed to the rivalry between two sorcerers, who take turns steering its course.

The volcano Hekla, on the other hand, was dormant during this time and did not become active before 1104. Its awakening was brutal enough. Up until then, no one had suspected that this majestic mountain, whose name means "hood," was a volcano. In any case, after their experiences with Eldborg and Katla, the inhabitants, who had by this time certainly discovered the hot springs and the earthquakes common to the region, must have known how things stood: the land they had settled was not exactly a safe and restful place.

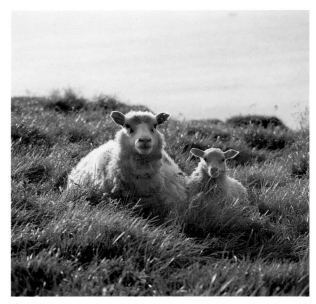

SHEEP

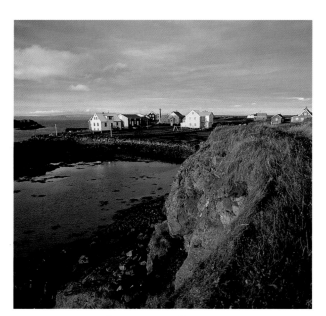

ISLAND OF FLATEY

One of the first things the colonists did was to *name* things, to find words in their Old Norse tongue for the phenomena they discovered upon disembarking after the long journey. To speak about the hot springs, they initially used the word "smokes," *reykir*. Place-names that have remained unchanged down to our own time offer ample evidence of this usage. Icelandic place-names are "transparent;" they generally have a precise meaning that often refers to nature or geography. The first of these names was perhaps bestowed on the place where the texts tell us that Ingólfur Arnarson himself settled in 874: Reykjavík, "the bay of smokes." Innumerable other examples followed: Reykjanes, "the peninsula of smokes" to the south of Reykjavík, and Reykholt, Reykjalundur, Reykjadalur, Reykjafjördur, or simply Reykir. In each case, the name indicates the presence of hot springs.

As the settlers became more familiar with Iceland's volcanic features, this imprecise word, *reykir,* was replaced by terms that we might characterize as more technical and which are still in use: *hver,* which originally meant "basin," and *laug,* which meant and continues to mean "bath." The latter word, which designates tranquil hot springs as opposed to those that send up jets of water, reflects the fact that medieval Icelanders used these springs for bathing. A circular medieval bath fed by a hot spring can still be seen at Reykholt, the home of the thirteenth-century writer Snorri Sturluson.

Like *reykir, hver* and *laug* also appear in place-names. For example, the big municipal swimming pool in Reykjavík is in a valley named Laugardalur. In contrast, the word *geysir,* which means "the spouter," and which is now used as a generic term the world over, is in Iceland a proper name. It designates the most famous hot spring of all, the Geysir, in the valley of Haukadalur, in the south. The Geysir first appeared after an earthquake at the end of the thirteenth century, and it continued its 200-foot-tall eruptions for hundreds of years, finally falling quiet at the beginning of the twentieth century. Then again, in June 2000, following a series of earthquakes in the region, it showed some impressive, though sporadic, signs of life.

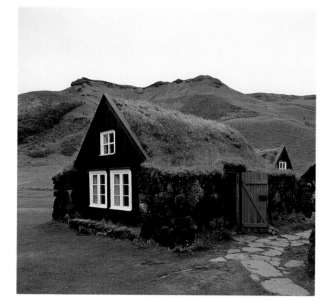

SKÓGAR MUSEUM

For volcanic eruptions, the first Icelanders simply used the word for fire, *eldur*. They spoke of an "outburst of fire," and this rather vague usage continued for a long time, perhaps because no one had gone close enough to see what actually took place. In an early scientific discussion of Icelandic volcanism, the author of *The King's Mirror,* a thirteenth-century Norwegian manuscript, spoke of an *elds ofurgangur,* an "overflow (or violence) of fire." Interestingly, among all the place-names of Iceland, there is not one with the precise meaning of "volcano." The word *hraun,* however, occurs commonly in place-names. This word, which originally meant "rocky terrain" or "scree," was used by the settlers to designate the expanses of lava that were now part of their daily landscape. The word took on this new, specialized meaning, and it remains in use today. One example of a place-name compounded from it is Ódádahraun, "the hraun of crimes," where, according to legend, outlaws took refuge from pursuit.

Place-names also show that the first inhabitants were quite aware of the difference between the two types of rivers found in Iceland, glacial rivers and spring-fed rivers. The first they usually called *jökulsá,* which simply means "glacier river," or sometimes *hvítá,* "white river," because of their distinctive color. When it came to spring-fed rivers, what seemed to draw their attention most was the presence of salmon. A number of rivers in Iceland bear the name *laxá,* "salmon river." To

TYPICAL SOUTHERN FARM

FAÇADE, REYKJAVÍK

distinguish them, information about where they are found was added, as in Laxá á Ásum, in northern Iceland, which today is famous for the dizzying prices that anglers must pay for the right to fish there—up to two times the monthly salary of the average worker for a single day with a single rod.

In this country, whose oddities undoubtedly seemed a little less threatening once they had been named, the Norwegian colonists began to make themselves at home. Their immigration is unique in that it was totally spontaneous, unprompted by any religious or political power. While individuals may well have been motivated by economic or political factors, the decision to emigrate was a personal one. Upon arrival in Iceland, the colonists settled freely on property they chose themselves, and at first they were not subject to any laws. At the most, probably to prevent abuses, they established rules to limit the extent of the land that an individual was allowed to claim. To have the right to a piece of property, a man had to be able to "consecrate it by fire" in a single day—that is, to mark its limits by lighting a series of bonfires in such a way that each fire was visible from the two bonfires closest to it. A woman—for among the colonists were female heads of families or lineages—had to be able to consecrate her property by leading a young cow around its borders, also in a single day. It is difficult to say what effect such rules actually had. According to the sagas, important Norwegian leaders often sought to stake out large, undivided regions, not to exploit for their own profit, but so that they could control who settled there by awarding parcels of the land to family and friends. One factor probably played a role in the colonists' search for places to settle: they looked for somewhere that resembled their native region in Norway, the land they had left behind. And if certain place-names reflected the physical realities of their new land, the settlers also brought names of places they knew from the old country, as a way of making themselves feel at home.

Although the land that spread before the new arrivals was vast, the possibilities for settlement were limited, for only the coastal regions are habitable. The colonists

HEIMAEY, VESTMANN ISLANDS

took this in stride easily, since, coming as they did from a country with a long coast-line, they were thoroughly accustomed to navigation and getting about by sea. Only in southern Iceland, and to a lesser degree in the west of the island, do large plains extend into the interior. Elsewhere, the landscape is dominated by valleys and small coastal plains formed by erosion during the Ice Age, which are surrounded by basaltic mountains whose darkness is occasionally gladdened by layers of yellow rhyolite. Northern Iceland features some large valleys, as does Fljótsdalshérad, in the east; and narrow valleys are found in the fjords of eastern and western Iceland, and also in parts of the north. In some places, only a narrow strip of land stands between the mountains and the ocean. The area around Mývatn, in the northeast, is almost the only habitable region that does not lie along the sea coast.

The highlands of the interior are a world apart from the coastal plains and valleys, and they must have remained unexplored by the new settlers for some time.

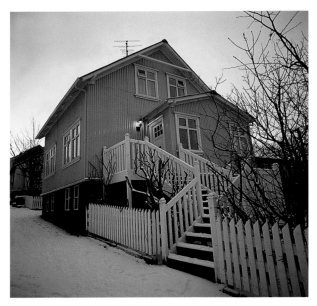

REYKJAVÍK

REYKJAVÍK

This interior region is a land of mountain peaks and desert plateaus, at the center of which stand three immense glaciers: Langjökull in the west, then Hofsjökull, and finally, the most impressive of all, Vatnajökull, whose 3,276 square miles make it by far the largest glacier in Europe. At the foot of these glaciers, travelers can cross such vast expanses as Kjölur, to the west, with the hot springs of Hveravellir at its center, or the seemingly endless desert of Sprengisandur in the east. This arid region could easily remind a visitor of the Sahara itself were it not for the black color of the volcanic sand thrown up by its violent storms and the glaciers that can be seen in the distance on either side.

The central highlands are continued on the south by the Mýrdalsjökull glacier and its companion, the Eyjafjallajökull, on the coast, both of which can been seen clearly from the plains of southern Iceland. Three of Iceland's glaciers are marked by a rare and, at times, terrifying distinction: lying beneath Vatnajökull, Mýrdalsjökull, and Eyjafjallajökull are active volcanoes, whose eruptions have wreaked havoc on more than one occasion in the island's history.

The colonists built their farmhouses in the habitable regions of their new country as best they could. These homesteads were often quite distant from one another, and they have remained so to this day. In contrast to continental European patterns, agricultural villages were never part of the Icelandic landscape, nor was there a city proper before the end of the eighteenth century, when small urban clusters began to grow up at Reykjavík and at Akureyri, in the north.

The first houses were of a common Scandinavian type known as *skáli*. Constructed of peat, they consisted of a single room, often quite long, with a hearth at the center and built-in benches for working, eating, and sleeping. The remains of such a house dating from the tenth century have been found at Eiriksstadir, in Haukadalur, in western Iceland, where medieval sources tell us that Erik the Red lived before leaving to oversee the colonization of Greenland, which he had discovered and explored. In the year 2000, to commemorate the discovery of America by Scandinavian navi-

gators, the Icelanders built a replica of this house next to the ruins. Open to visitors, the reconstruction gives us a good idea of what dwellings must have been like during the early period of colonization.

As time passed, the houses grew larger. The *scáli* was sometimes divided by a partition, and rooms were added onto it for such purposes as food storage. A house of this more evolved type, probably dating from the twelfth century, has been excavated on the Stöng farm, in the Thjórsá river valley. The remains can be visited, as can a modern reconstruction of them called Thjódveldisbærinn, not far from the nearby Búrfell hydroelectric center. Far more austere than the reconstruction of the earlier house at Eiriksstadir, this replica nevertheless gives an equally good idea of a typical dwelling a little after the colonization. Inside wealthier, larger farmhouses, paneling made of wood imported from Norway might be decorated with engraved or sculpted images—that is, if we can believe the *Laxdale Saga* (the *Saga of the Salmon Valley People),* which tells of how a poet immortalized Ólaf Pá's home at Hjardarholt by singing the splendors of its carved paneling. Judging by the fragments of this poem preserved in other texts, the scenes on the paneling were drawn from pagan mythology and illustrated, among other things, the burning of the god Baldur and the battle of Thor and Midgardsormur, the serpent-monster who encircled the Earth. The saga's chronology dates the poem to around 978. The fabled interior disappeared long ago, but the magnificent carved door of Valthjófsstadir, now housed in the National Museum in Reykjavík, gives us an idea of its style.

Toward the end of the Middle Ages, the Icelandic house evolved into what was to become its classic form, which continued to be built well into the twentieth century, even as late as 1950. It was laid out in multiple rooms arranged along a central corridor, with the common room generally at the rear. Many farmhouses of this type have been preserved as museums, the best known of which is probably Glaumbær, an eighteenth-century farmstead in the district of Skagafjördur. Visitors should keep in mind that the serrated profile formed by the pointed gables of its

REYKJAVÍK

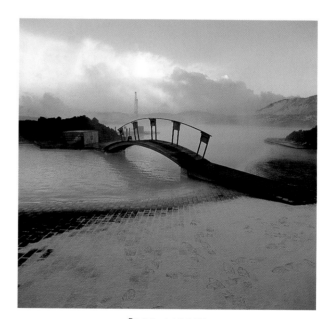

BLUE LAGOON

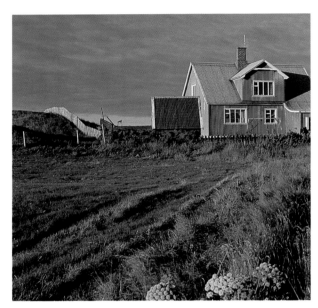

FARM, HEIMAEY, VESTMANN ISLANDS

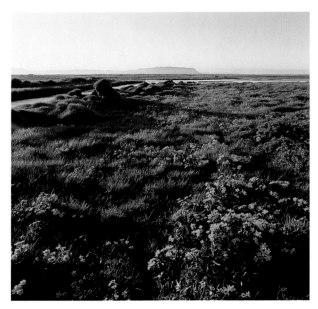

REYKJANES

façade is not authentic for the period, since this façade type only became popular during the nineteenth century. In fact, it became so popular that Icelanders today often mistakenly take it as a symbol of their ancient rural civilization. The interior of Glaumbær, however, is of a type that has remained unchanged for centuries.

The basic framework of Icelandic life was thus established during the first centuries of settlement, and it remained unaltered for centuries to come, untroubled by immigration or invasion. The same agricultural regions were cultivated, and on the farms, corridor house succeeded corridor house as the humid climate made periodic rebuilding a necessity. We can get a sense of this continuity by noting that numerous medieval farms—some established by the first colonists and listed in the *Book of Settlement,* whose earliest, now lost, version probably dates from the twelfth century, and others established only slightly later—have existed under the same names from very early times up to the present day. But the most vivid testimony to this geographical and cultural continuity is found in the sagas, which are the classical literature of Iceland and the very foundation of its culture. Written during the thirteenth century, but recounting events supposed to have occurred some three centuries earlier—between the beginning of settlement and the first third of the eleventh century—these works are profoundly anchored in the realities of Iceland and in the daily life of its people. Their protagonists live on farms that are real and known, and whose names are cited. When they travel, they follow precise itineraries, and events are meticulously placed in a real landscape.

In the *Saga of Gísli,* for example, one of the protagonists, Vésteinn, returns to Iceland after spending some time abroad. He lands at Önundarfjördur, in the Westfjords, and then takes the road to Dýrafjördur to visit his brother-in-law, Gísli, all the while not knowing that events have occurred during his absence that now endanger his life. Gísli learns of his brother-in-law's arrival and quickly sends messengers to warn him to turn back. Between the two fjords there is but one single road, which passes through a valley, over a mountain path, and then across another valley—the

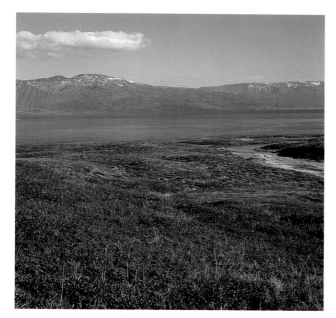

FJORD, DALVÍK

very route followed by the same road today. Despite Gísli's efforts, the unthinkable happens: the messengers do not come across Vésteinn, and they continue on their way before realizing their error and turning back. They catch up with Vésteinn, but it is too late, for he has passed the place where the waters part, where, as he says, "All waters now flow toward Dýrafjördur." Having come to this point, he will no longer turn back, but goes to meet his destiny.

How did the Gísli's messengers miss meeting Vésteinn? As the saga tells us, specifying all the places involved, the messengers crossed the path taken by Vésteinn in the only place where it was possible for travelers coming from opposite directions to pass one another without meeting. The road divides in two for a short distance, and a hill between the separate paths blocks the view. Similarly, in the *Saga of Hrafnkell,* the mountainous route taken by the shepherd Einar during his fateful ride on the forbidden horse of the god Freyr is described with almost scientific precision.

Numerous examples of such precise description can be found in the sagas. We can almost always follow the events on a present-day map, for the names of farms, places, and other specifics have remained the same since they were first written down. In 1981, when Ágúst Gudmundsson made *The Outlaw,* a film based on the *Saga of Gísli,* he was able to shoot many of the scenes in exactly the same places they occur in the saga—in the southern reaches of the Westfjords and on an island in Breidifjördur.

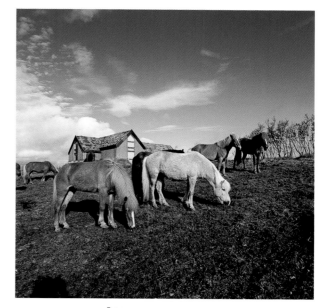

ICELANDIC HORSES

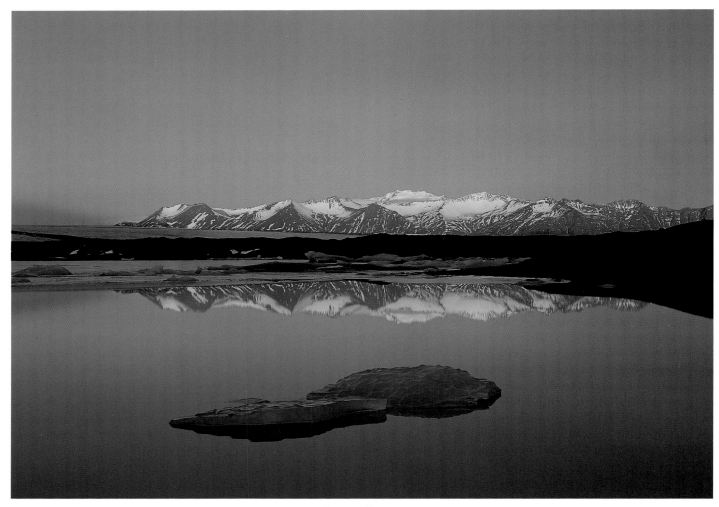

VATNAJÖKULL

Conversely, when readers of the sagas travel across the country, they often pass places that evoke legendary characters and events: Helgafell, in the district of Snæfellsnes, remains, for anyone familiar with Icelandic literature, the farm of Snorri the Godi and the place where Gudrún Ósvífursdóttir is buried. The island of Drangey, in Skagafjördur, is the place where the outlaw Grettir met his death. Hlídarendi and Bergthorshvoll are the farms of Gunnar and Njáll, respectively. Many Icelandic regions are closely associated with a particular saga: the district of Snæfellsnes with the *Eyrbyggja Saga,* the valleys at the bottom of Breidifjördur with the *Laxdale Saga,* the southern reaches of the Westfjords with the *Saga of Gísli,* the northern reaches of the Westfjords with the *Saga of the Sworn Brothers,* numerous places in the

North with the *Saga of Grettir,* and the entire Southeast with the *Saga of Burnt Njáll.* The novelist Halldór Laxness once said with some justice that the anonymous authors of the thirteenth-century sagas drew up a map of Iceland, and he added that no better map had been made since.

Readers also discover, however, that the sagas have little to say about the landscape and speak rarely about nature in general. What interests their authors is the story, the relationships, and conflicts between protagonists, who reveal their natures through words and deeds. All this is recounted in a sober, restrained style and—apart from a few wildly exaggerated battle descriptions—with great economy of means. The authors do not dwell on details that were clearly secondary for them, such as natural settings, unless these have a direct effect on events or add another dimension to the action. Such is the case with the storm that rages during the night when Vésteinn is killed in the *Saga of Gísli,* and the heavy snowfall at the end of the *Saga of Burnt Njáll.* In the voyages of Vésteinn and of Einar, the enumeration of small details in the descriptions creates a feeling of inexorable fate.

Despite the economy of the language of these stories, it is the true Iceland that we sense through the sagas. Events take place against a backdrop of daily life and reflect the relationship between the people and their country. The authors are keenly aware of the importance of this relationship, and they display an acute sense that the natural surroundings have deteriorated since the arrival of the first settlers. They note that when the events in their tales took place, forests were more abundant than in their own day, and occasionally they cite specific examples.

In fact, deforestation began with the arrival of the first colonists, for their sheep made short work of young shoots, and thus prevented the birch scrub from renewing itself. It is now thought that by the thirteenth century most of Iceland's birch forests had already disappeared. This ecological disturbance finds an interesting echo in the semantic evolution of the word *holt.* At first, like the German word *Holz,* it meant "forest." This is its sense in place-names such as Reykholt and Hjardarholt,

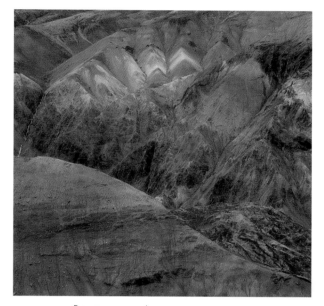

RHYOLITE, LANDMANNALAUGAR

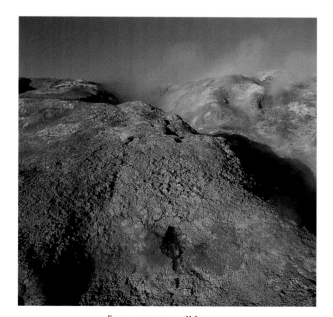

FUMAROLES, MÝVATN

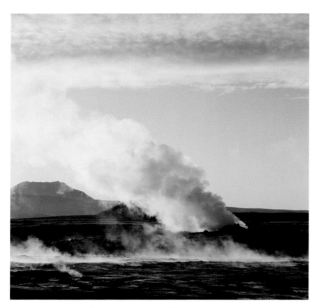

FUMAROLES, NÁMASKARD

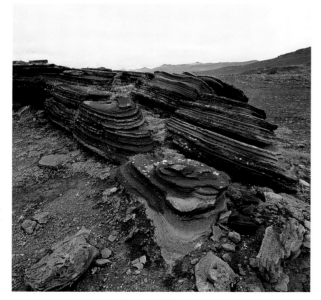

TUFF, MÝVATN

and also in some passages of the sagas. But as the woods disappeared, the word came to designate the sad sight that remained after a forest had gone—a field or low hill, stony and barren. This secondary sense is also well attested in the sagas.

The catastrophic consequences of deforestation became increasingly evident after the thirteenth century. No longer protected by birch scrub, the soil began to erode, and ever larger regions grew barren. The process was quickened by climatic changes as well. When the Norwegian colonists first arrived in Iceland, the climate was relatively warm, probably a little warmer than it is today. Despite the several harsh years evoked in the sources, this mild climate generally continued through the twelfth century, and it may perhaps even have grown warmer, which explains why agriculture was far more varied in those years than it became later. Numerous place-names attest to the fact that pigs were raised along with sheep and cows and, at least in the South, that grains were grown. The *Saga of Burnt Njáll* includes a scene where Gunnar, struck by the beauty of the "fields of golden wheat," refuses to go into exile. In the thirteenth century, however, the climate grew considerably cooler, and this change was to last a long time. The fourteenth century remained cold, and though we lack sources for the fifteenth century, we know that the climate did not grow warmer at the end of the Middle Ages and that during the sixteenth century it grew even colder. This was the beginning of an especially cold era, sometimes known as the "little ice age," which lasted for centuries, until around 1920. The cooling showed itself in various ways: glaciers advanced, sometimes burying ancient farms in their path, and ice floes appeared off the coast, in some years closing off the fjords of the north and east of the island, interrupting sea travel or halting it altogether, and with it the transport of goods into Iceland. The combination of deforestation and climate change, together with the enormous pressure placed on the remaining vegetation, meant that "wounds" inflicted by volcanic eruptions could no longer heal as quickly as they had in the past. The eruptions, of course, continued as before: the volcano Hekla caused problems once or twice per century, Katla around every seventy years, and many

others did so, as well, from time to time. But the most spectacular—and the best documented—eruption of all was undoubtedly that of a volcano in the southeast, Laki, in 1783. In that year, from Laki's crater surged the largest flow of lava ever recorded during the historical era for a single eruption anywhere in the world. It covered 220 square miles. Today the hardened lava is covered with an immense expanse of moss.

With the climatic change and progressive desertification, the conditions of life in Iceland deteriorated as well. Husbandry was impoverished. In the sixteenth century the cultivation of grains was abandoned, pigs were no longer raised, and raising sheep took on a greater importance than herding cattle. Particularly harsh winters, sometimes followed by seasons that included summer in name only, triggered famines. Natural catastrophes were equally lethal. The eruption of Laki in 1783 spewed toxic gasses that killed thousands of livestock and poured forth a molten river of lava that destroyed several farms in its path. After this catastrophe, the population of Iceland dropped by almost a quarter. Nearly a century later, in 1875, a similarly destructive eruption of the volcano Askja in the mountains of the northeast touched off an emigration movement to Canada.

A detail, perhaps symbolic but in any case striking, illustrates how harsh life had become. At the end of the Middle Ages, when firewood had become very scarce, the custom arose of leaving the common room, the *skáli,* during cold weather to take refuge in the *badstofa*—a bath chamber similar to a sauna—which was easier to heat. During the seventeenth century, houses normally had both a *skáli* and a *badstofa,* although it seems that people generally preferred to stay in the badstofa. During the nineteenth century the *skáli* disappeared altogether, and the *badstofa,* which could no longer be heated as in the past, became the common room. It was for this reason that in the last years of the ancient rural civilization of Iceland, the common room was called the "bath room."

But this country, which grew increasingly harsh for human beings, had a dual nature. Next to the visible world of men, who carried on as best they could with their

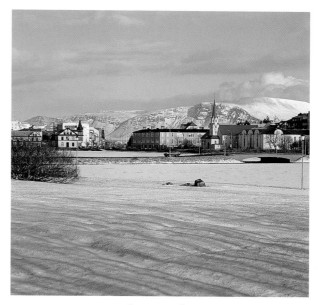

REYKJAVÍK

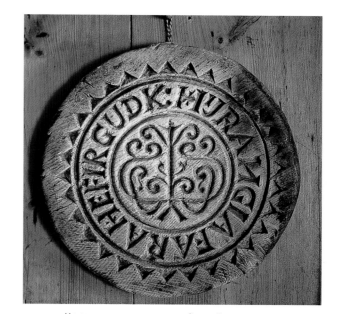

WOOD ENGRAVED IN OLD ICELANDIC

REYKJAVÍK

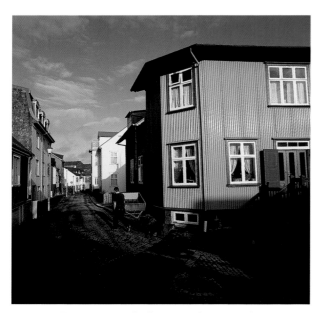

NEAR LAKE TJÖRNIN, REYKJAVÍK

daily lives, there was another world, partly invisible and entirely unknown, peopled by beings that haunted the colonists' imaginations when they felt worn down by daily hardships and sought escape in dreams mingled with fear. In the mountains there were giants, who lived in grottoes and were generally hostile to humans—they had remained pagan, besides—though they could be helpful under the right circumstances. The interior regions of the country, it was said, were also populated by outlaws, who stole sheep and lived in splendor. According to the stories, these outlaws lived in unmapped mountain valleys covered with immense roofs. There, life was much easier than in the lowlands, where ordinary people still continued to live at the mercy of the elements. Moreover, in the hills surrounding the farms, and in the rock formations of the lava fields, there were elves, known as *huldufólk,* or "hidden folk." These beings could enter into relations with humans and could also be helpful, though it was essential not to provoke them or to disturb their homes. Like human beings, the elves had their own churches—large rock formations recognizable by their form. Children were forbidden to make noise nearby. And everywhere there were ghosts who roamed the land at night, terrifying one and all.

It is difficult to trace the evolution of this invisible world. It doesn't play a large part in the classic sagas, although certain aspects of it do appear. The *Eyrbyggja Saga,* which dates from the mid-thirteenth century, includes a hair-raising ghost story, and giants, who already loomed large in Germanic mythology, dwell in the grottoes described in the early fourteenth-century *Saga of Grettir.* But it is above all in folk tales collected during the nineteenth century that the invisible world appears in its full splendor.

We know that some changes had already taken place by then. While tales were still told in which giants appeared, people apparently stopped believing in giants during the eighteenth century, perhaps because the formerly unknown tracts of the country's interior had become better known by then. But other beliefs remained in force and even persist to the present day, as the excellent French documentary

Investigation into the Invisible World (*Enquête sur le monde invisible*), filmed in Iceland by Jean-Michel Roux and released in 2002, has recently shown. Readers of Icelandic newspapers have more than once learned that a road has been rerouted or a construction project abandoned because of rock formations where the hidden folk are supposed to dwell, and some Icelanders say firmly that they have had dealings with elves. At the University of Iceland today, researchers collect modern popular stories that are every bit as fantastic as the tales of long ago, in which the same ghosts appear—although now they sometimes hitchhike.

In all other ways, the situation in modern Iceland has changed completely. The climate has grown warmer since 1920, the glaciers have significantly receded, and ice floes have moved away from the coast. Above all, the development of the fishing industry since the end of the nineteenth century has allowed the economy to take off, bringing about unprecedented changes, most notably the growth of the cities and the accompanying exodus from the rural regions. Cod fishing and the herring boom during the years around 1900, gave rise in the smaller fjords to numerous fishing villages, some of which owed their rapid expansion to Norwegian fleet owners. These villages are charming places filled with very pretty, Scandinavian-style wooden houses, though many have been marred by later construction. Well preserved examples can yet be found in such places as Seydisfjördur in the east, on the island of Flatey in the Breidifjördur, and even in the center of Reykjavík, to the east of the lake. Lastly, the growing economy led to the urbanization of the country, especially the unbridled growth of Reykjavík, which today is home to more than half the population of the country. Unfortunately, the architecture in the new urban neighborhoods is often distressingly mediocre.

Icelanders' attitude toward nature remains contradictory. Thoroughly aware of the dangers posed by desertification, they have tried to reverse the process, sometimes with spectacular results. The expanses of sand in the southeast, until recently black and sterile, are today partly covered with a resistant species of grass.

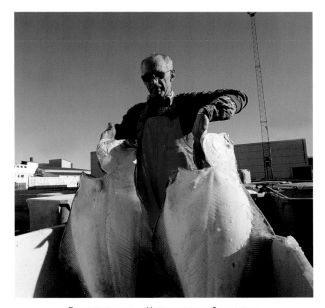

FISHERMAN, VESTMANN ISLANDS

TRADITIONAL FISHING NETS

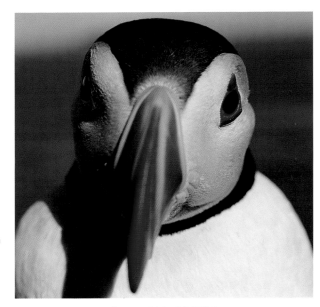

ATLANTIC PUFFIN

Reforestation has been avidly and successfully pursued, notably by importing foreign species that adapt well to the Icelandic climate. A good example of this is the Alaskan poplar, which today is widely grown. However, magnificent landscapes are also disappearing beneath lakes created by hydroelectric dams. One such dam currently under construction in Kárahnjúkar, in the eastern mountains, has provoked a wave of opposition.

This contradictory attitude may perhaps be the sign of a newly emerging sensitivity to the grandeur and extraordinary diversity of the Icelandic countryside, one that accepts both its welcoming side and its darker, more threatening aspects. This sensitivity began to emerge in the nineteenth century with the Romantic poets, who were the first to find inspiration in the landscape, and it grew during the twentieth century through what might be called the artistic conquest of Icelandic nature. It can be seen in the way that painters have gradually become engaged with the landscape—tentatively at first, recording views of distant glaciers and volcanoes, then gradually drawing nearer, paying more and more attention to details in order to capture their truth. Thus the great painter Jóhannes Kjarval spent much of his life trying to capture the nuances of color produced by shifting light over the lava fields—where he often sensed the presence of "hidden folk." In music, the vast tone-paintings of the composer Jón Leifs evoke the nature of Iceland in a harsh and majestic style influenced by the folk music of the country. Almost unknown at the time of his death in 1968, these compositions are often played today, despite their difficulty. The choreographic drama *Baldr,* inspired by the same mythological episodes as the wood carvings the medieval poet sang of at Hjardarholt, ends with an evocation of a volcanic eruption unparalleled in its power. Only the future will tell us what form this sensitivity will take in the coming years, and what influence it will have on the life of Iceland.

— EINAR MÁR JÓNSSON

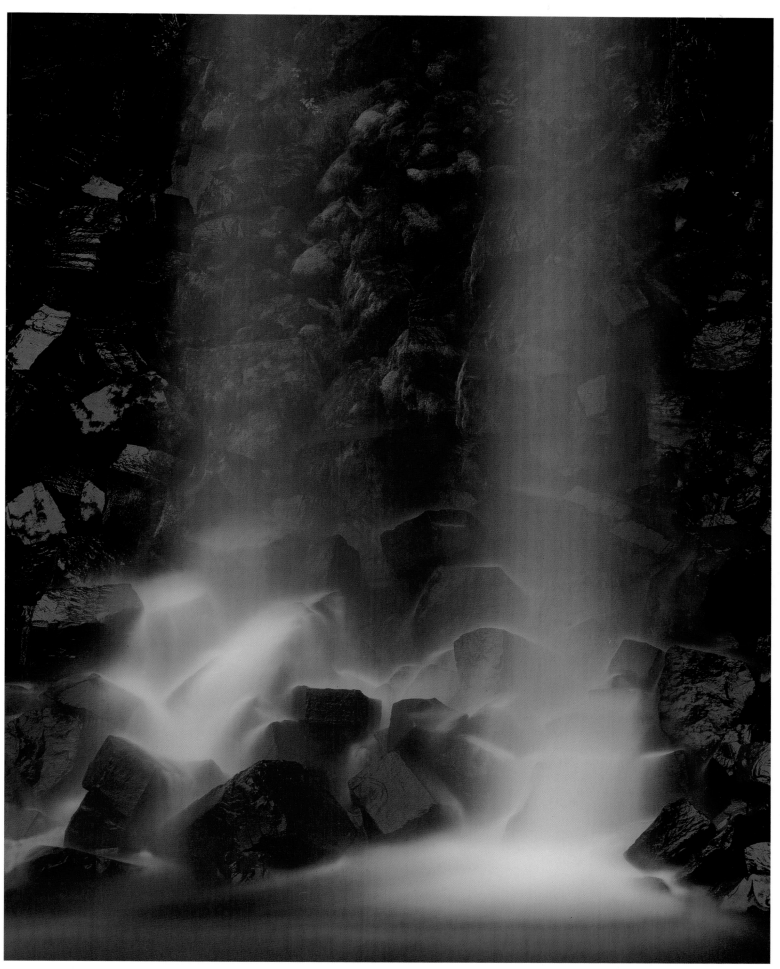

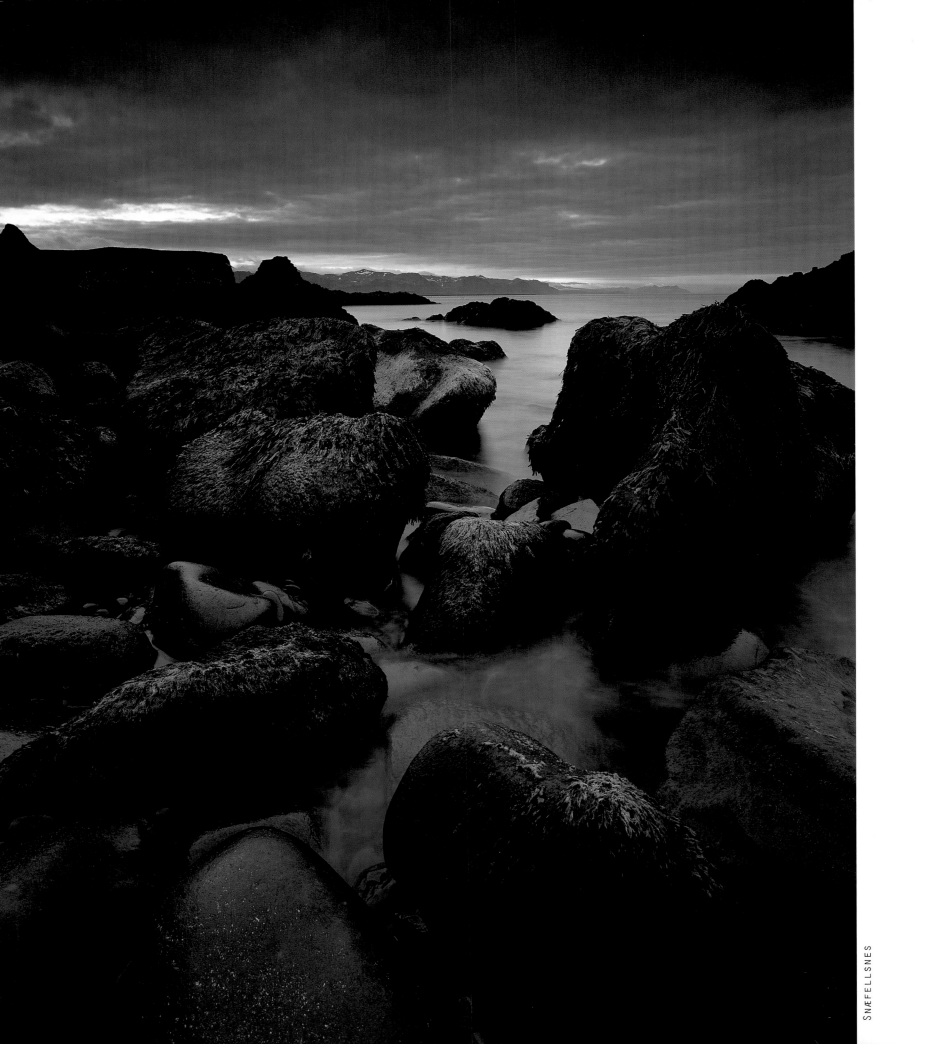

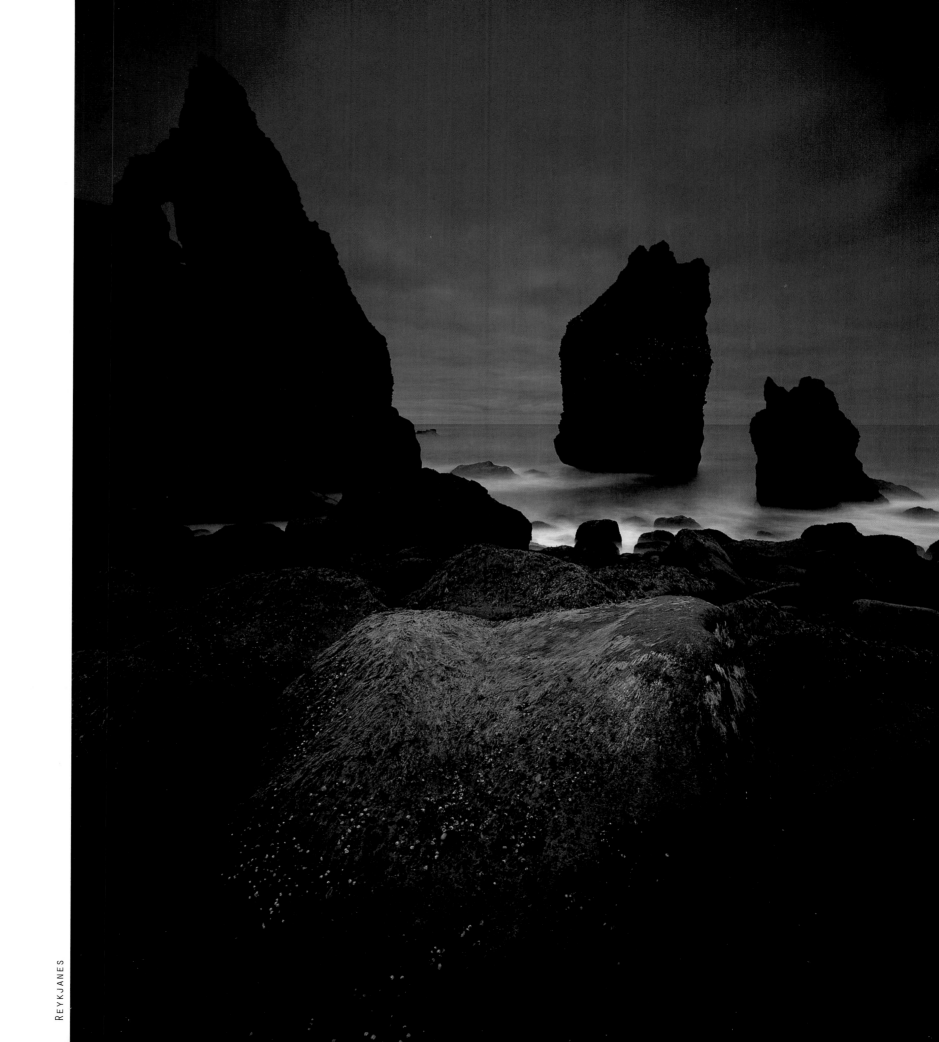

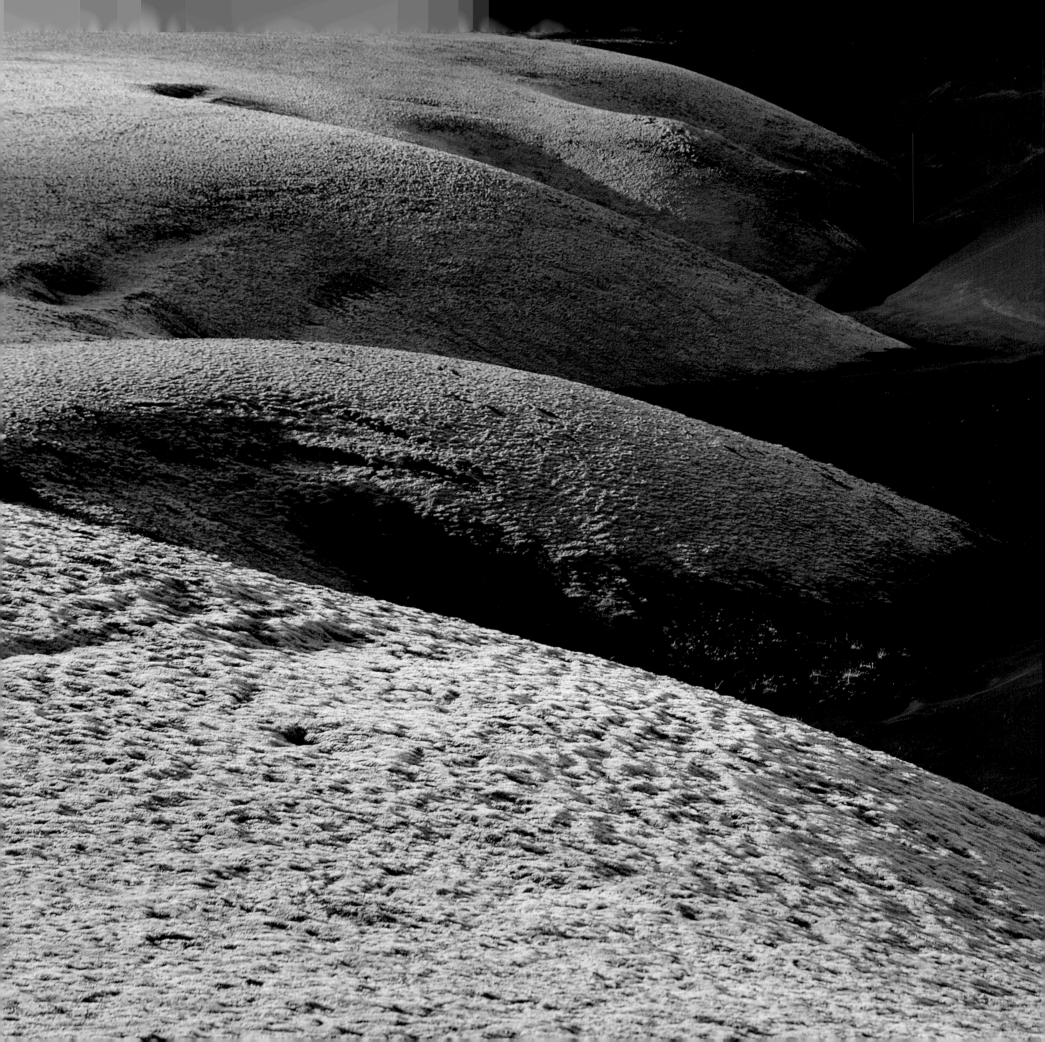

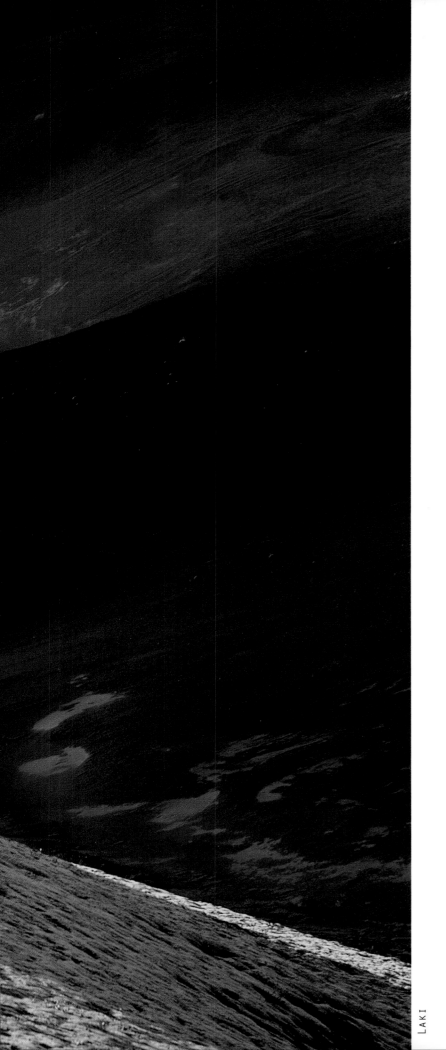

LAKI

HINUM MEGIN VIÐ FJALLIÐ
From the other side of the mountain

ER ÞÖGNIN ÁÞREIFANLEGRI
The silence is more palpable

INGIBJÖRG HARALDSDÓTTIR, from *Svar*

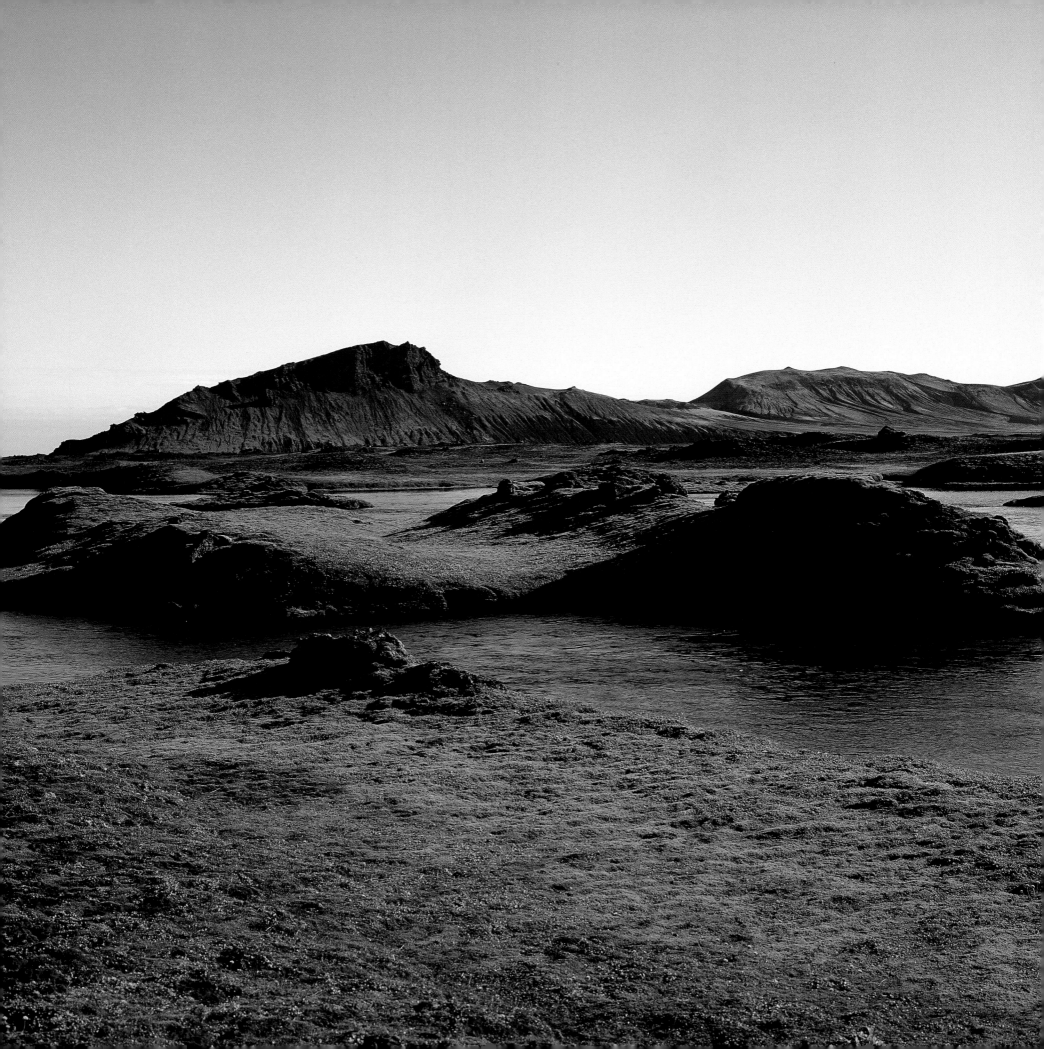

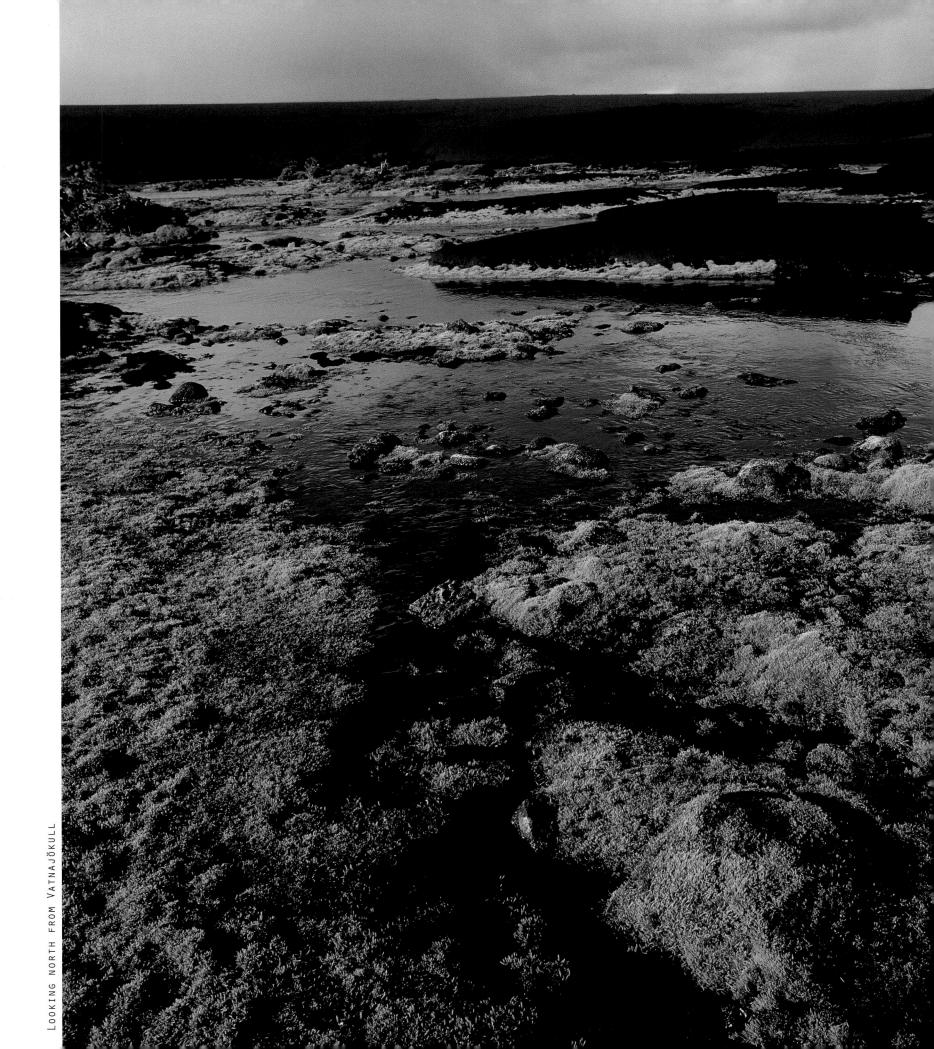

LOOKING NORTH FROM VATNAJÖKULL

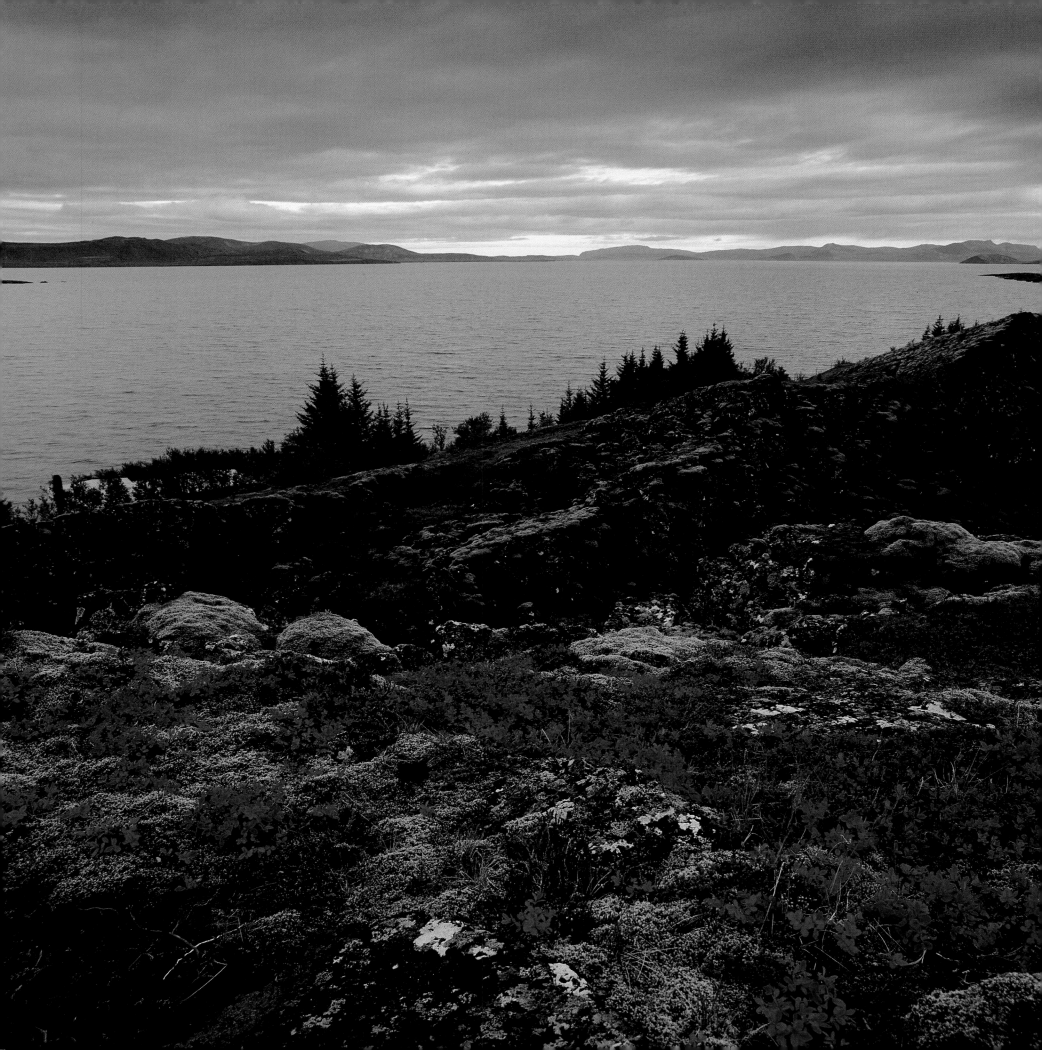

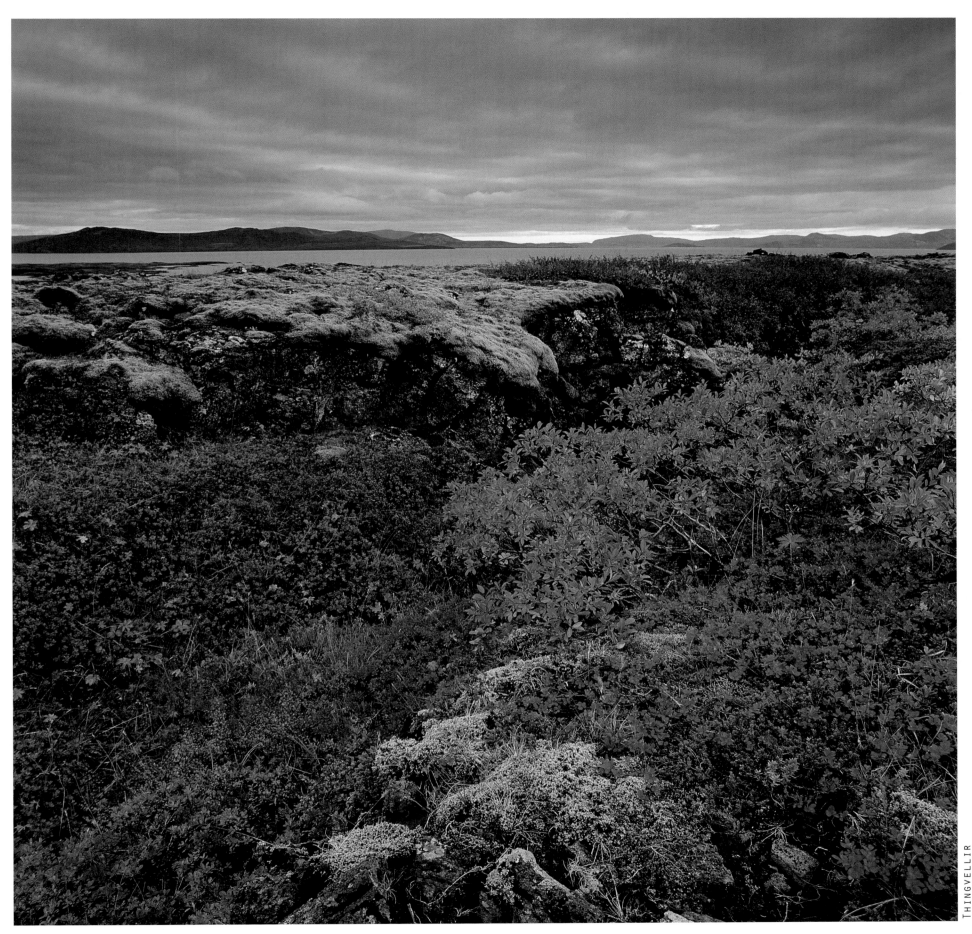

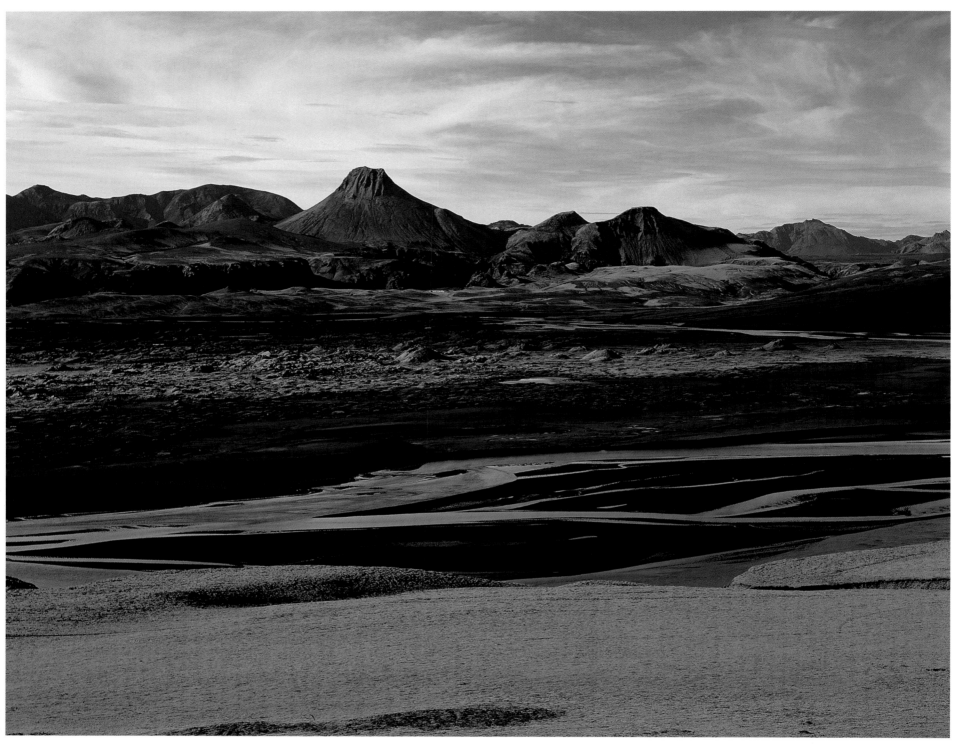

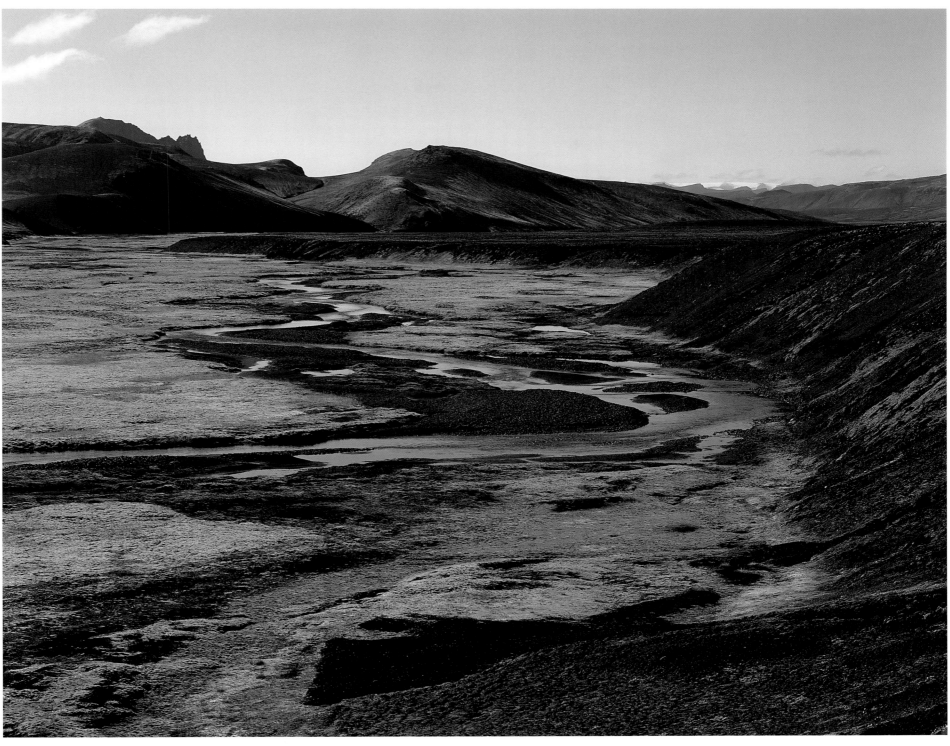

LAKI

43

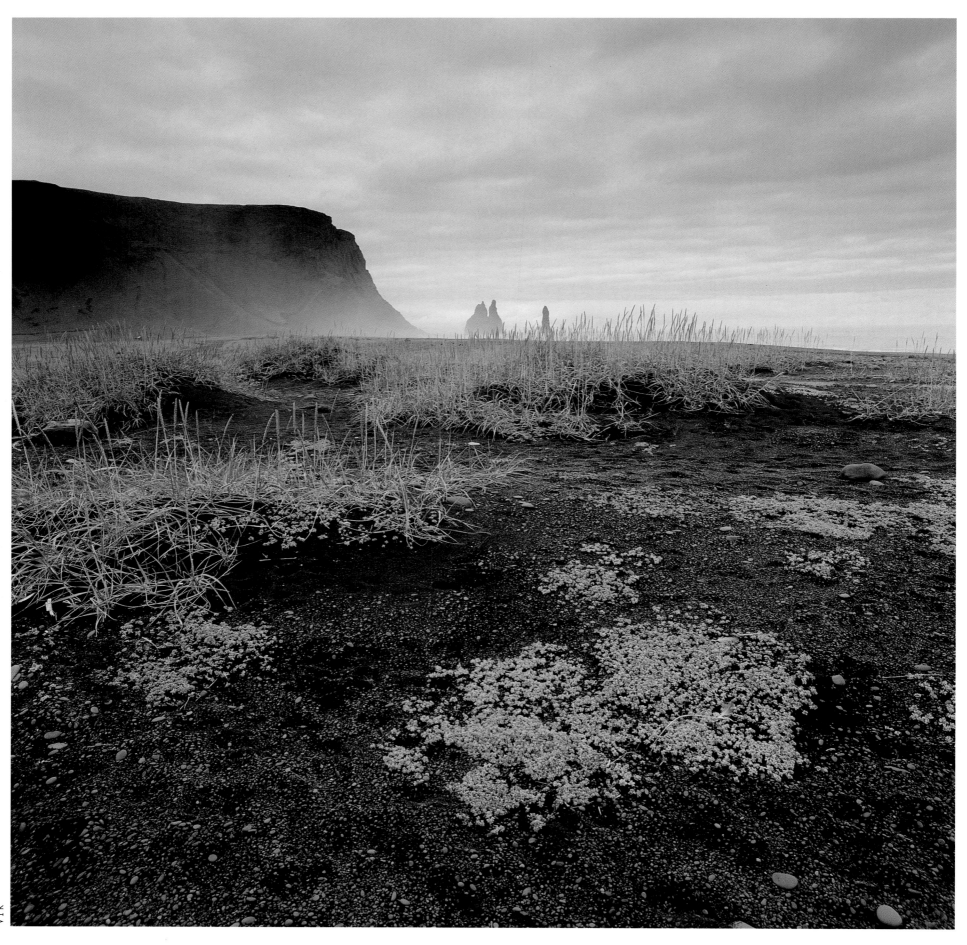

VÍK

HVERT LIGGUR ÞESSI VEGUR?

Where, then, does this path lead?

ÓLAFUR JÓHANN SIGURÐSSON, from *Hvert Liggur Thessi Vegur?*

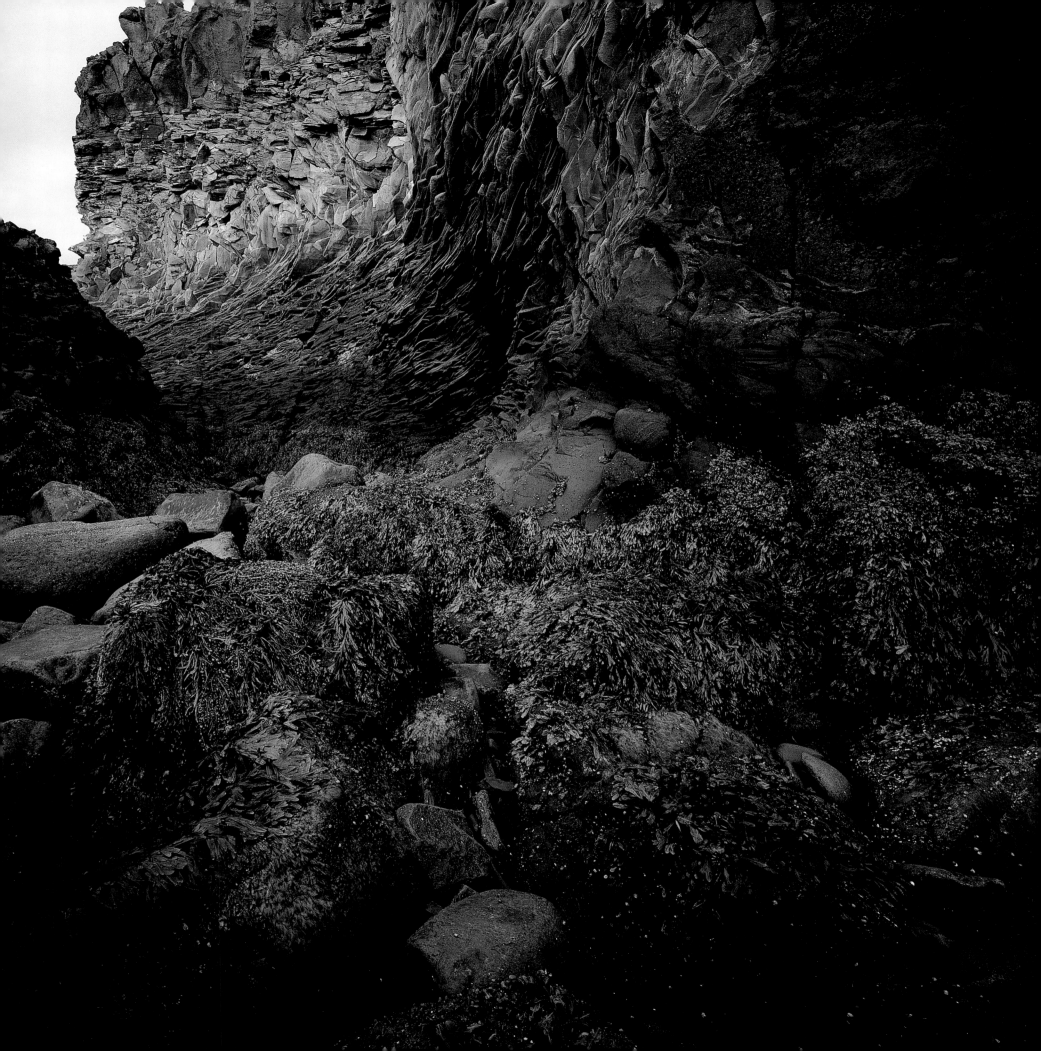

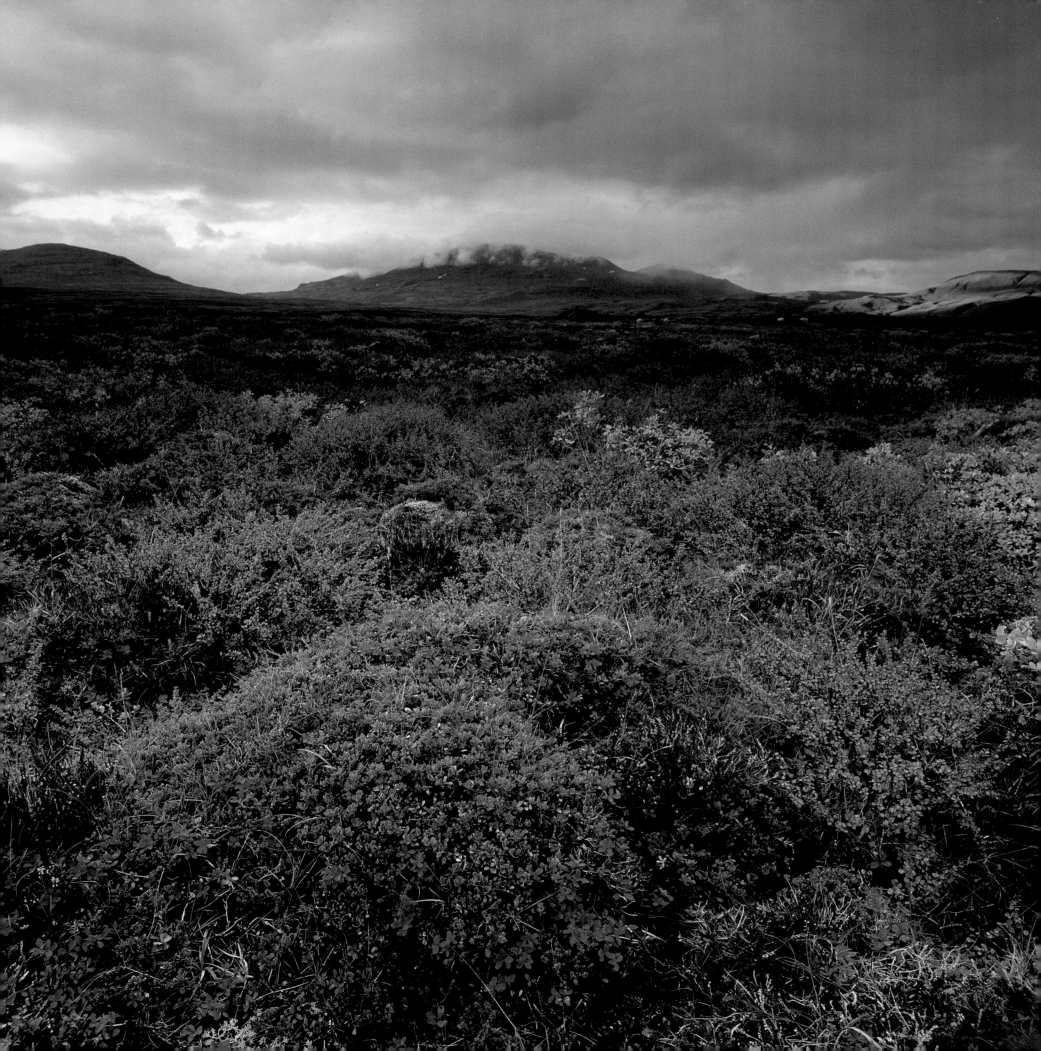

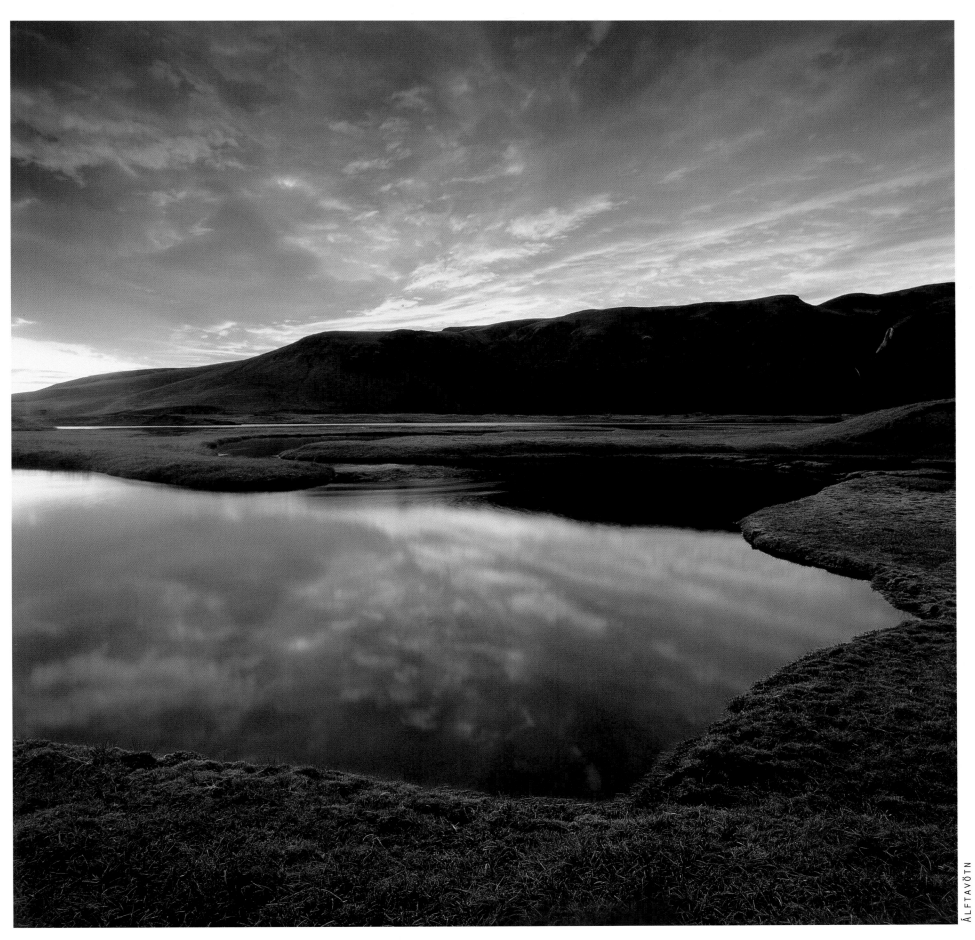

ÁLFTAVÖTN

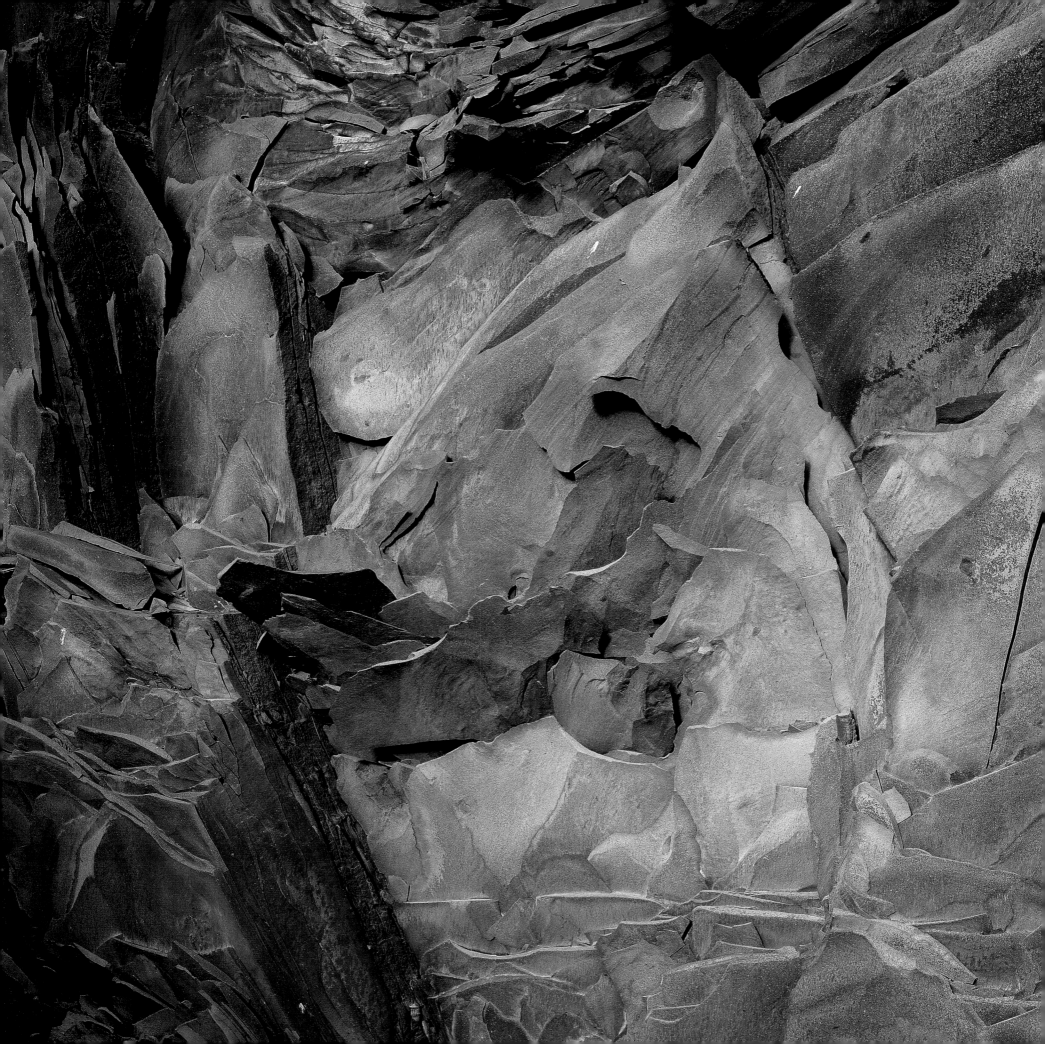

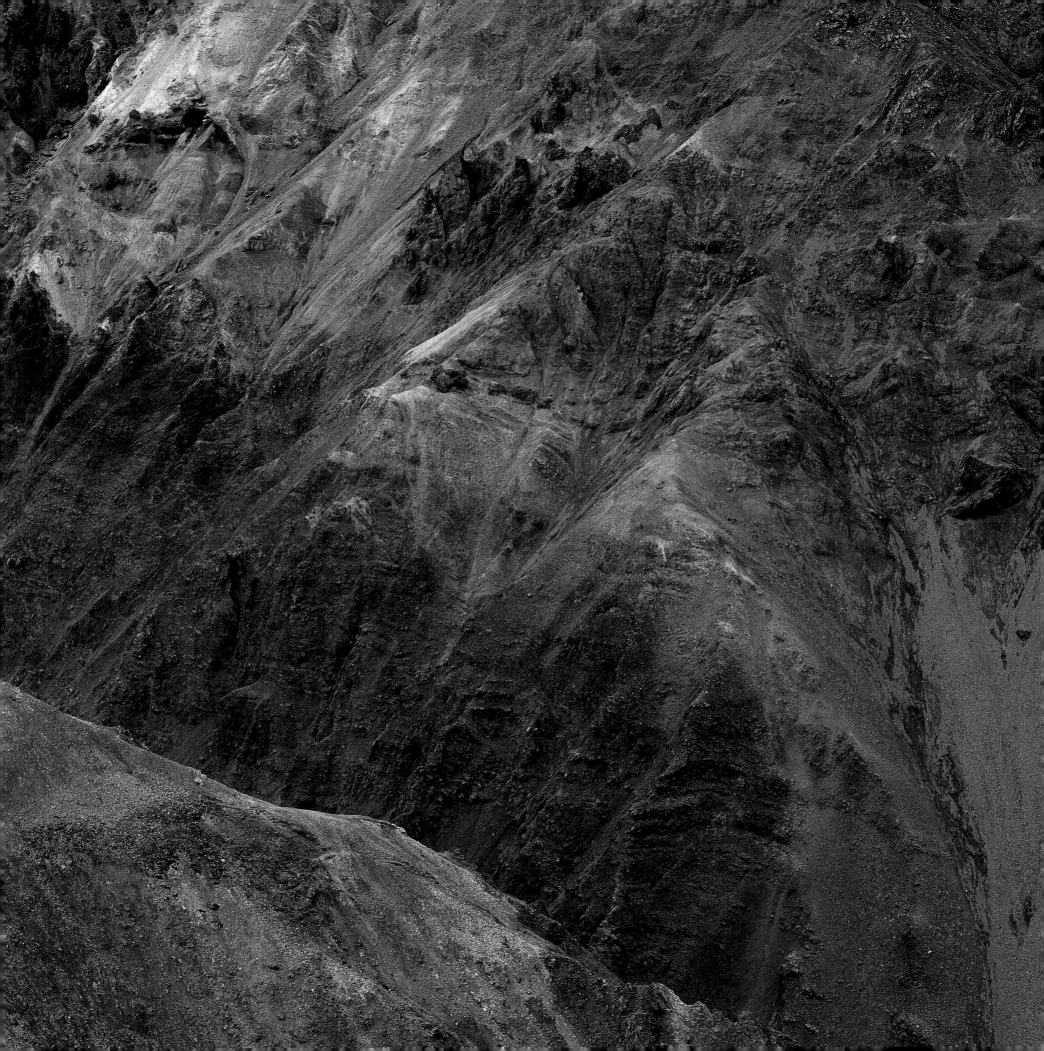

SJÁÐU.

Look,

ÞAÐ ER EKKERT, EKKERT.

There is nothing, nothing.

ÞÚ HEFUR ALDREI VERIÐ HÉR.

You were never here.

STEINN STEINAR, from *Vögguvísa*

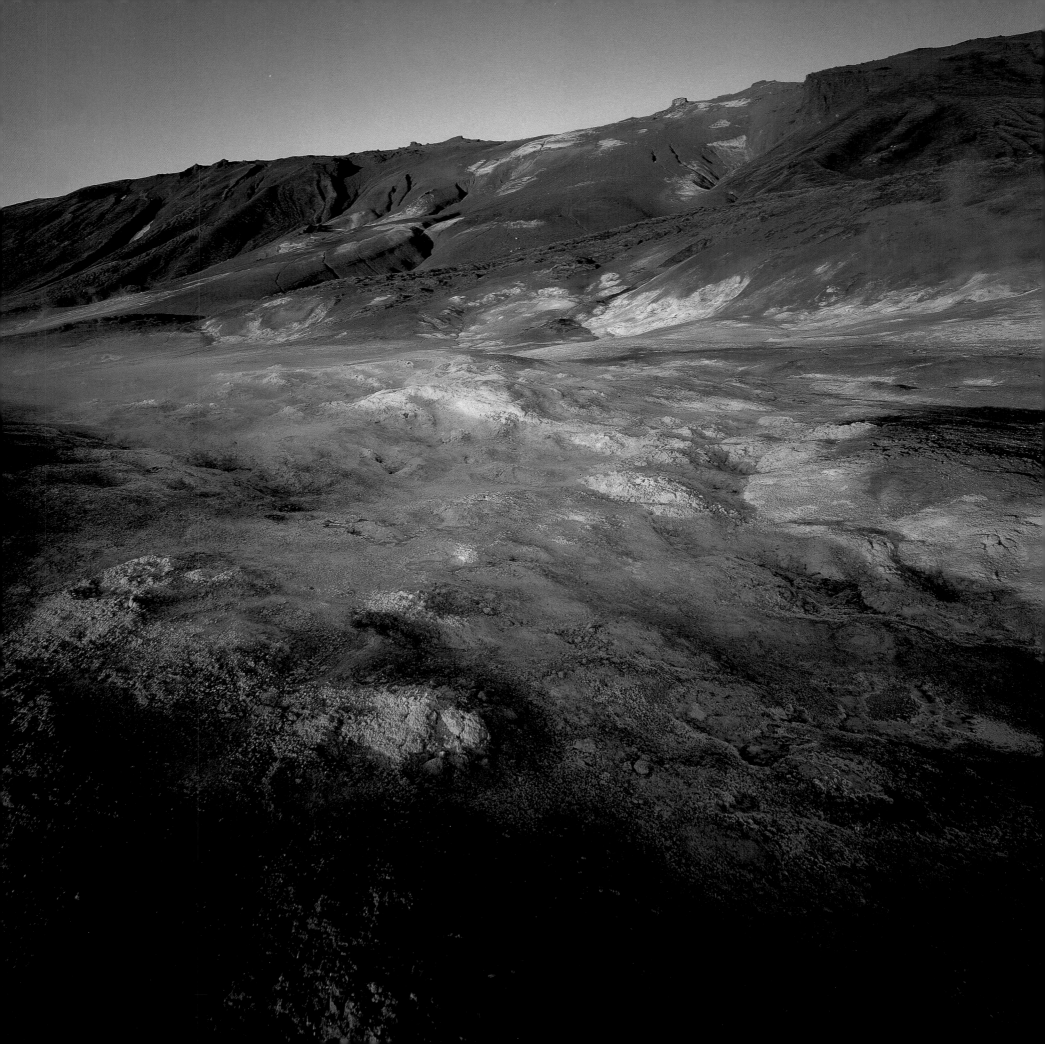

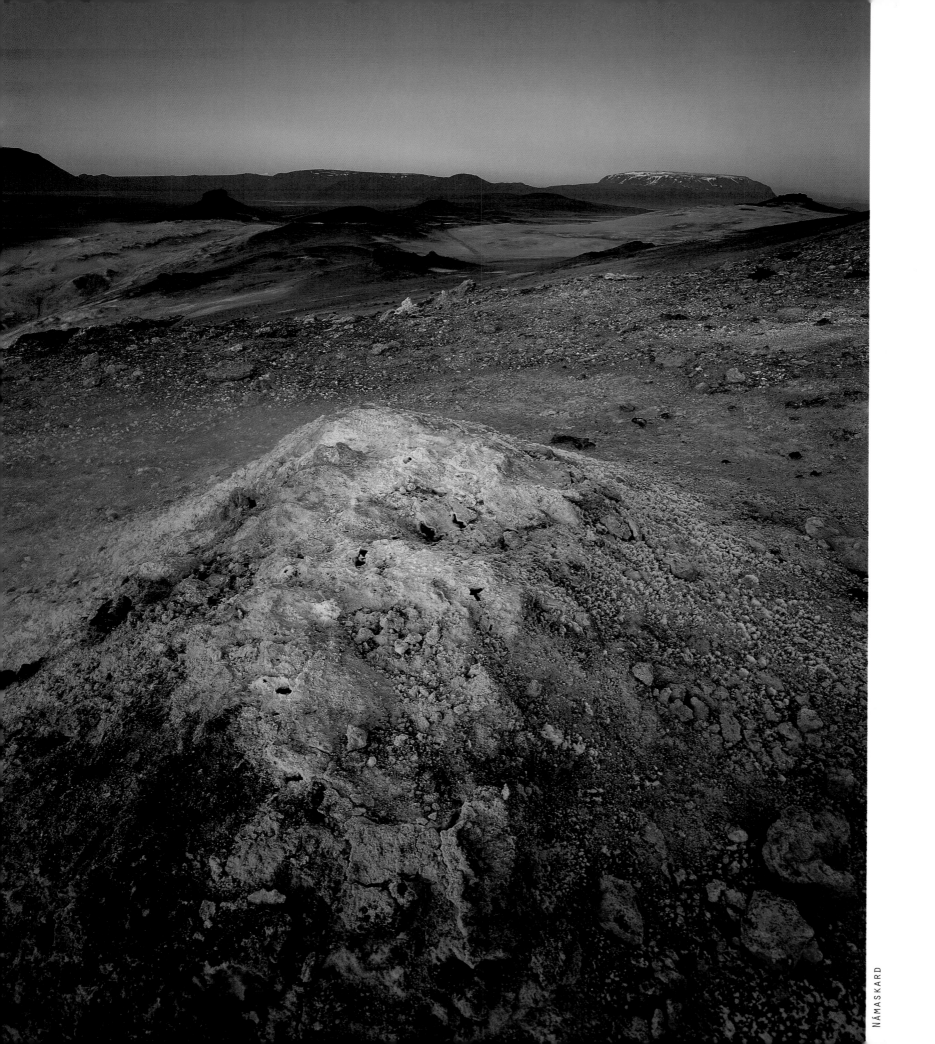

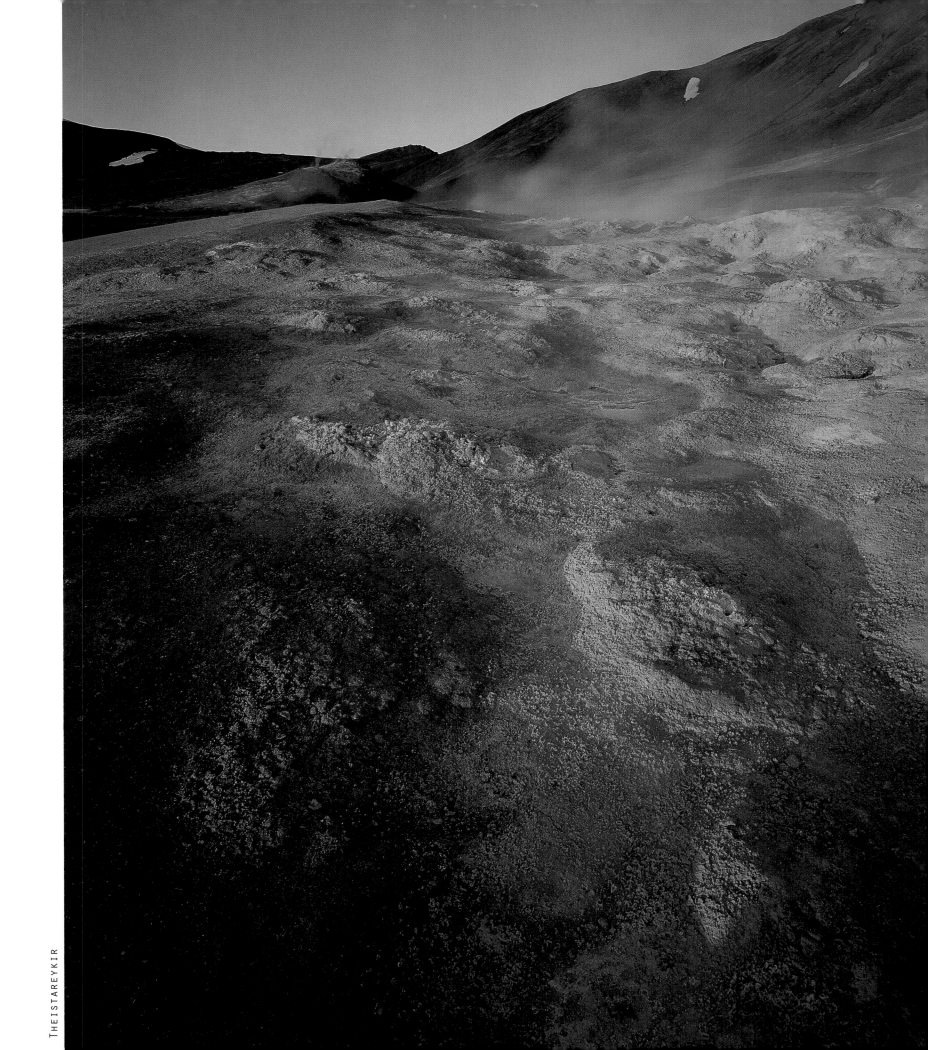

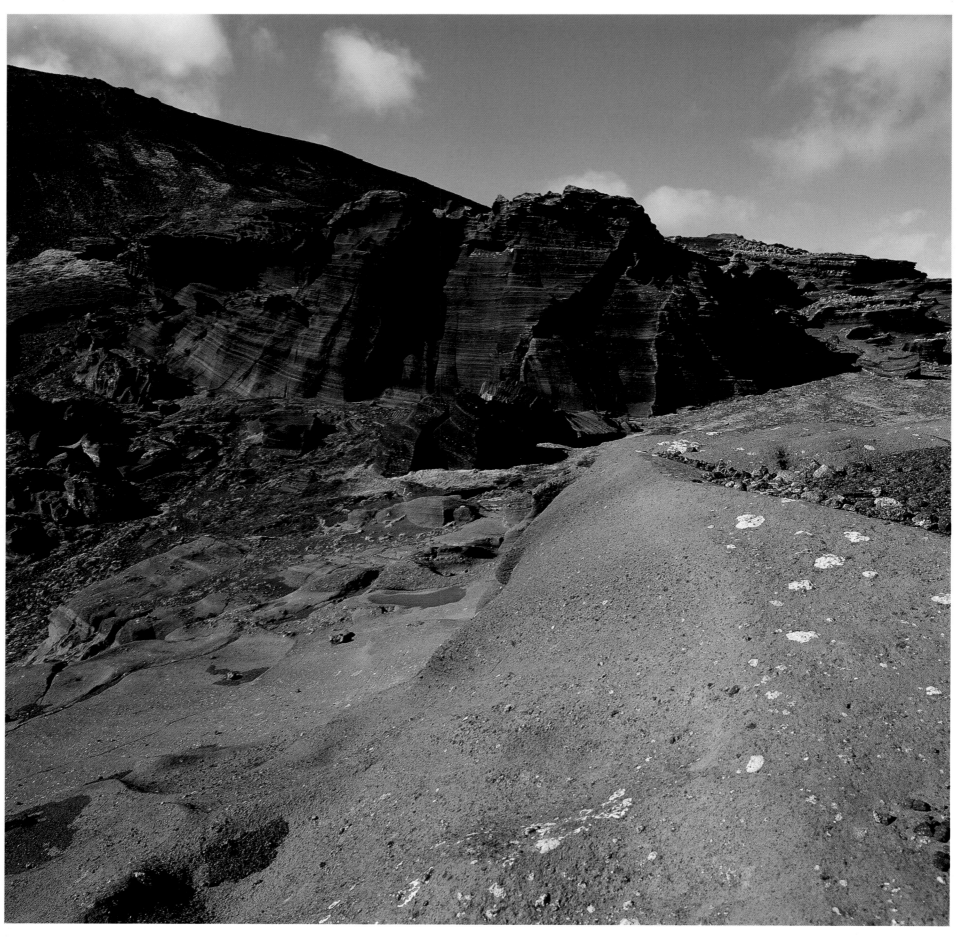

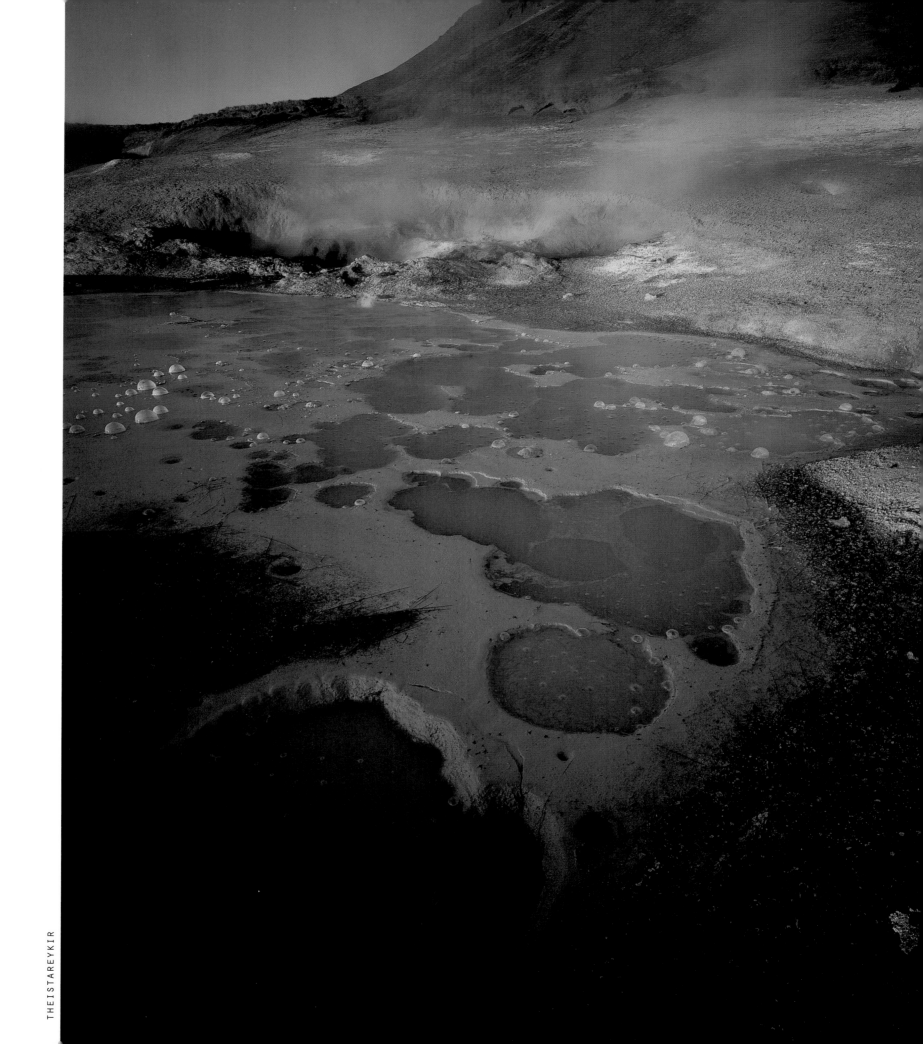

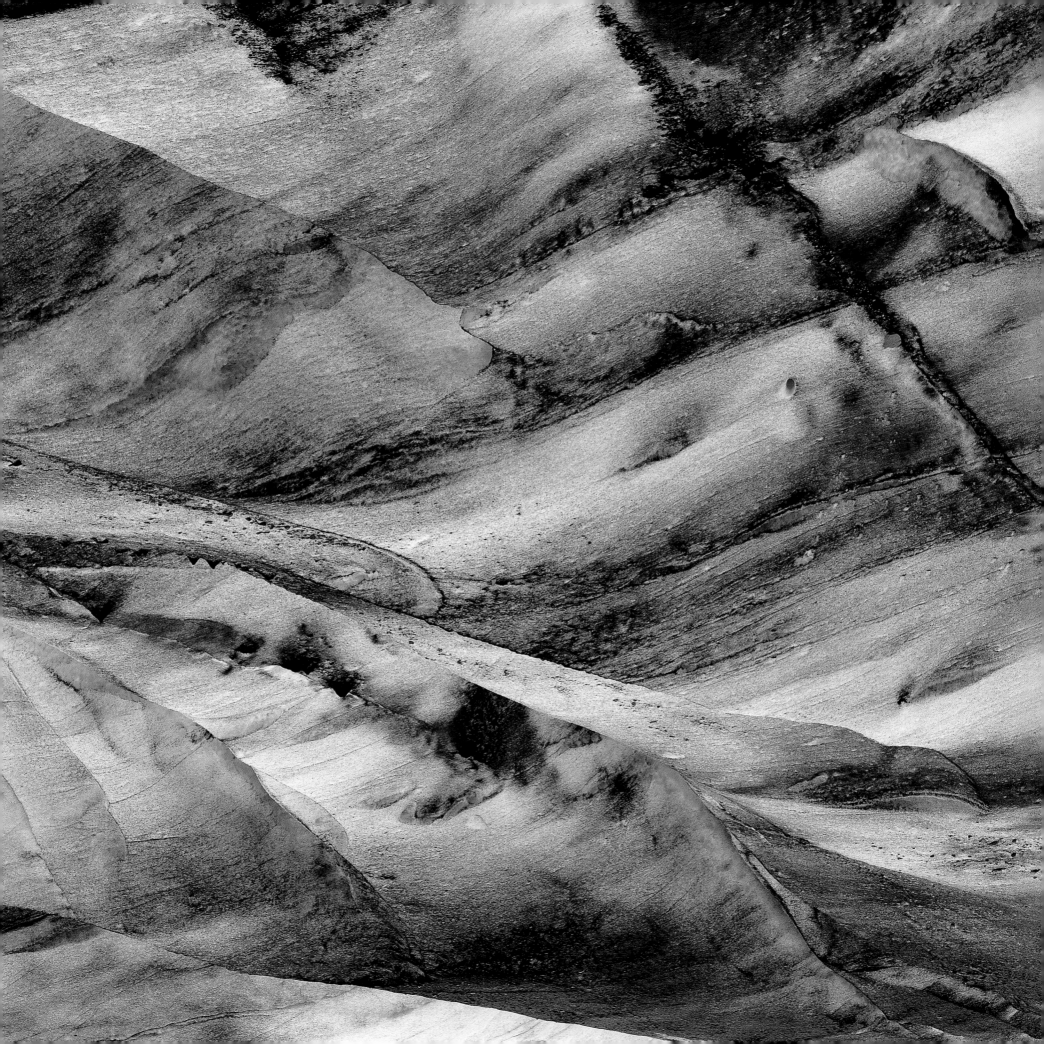

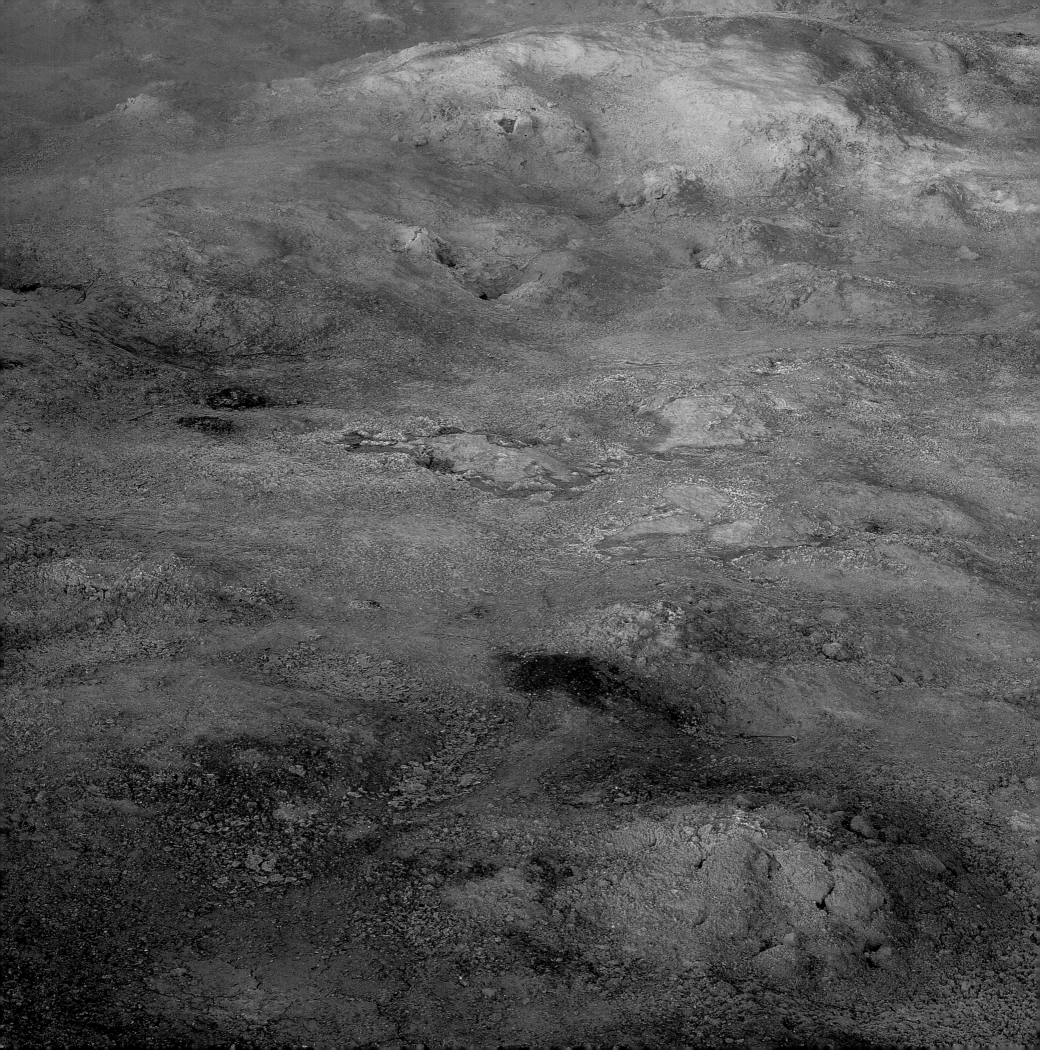

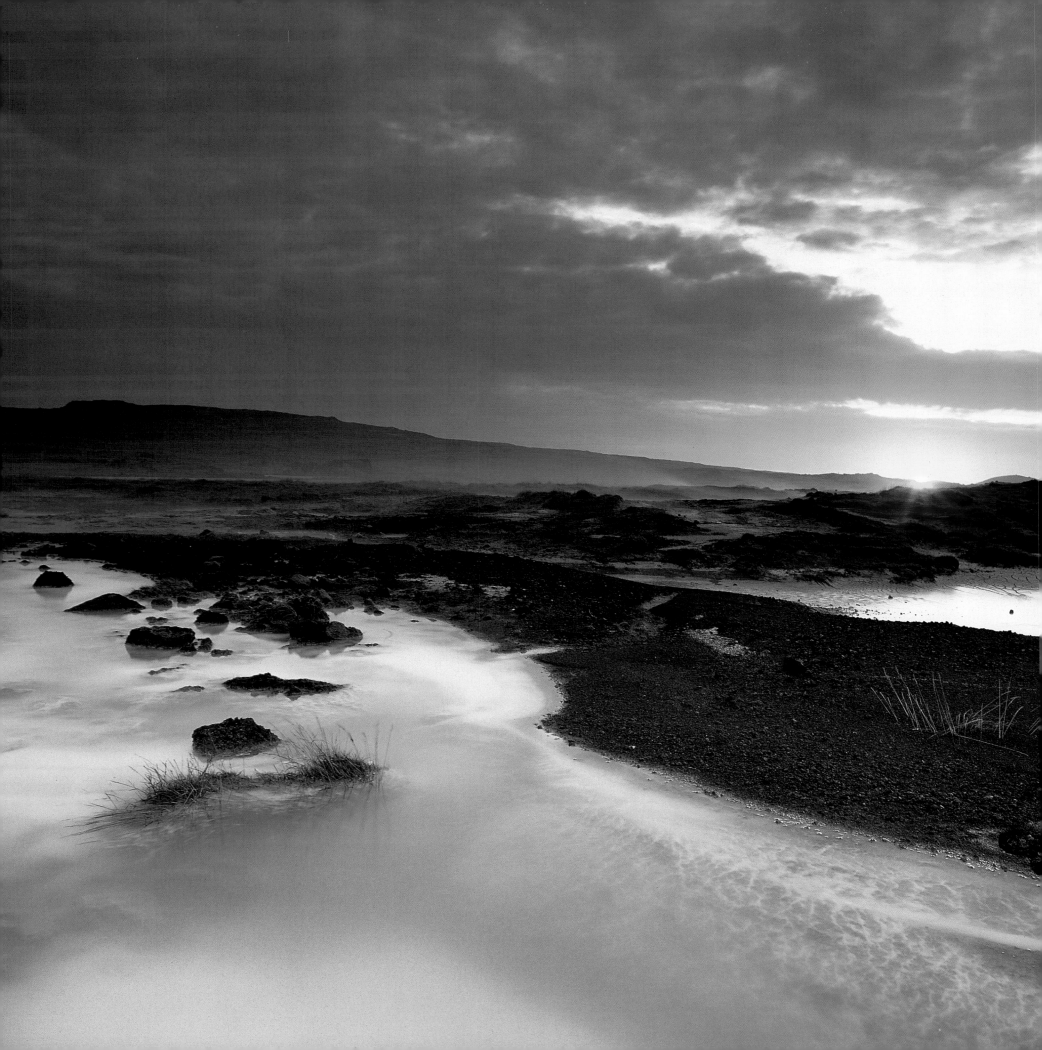

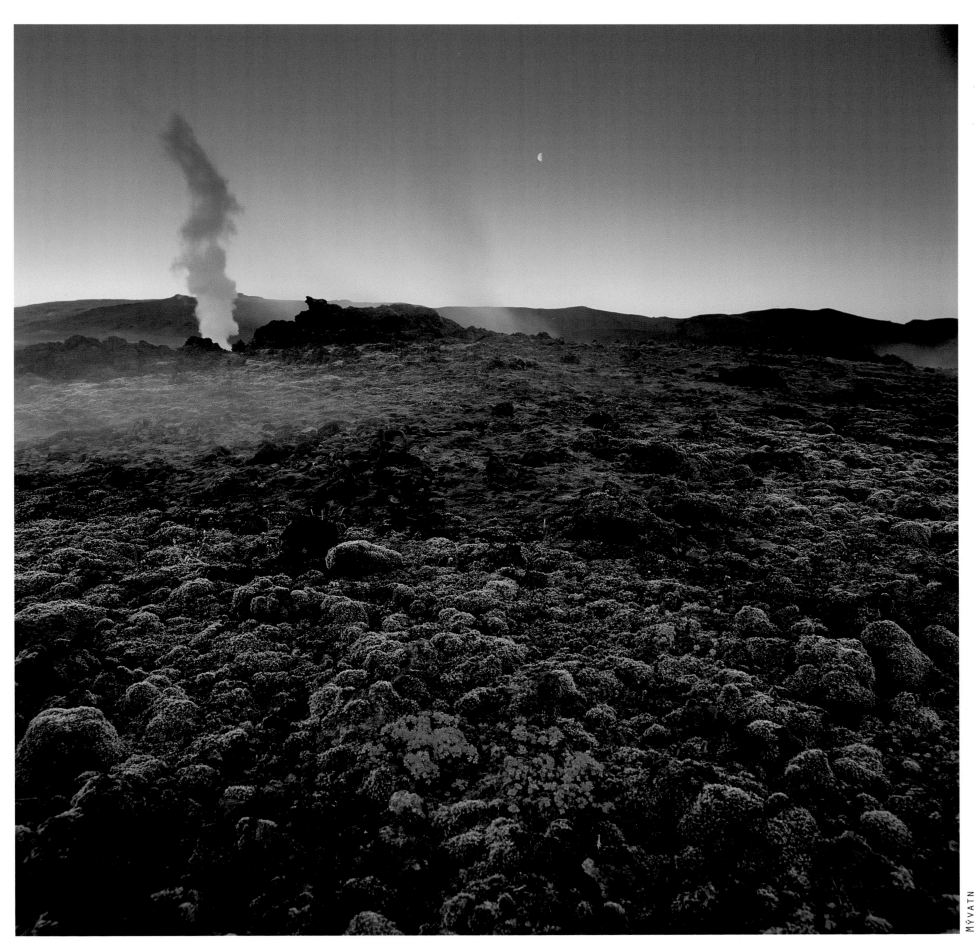

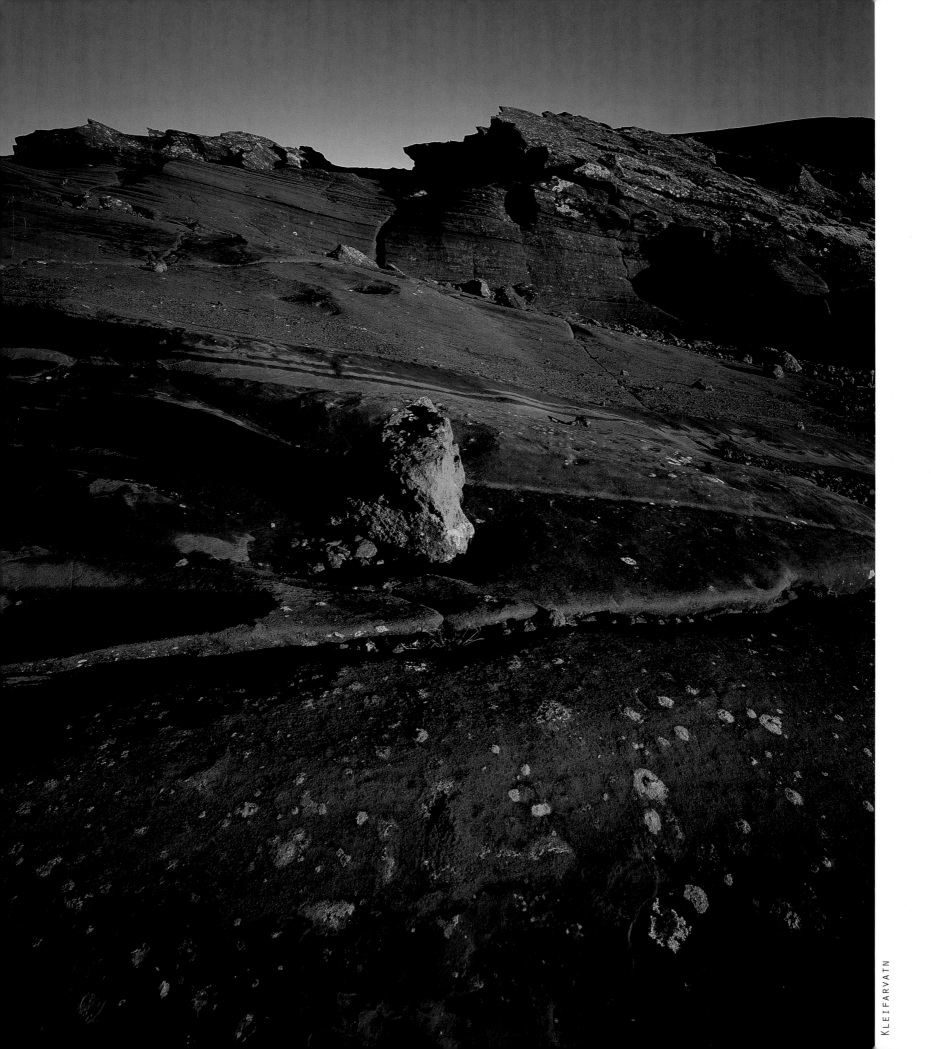

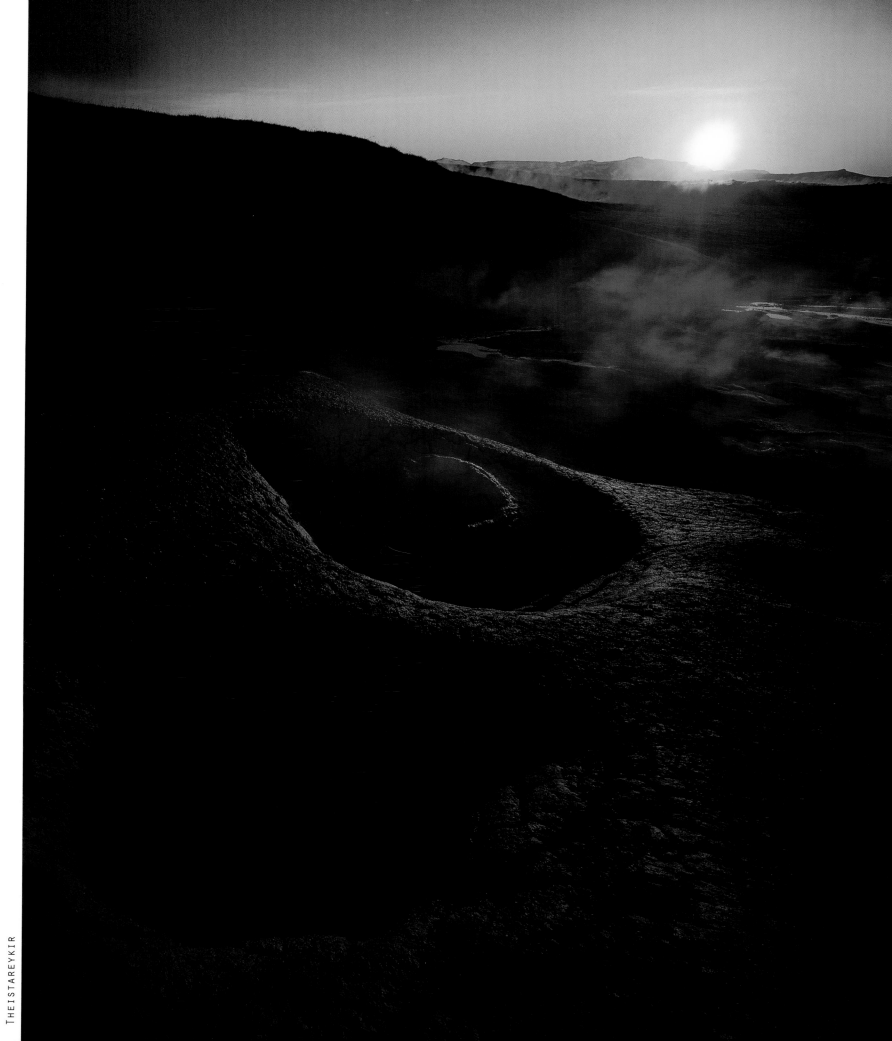

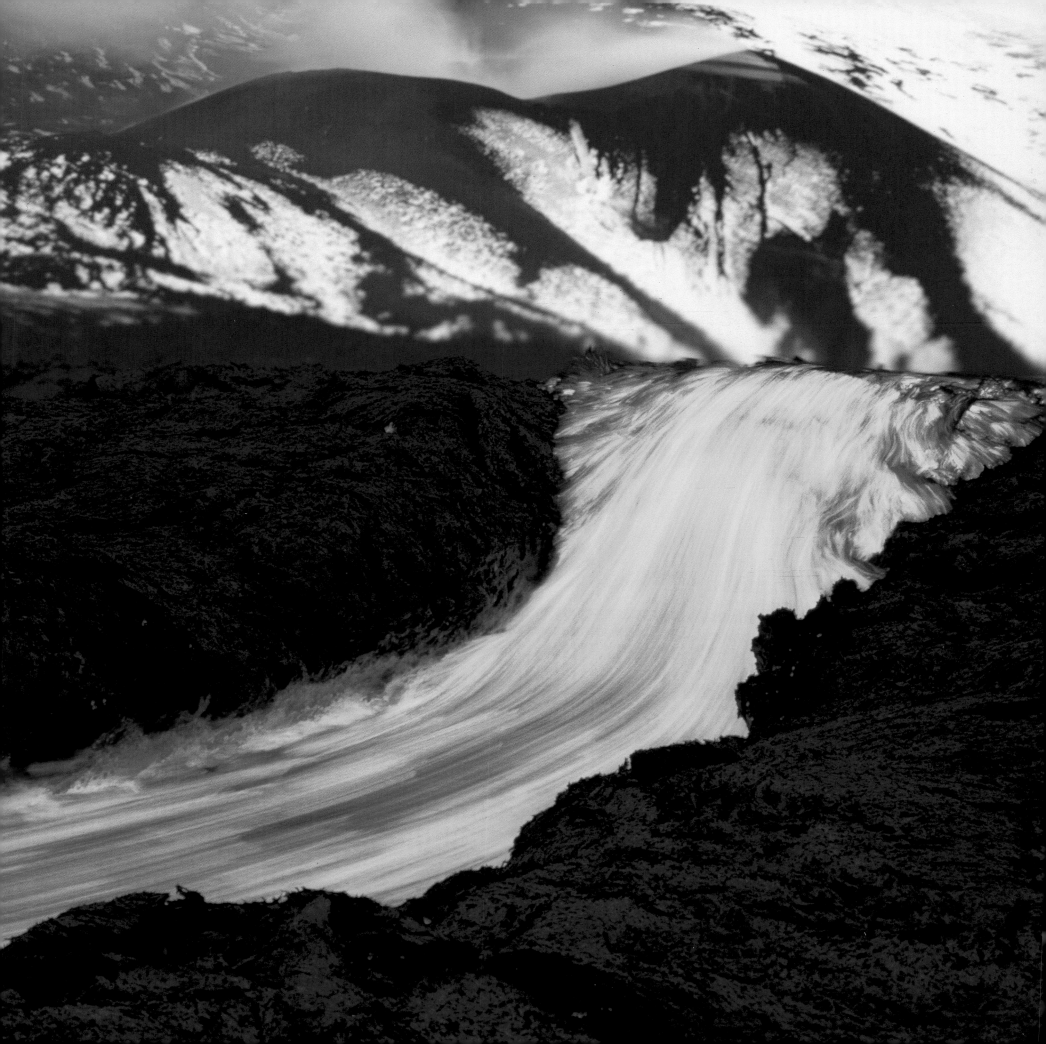

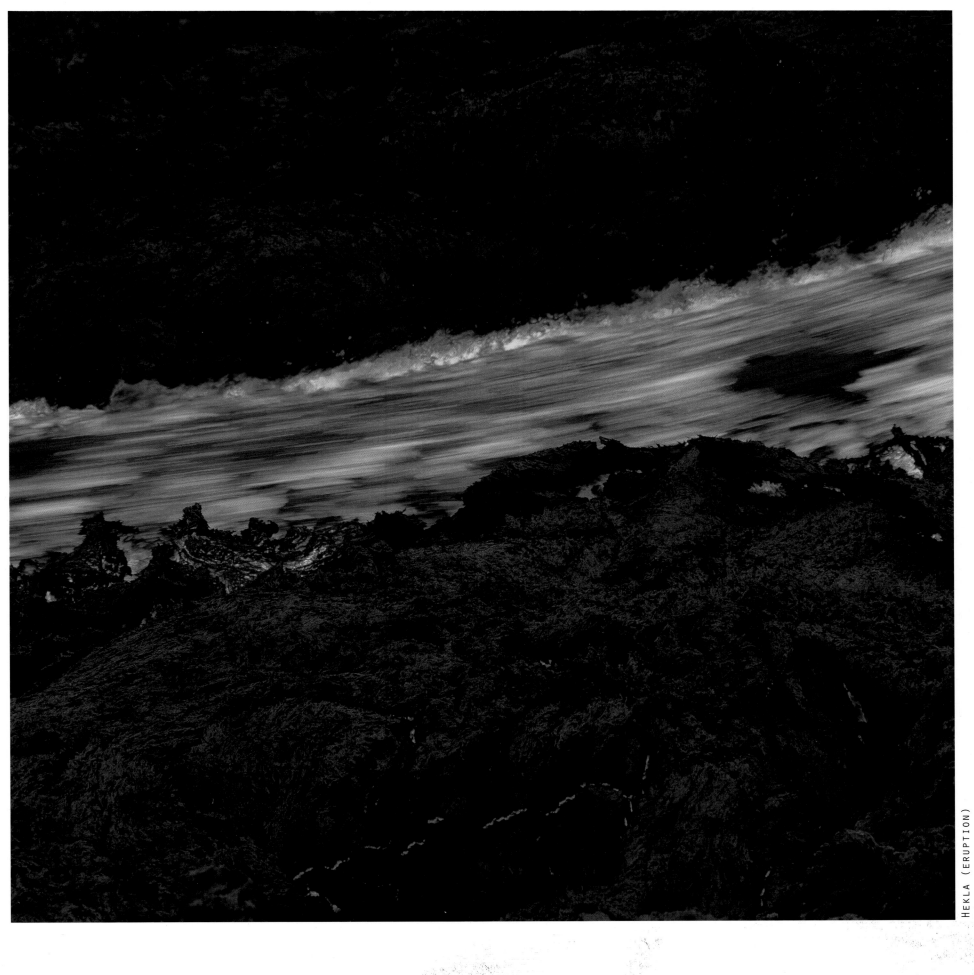

HEKLA (ERUPTION)

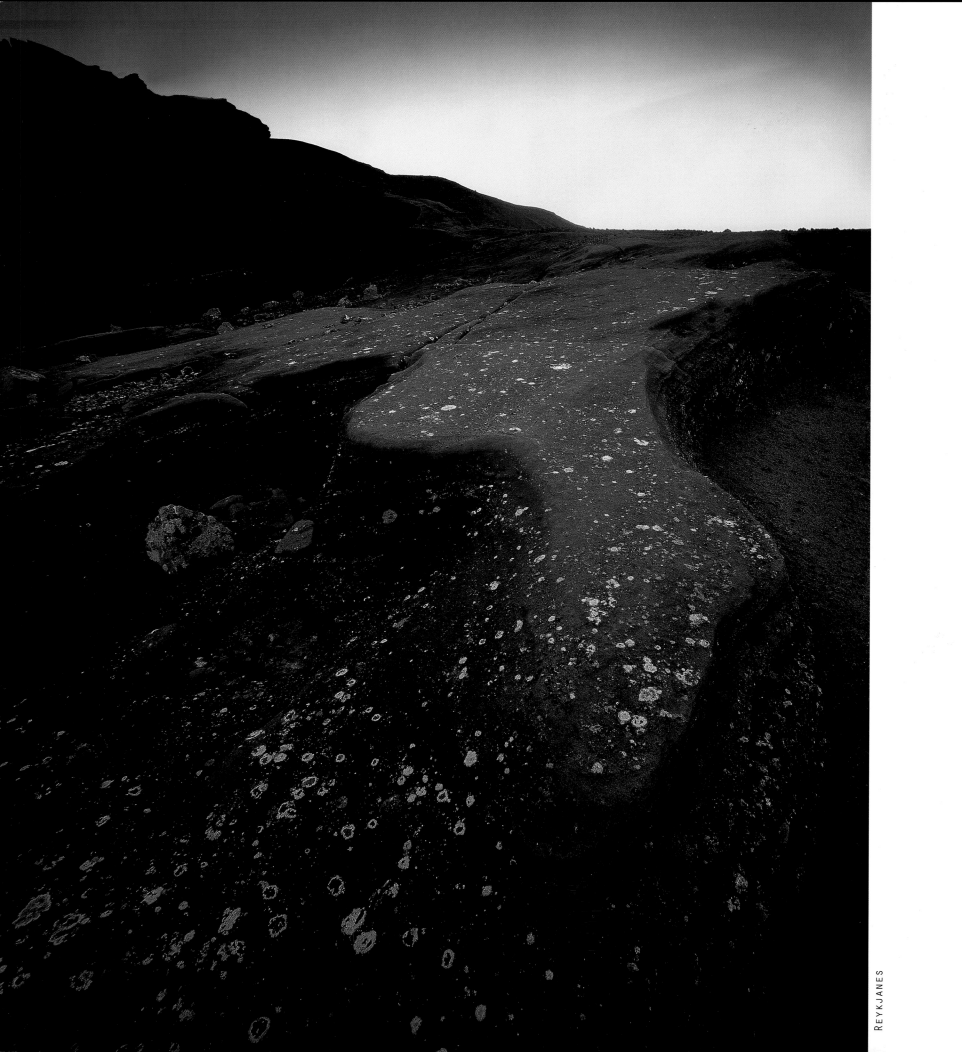

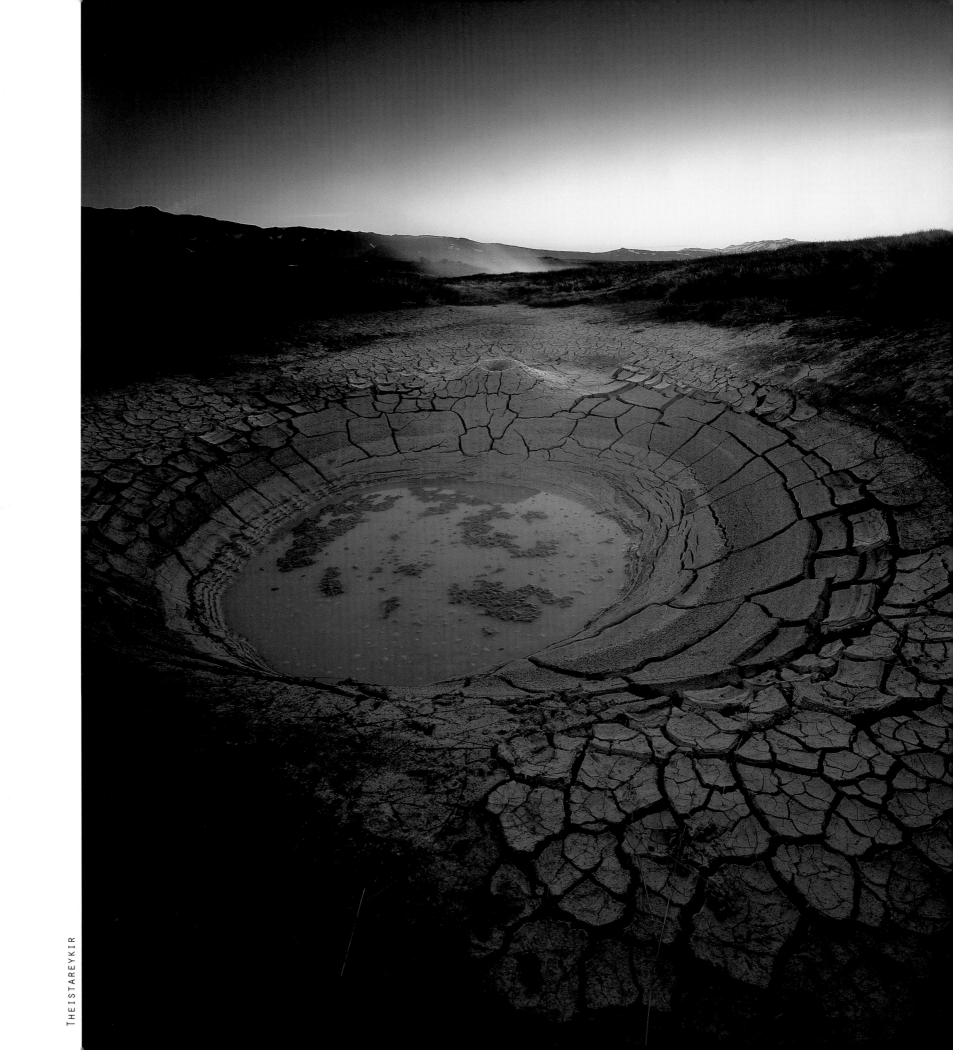

Fagurt er suður til fjalla

Beautiful are the mountains to the south

JÓN TRAUSTI, from *Einsamall á Kaldadal*

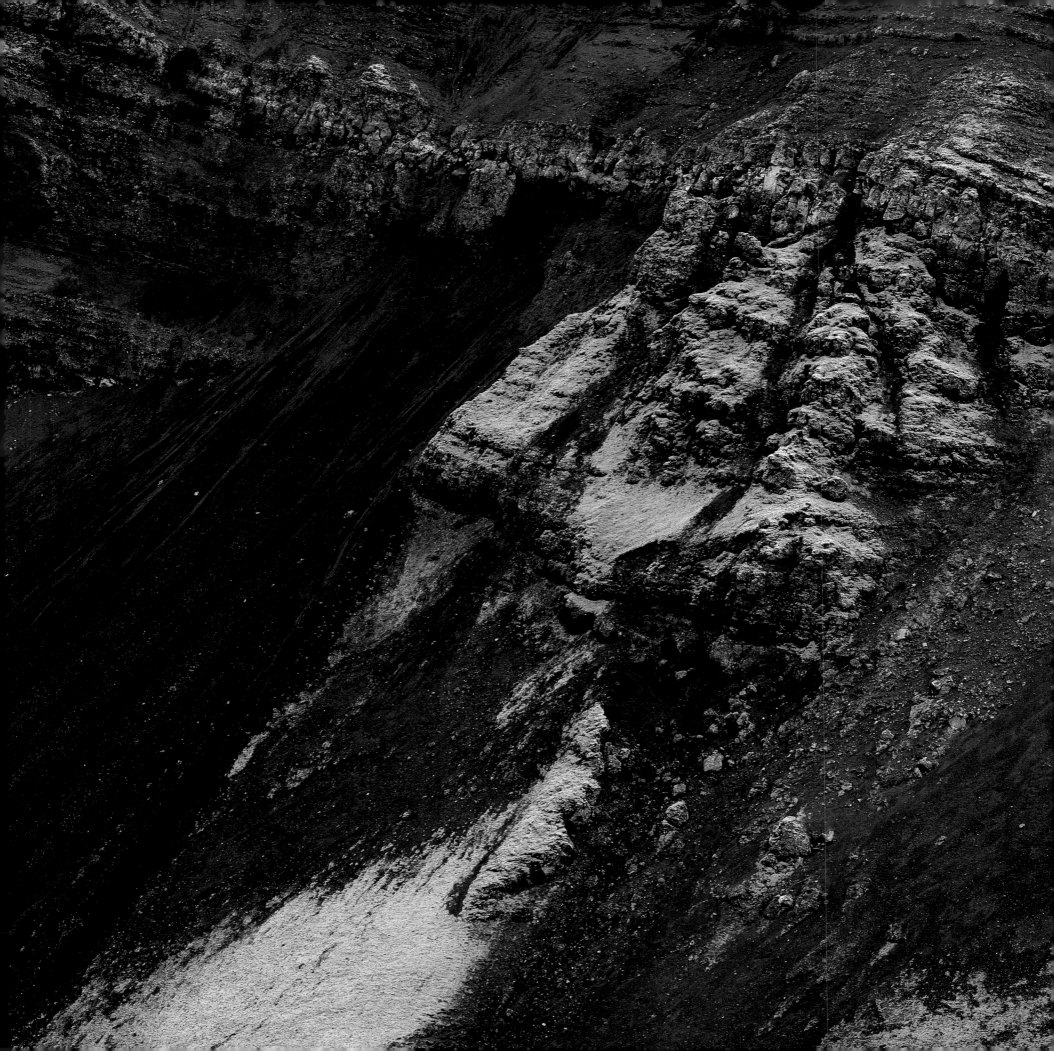

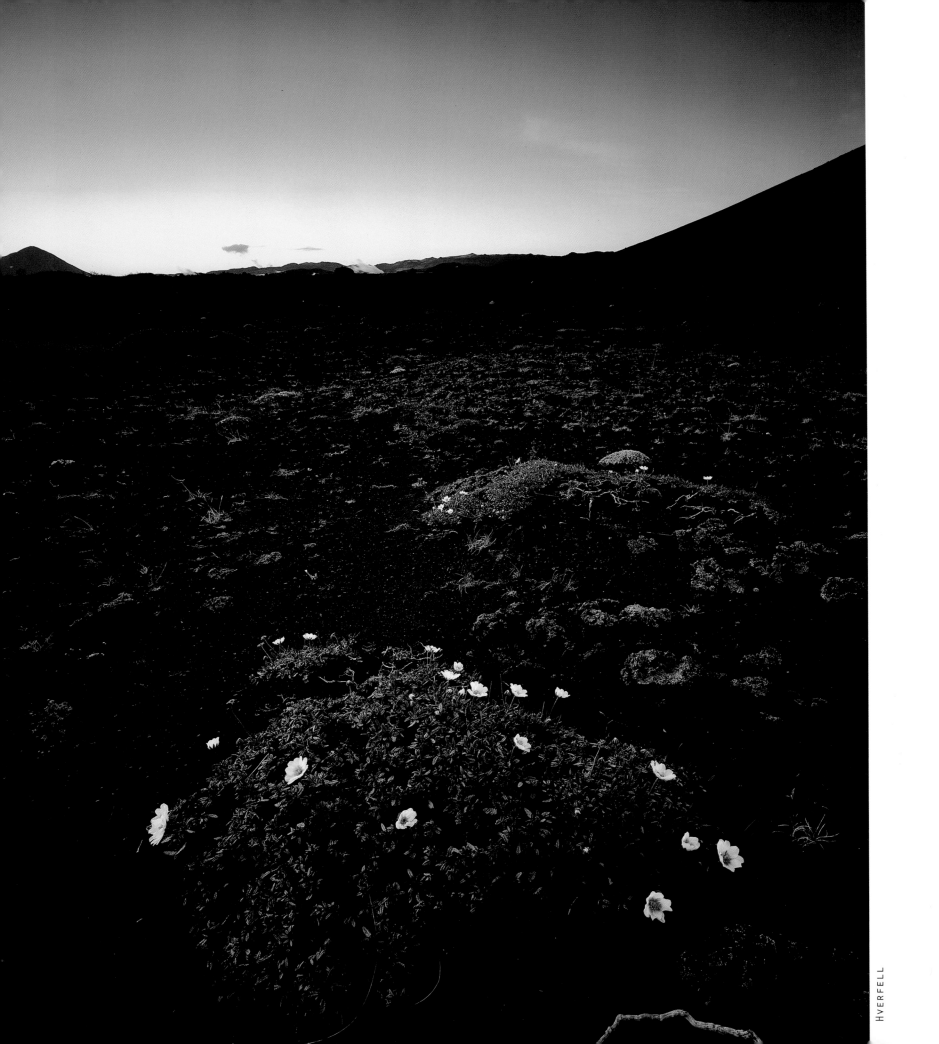

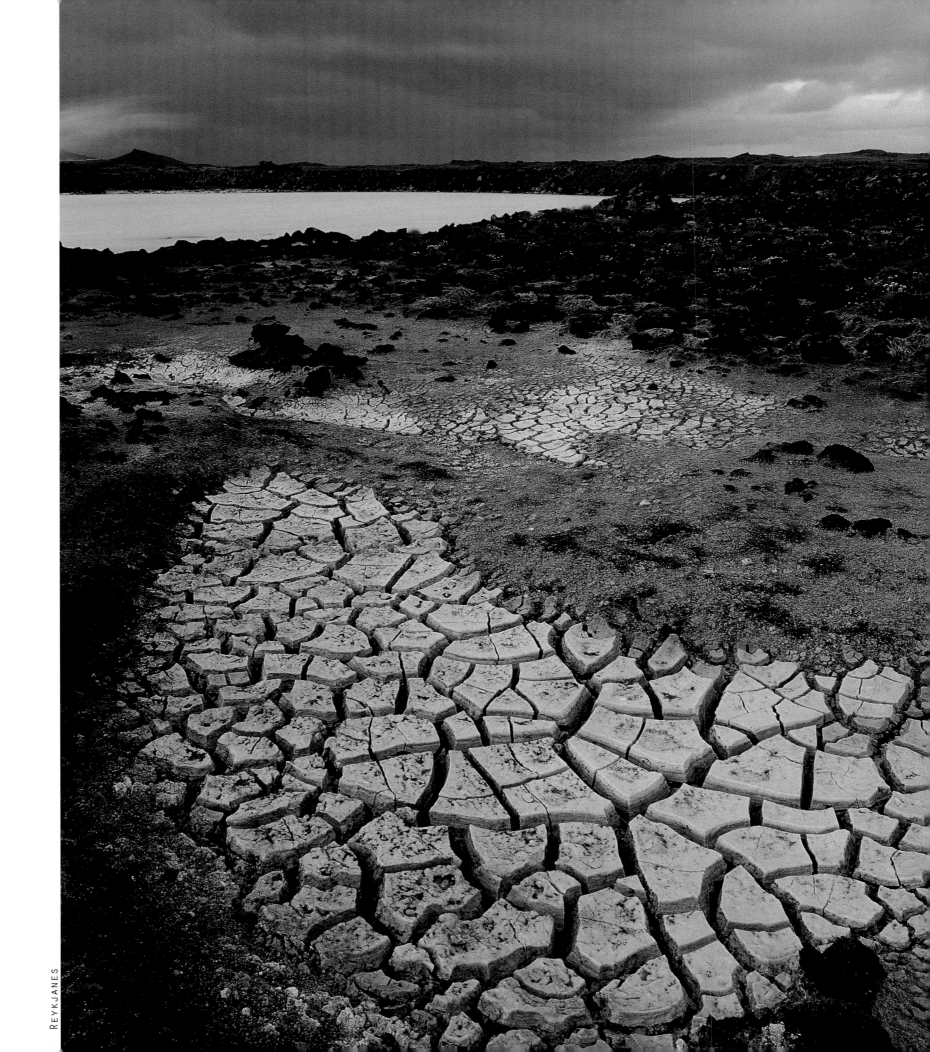

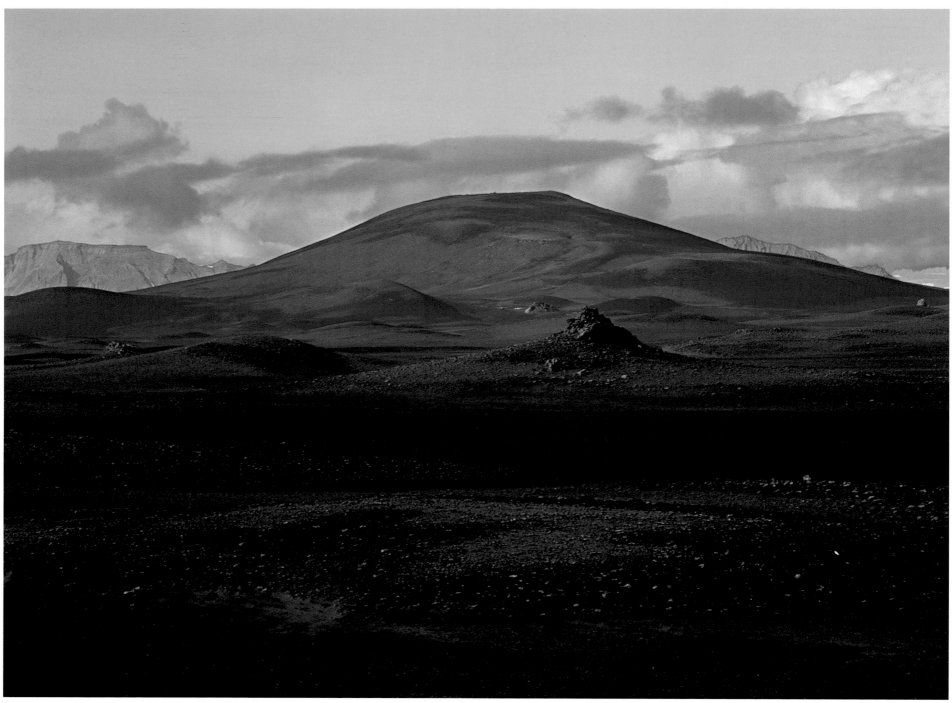

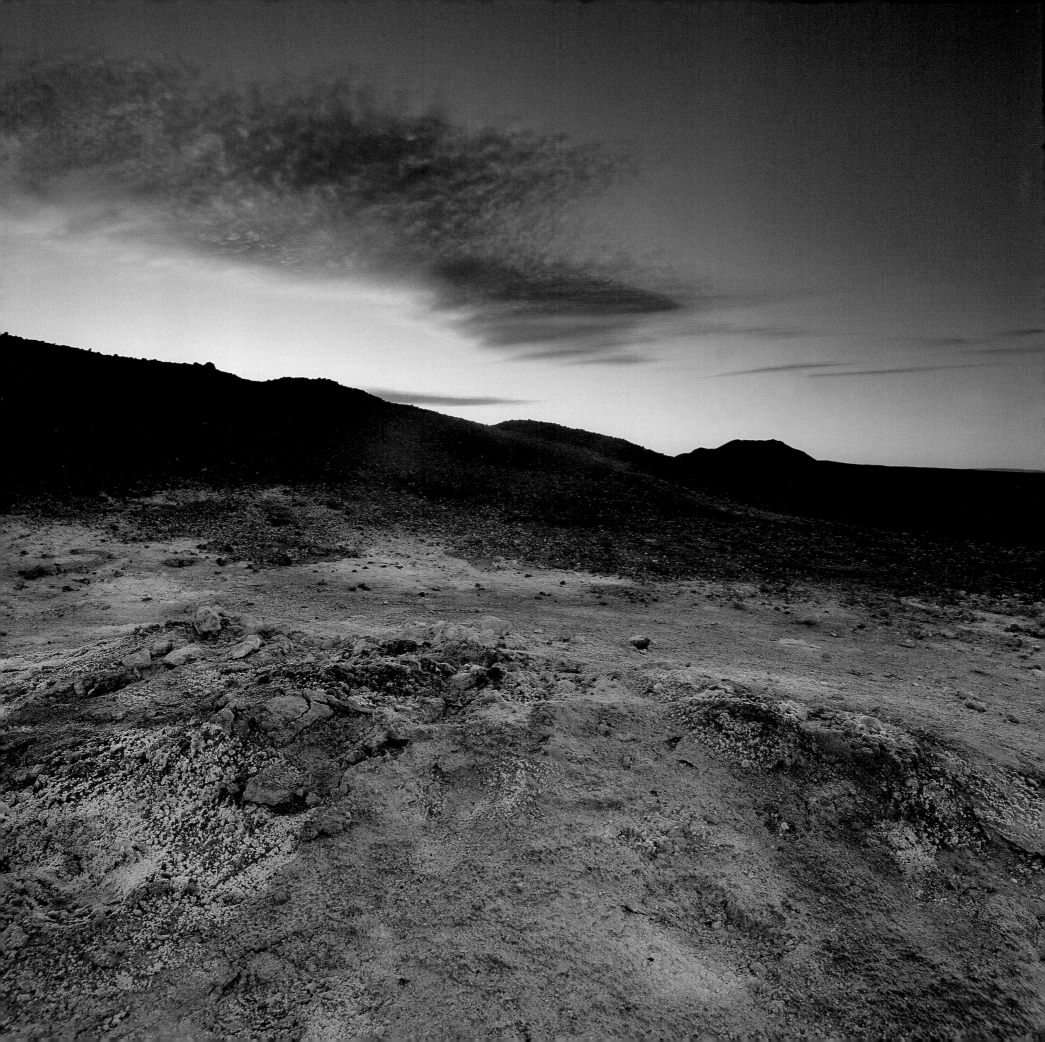

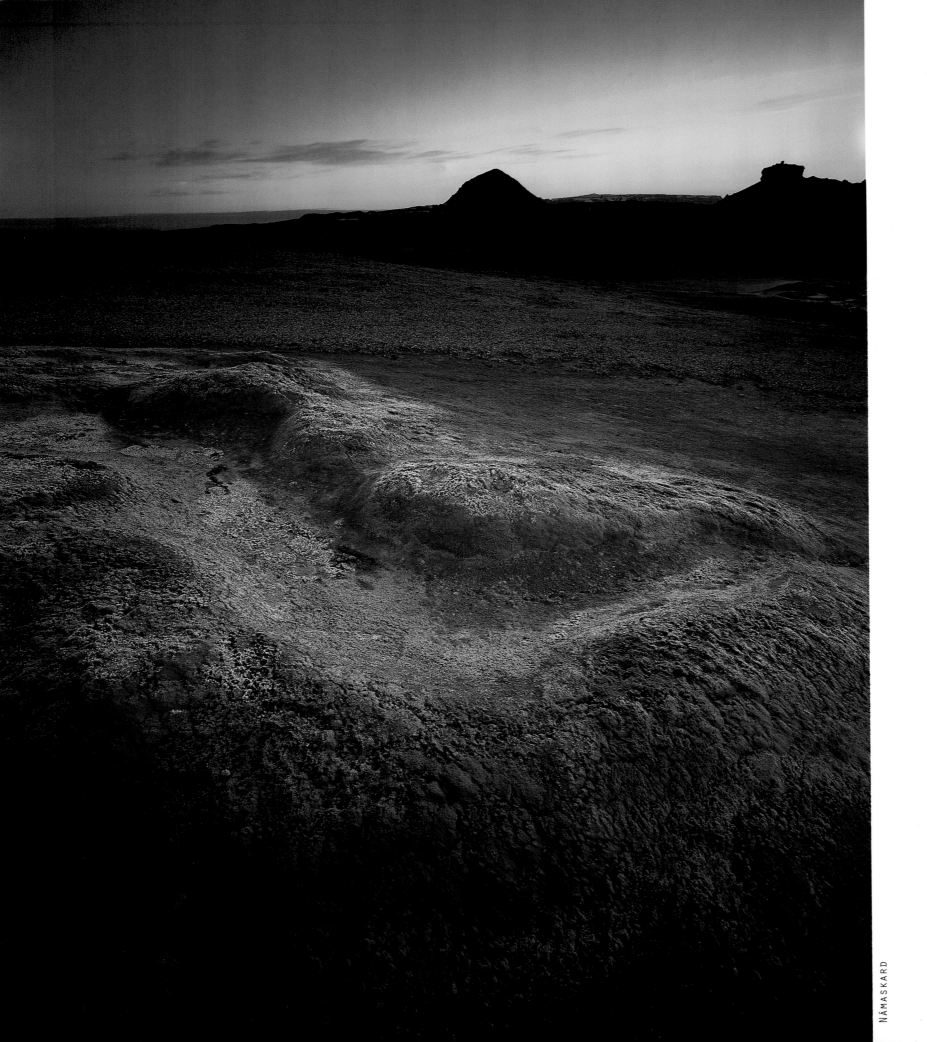

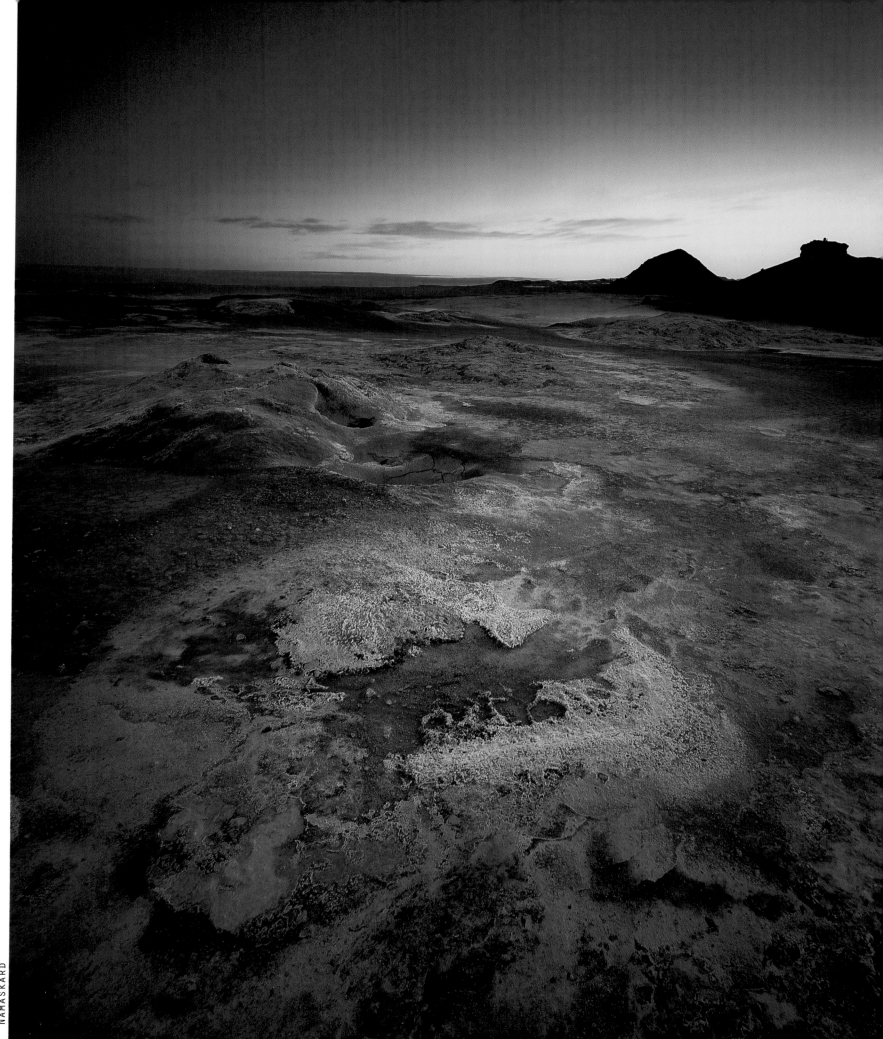

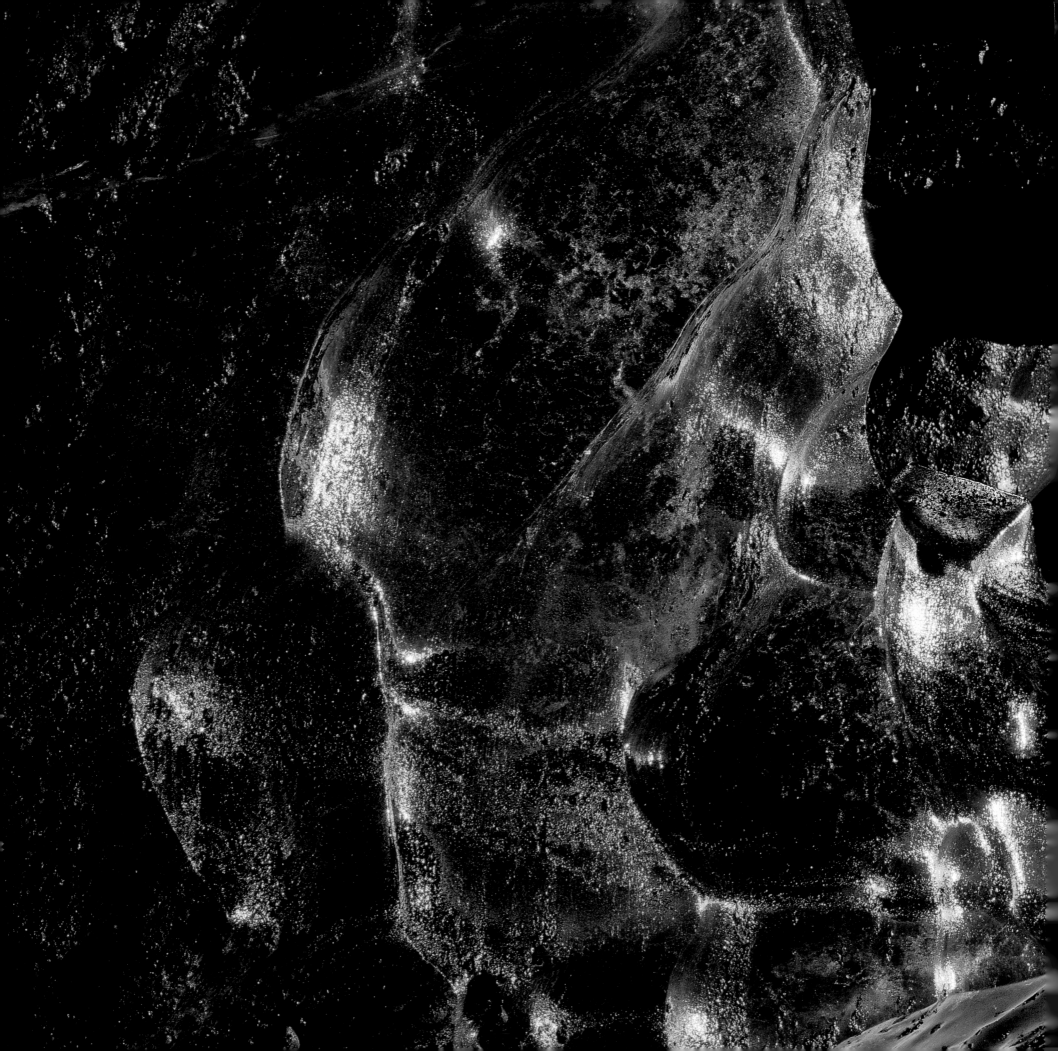

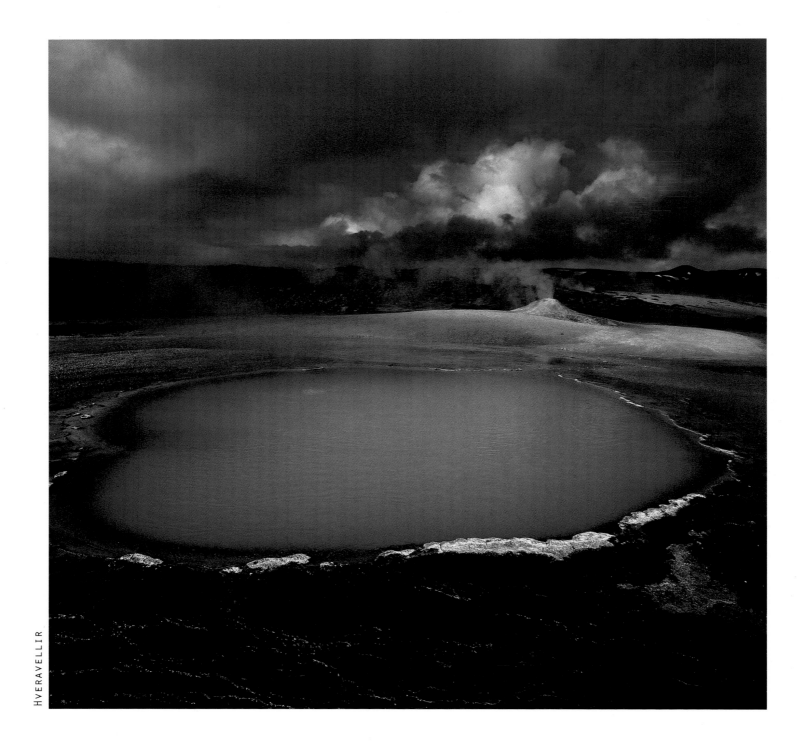

HVERAVELLIR

LOOKING NORTH FROM VATNAJÖKULL

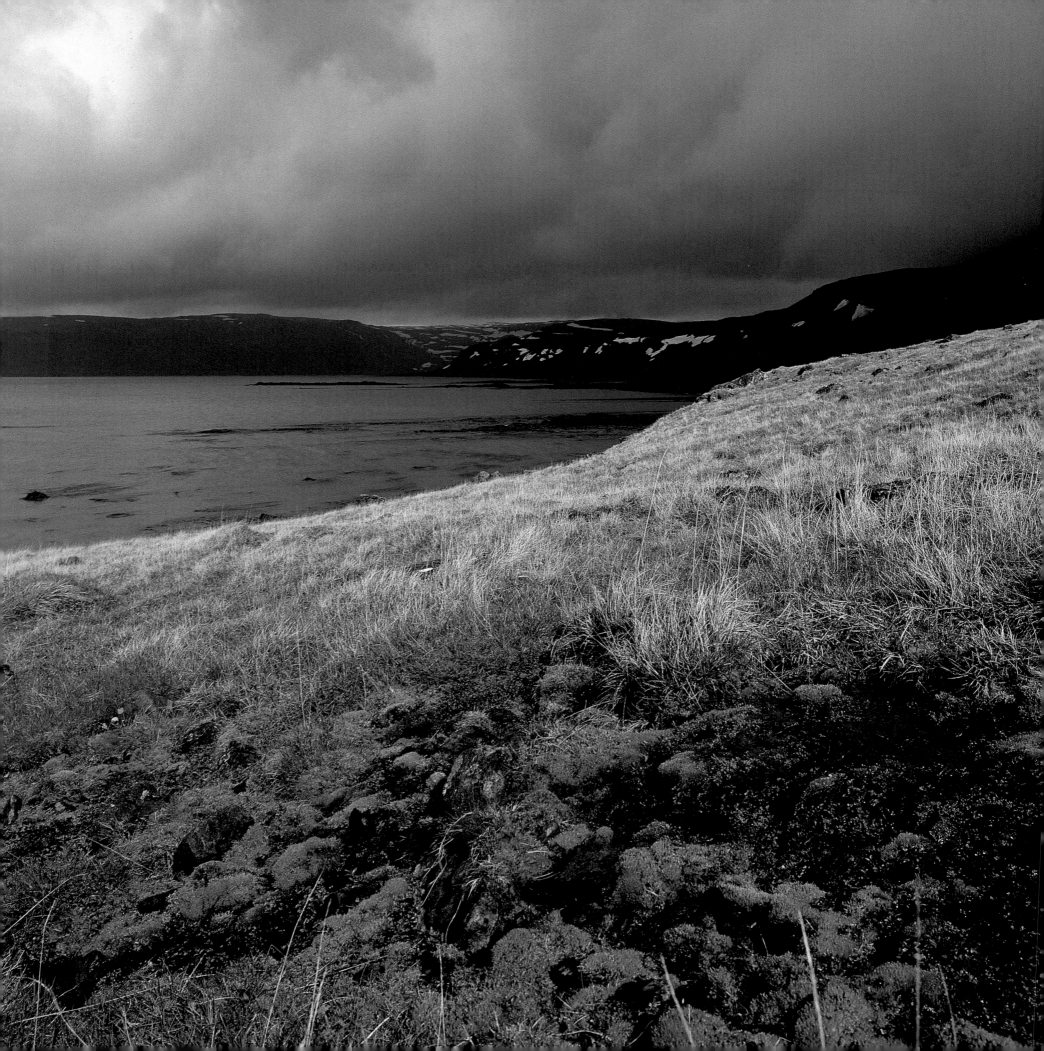

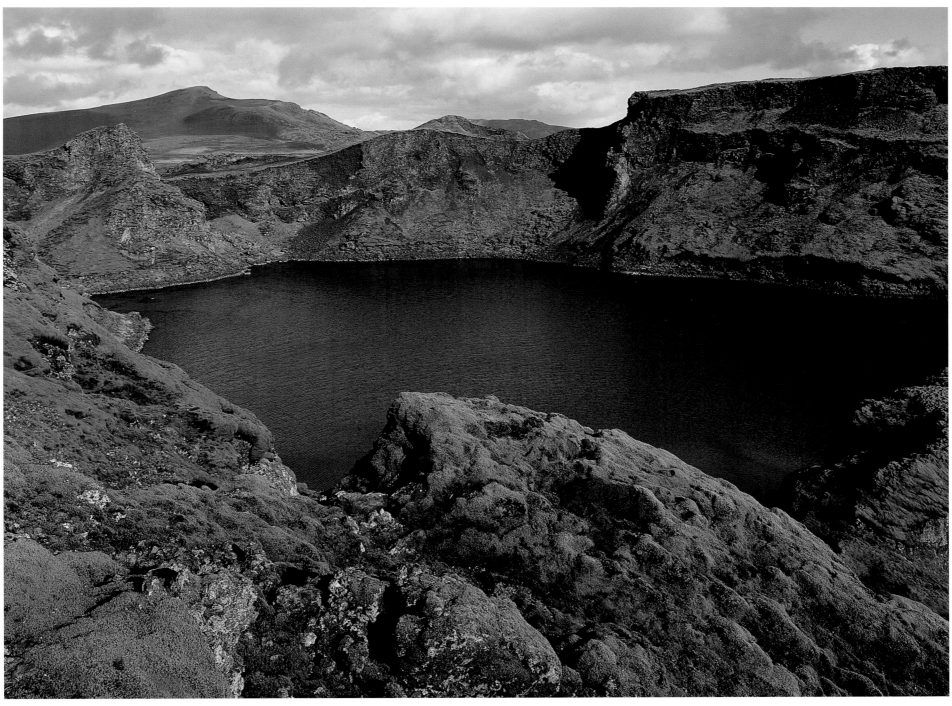

KOLLAFJÖRÐUR

LAKI

81

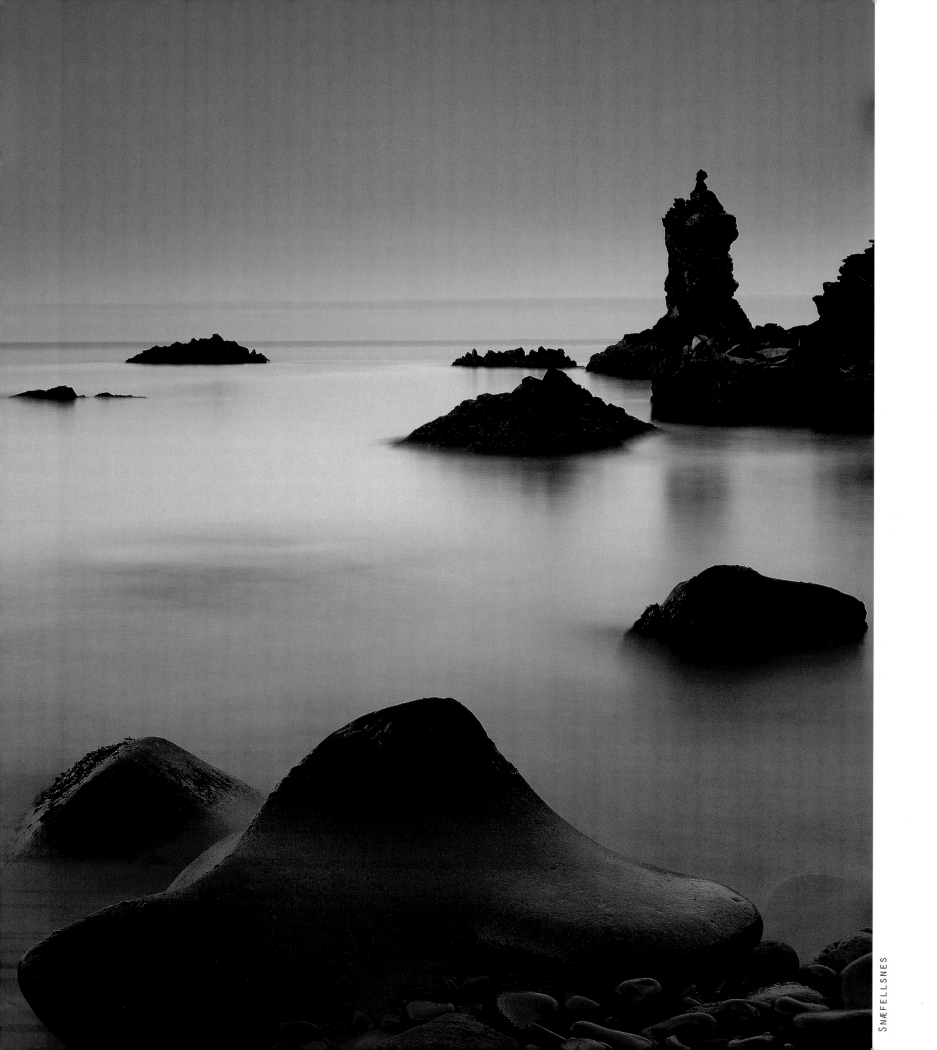

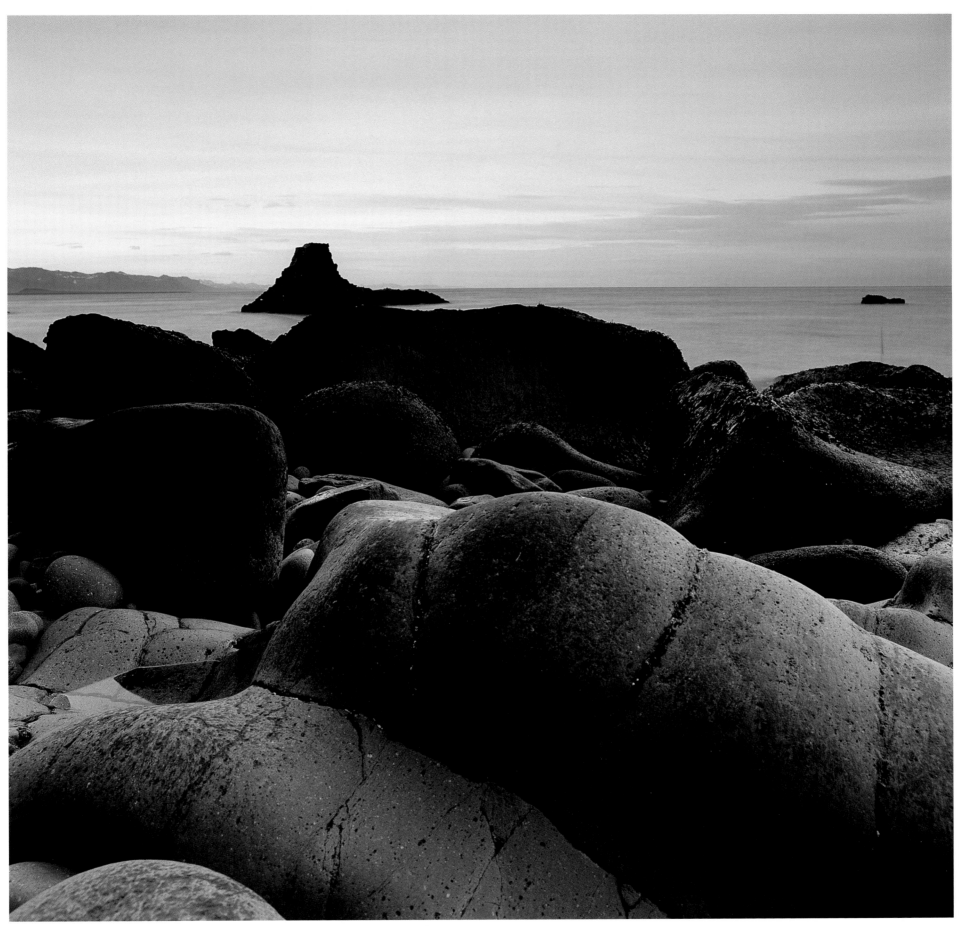

AÐ BAKI OSS LIGGUR HIN EILÍFA AUÐN

Behind us looms the eternal void

OG YFIR HÖFÐUM VORUM TINDRA STJÖRNUR HIMINSINS

And above us the lost stars of the heavens

STEINN STEINAR, from *Gönguljód*

JÖKULSÁRLÓN

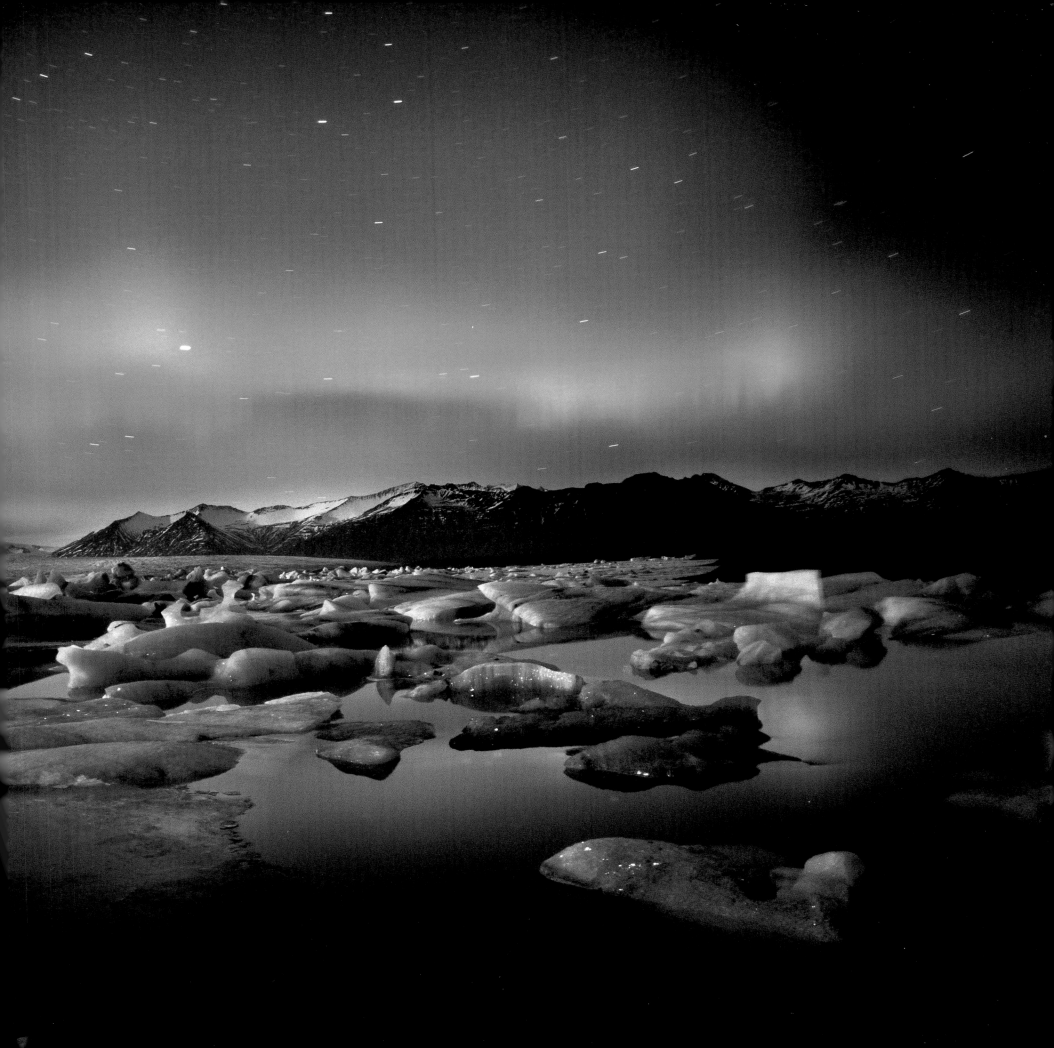

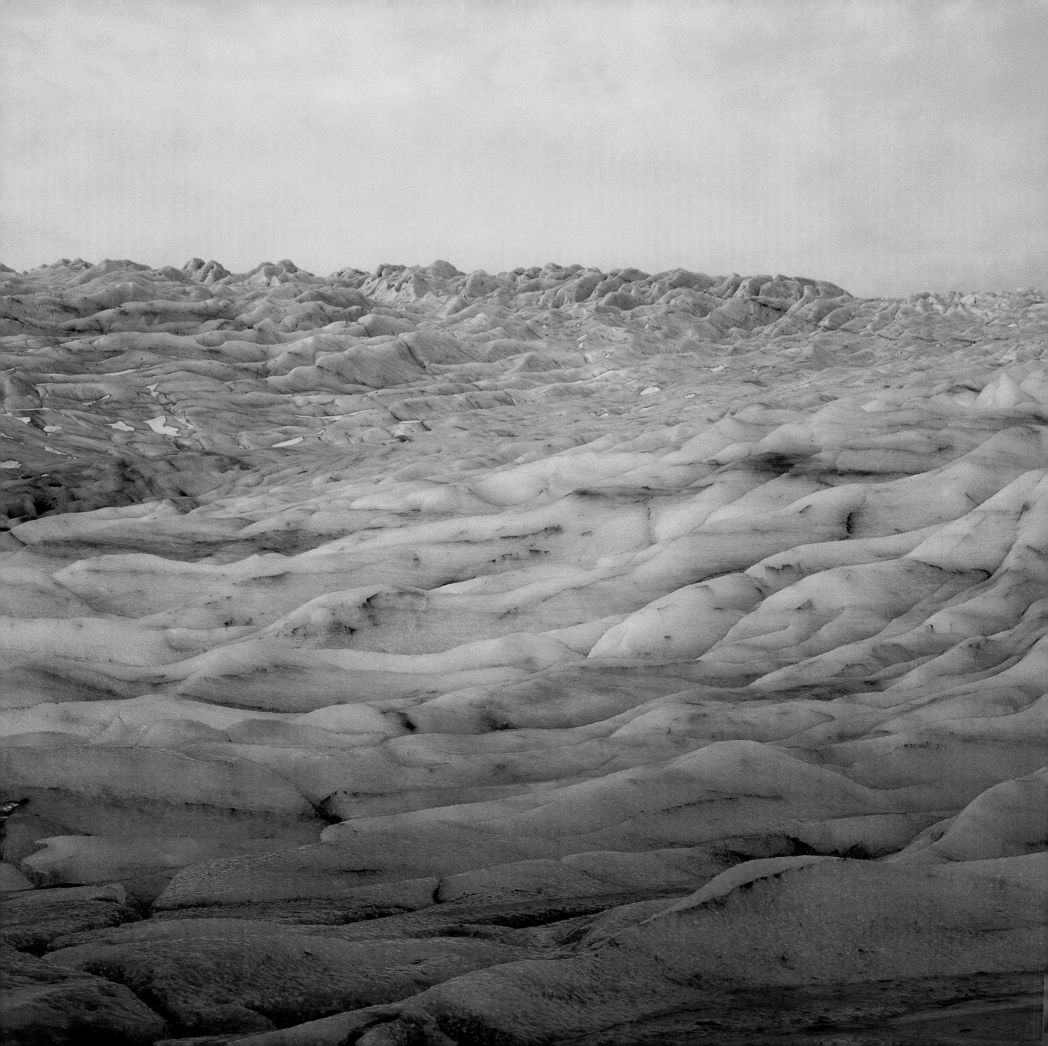

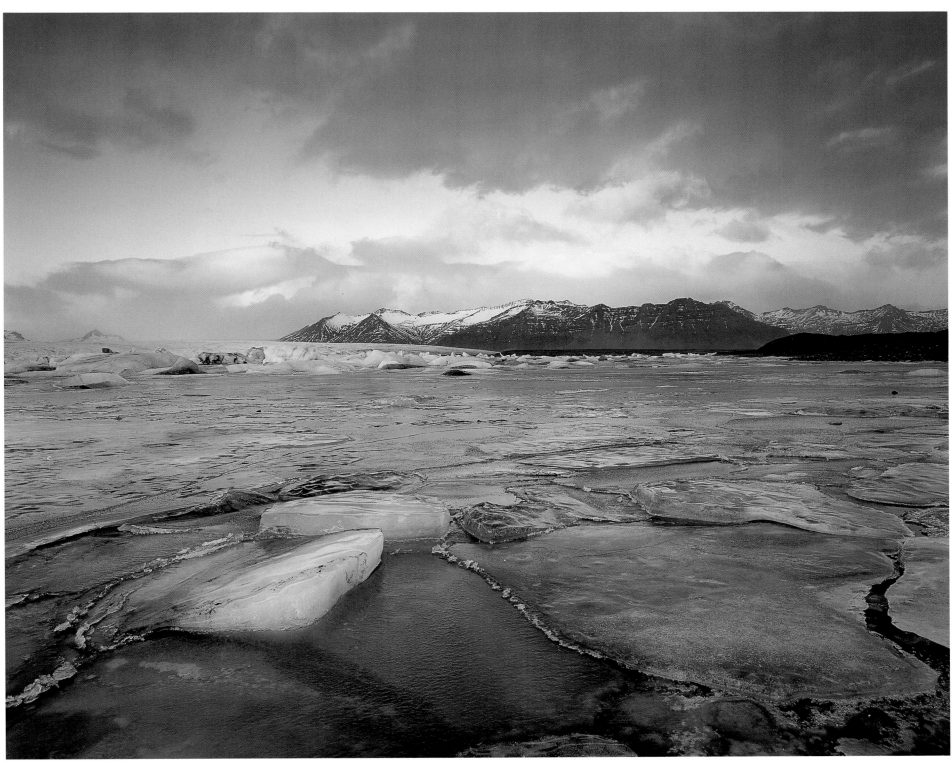

JÖKULSÁRLÓN

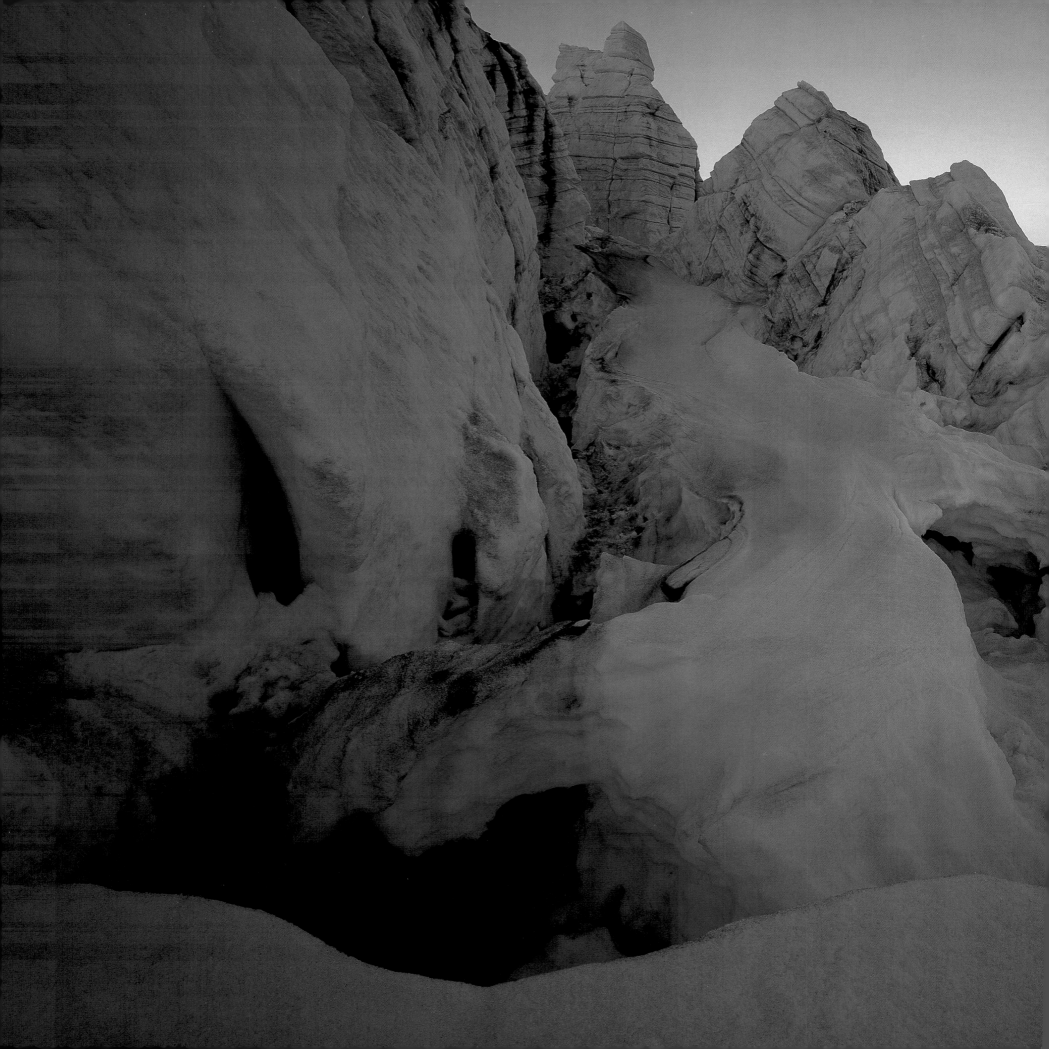

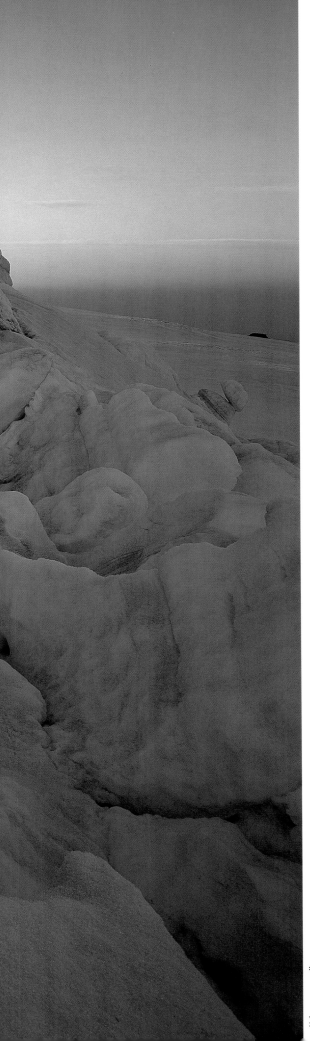

MÝRDALSJÖKULL

VÉR LEITUM FRÁ ÖRÓFI ALDA

We have been searching since the dawn of time

UM EYÐIMÖRK TÍMA OG RÚMS

Across the desert of time and space

STEINN STEINAR, from *Gönguljóð*

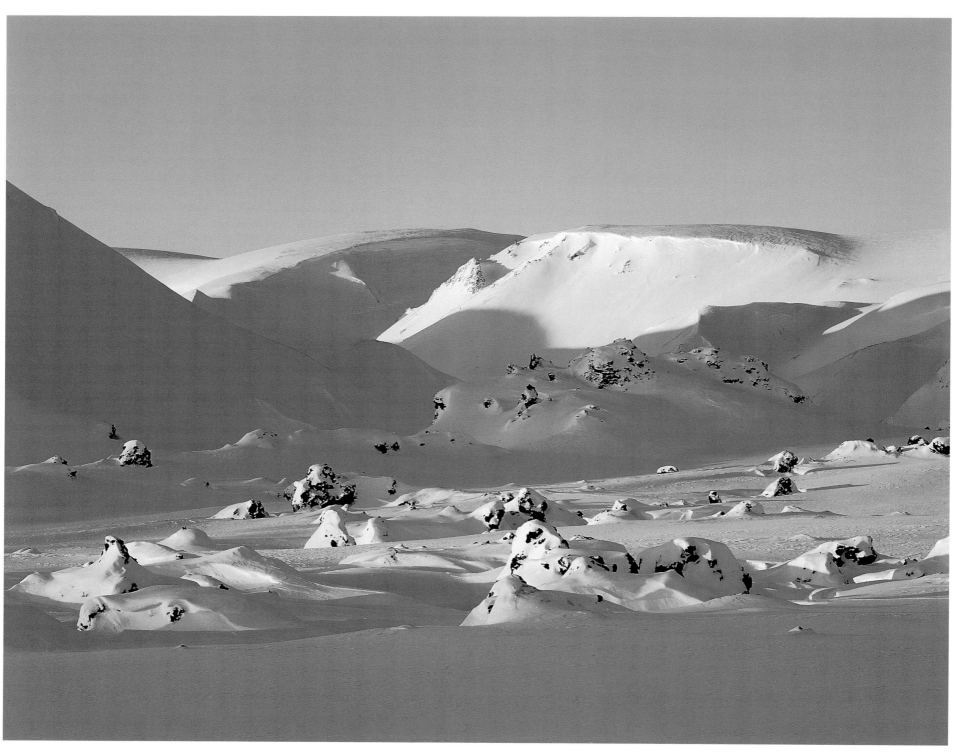

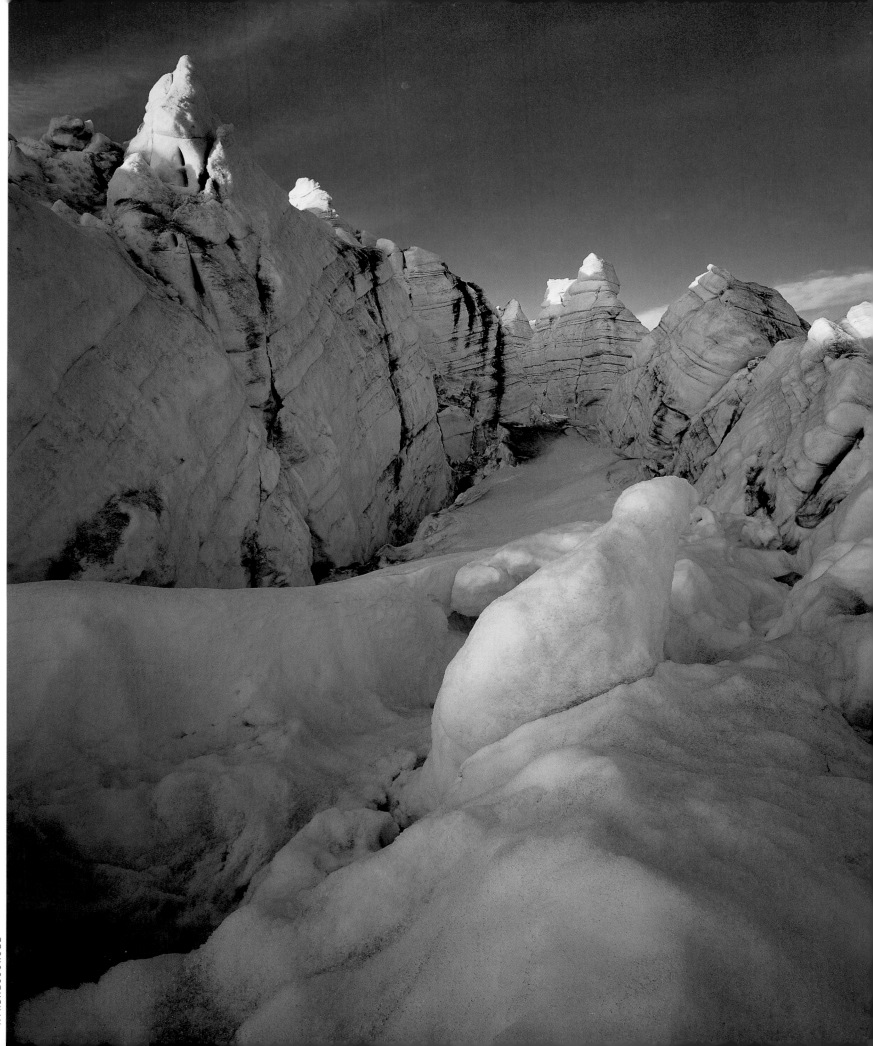

TÍMINN ER EINS OG VATNIÐ,
Time is like water,

OG VATNIÐ ER KALT OG DJÚPT
And the water is cold and deep

EINS OG VITUND MÍN SJÁLFS
Like the consciousness of my own self.

STEINN STEINAR, from *Tíminn og Vatnid*

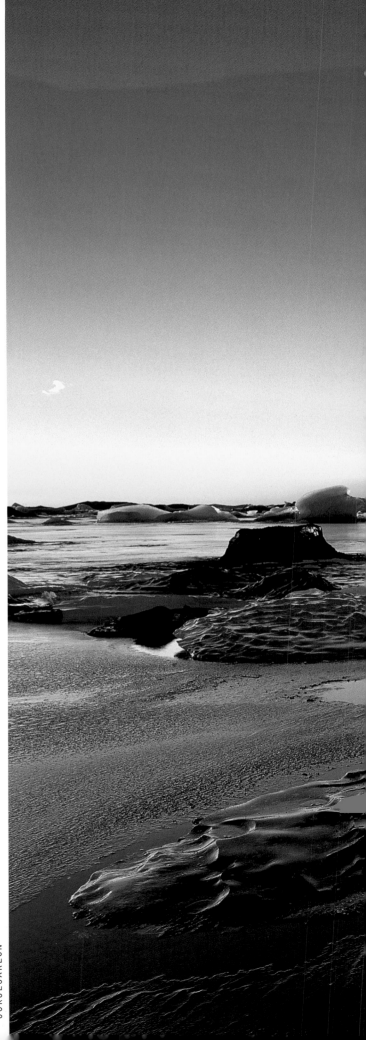

JÖKULSÁRLÓN

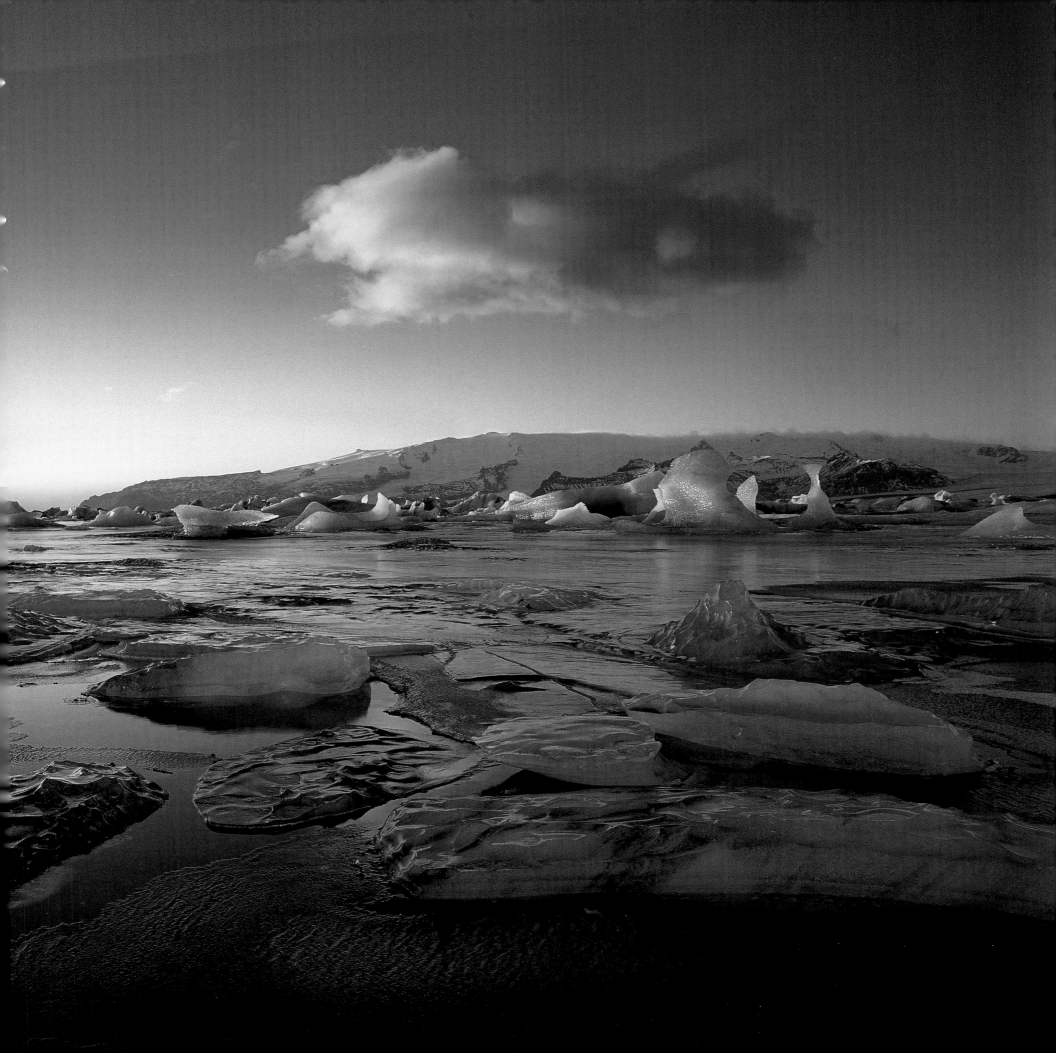

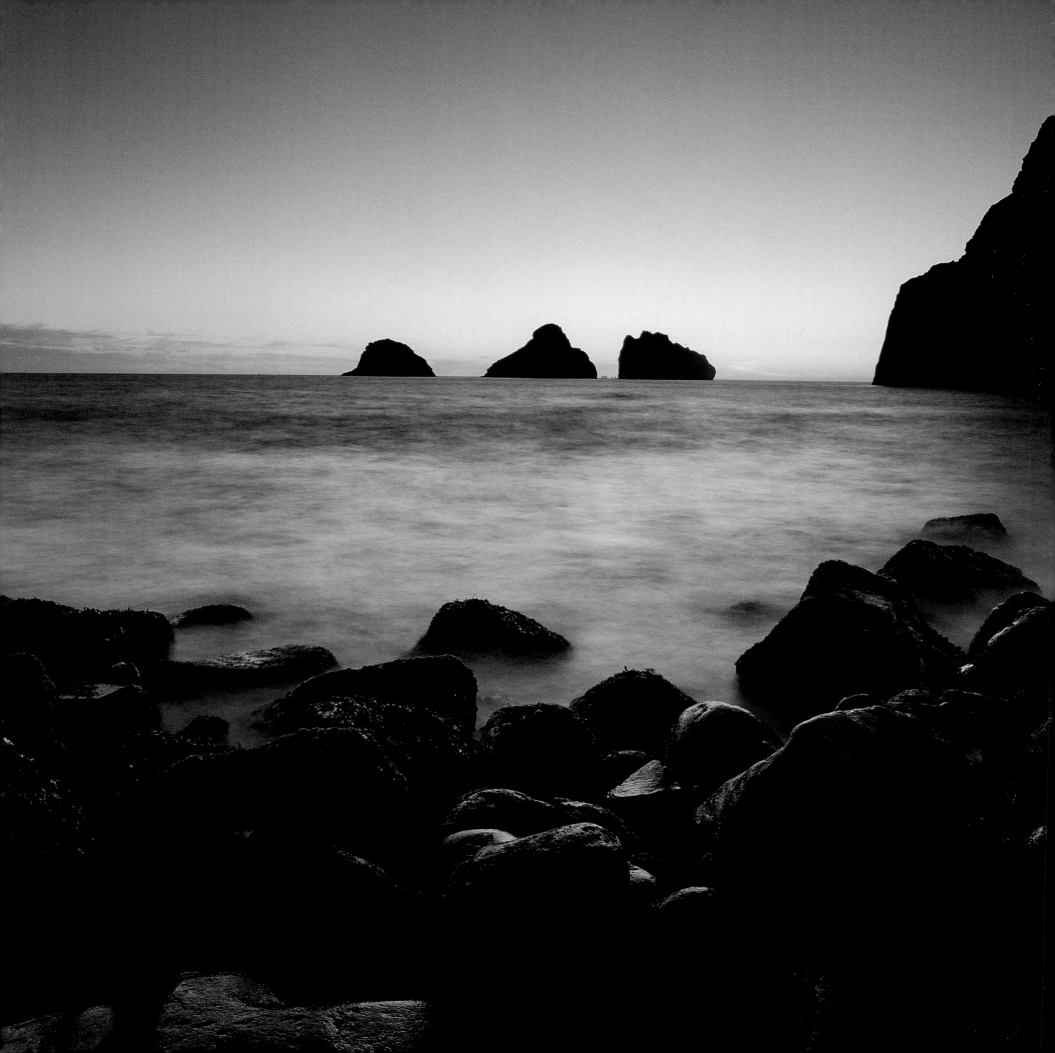

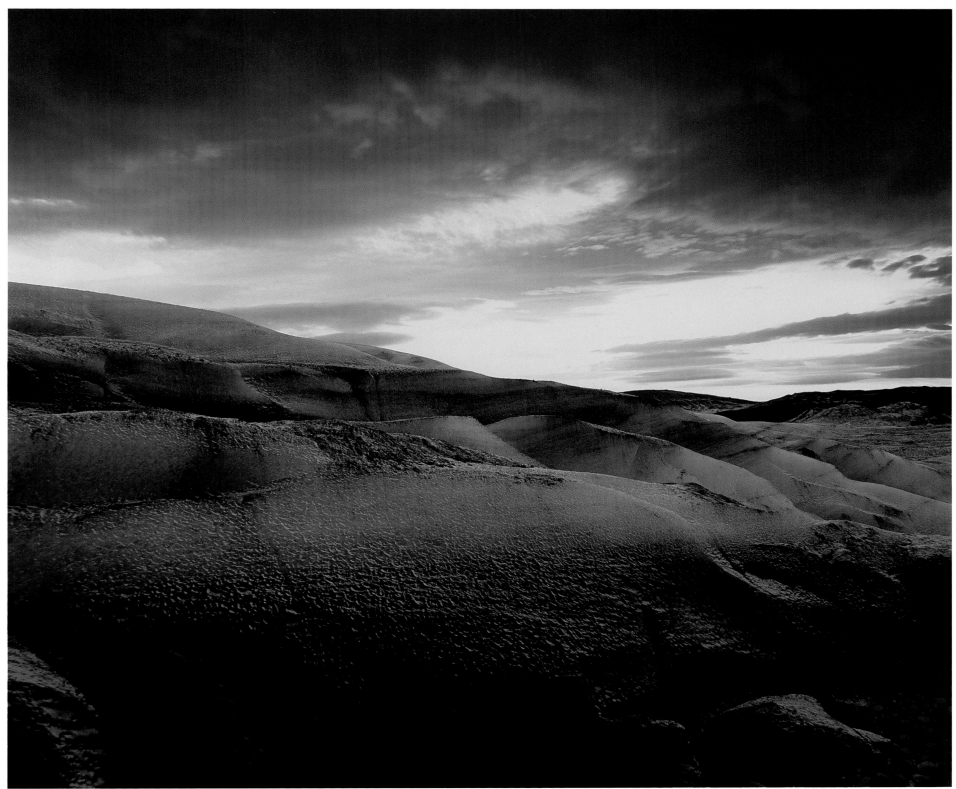

SVÍNÆFELLSJÖKULL

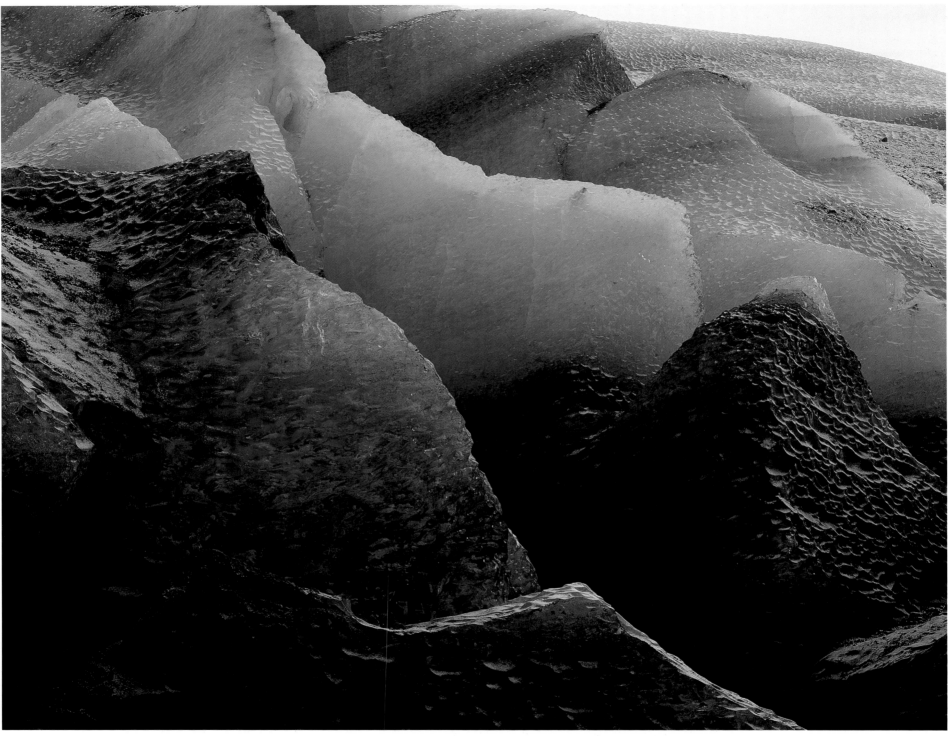

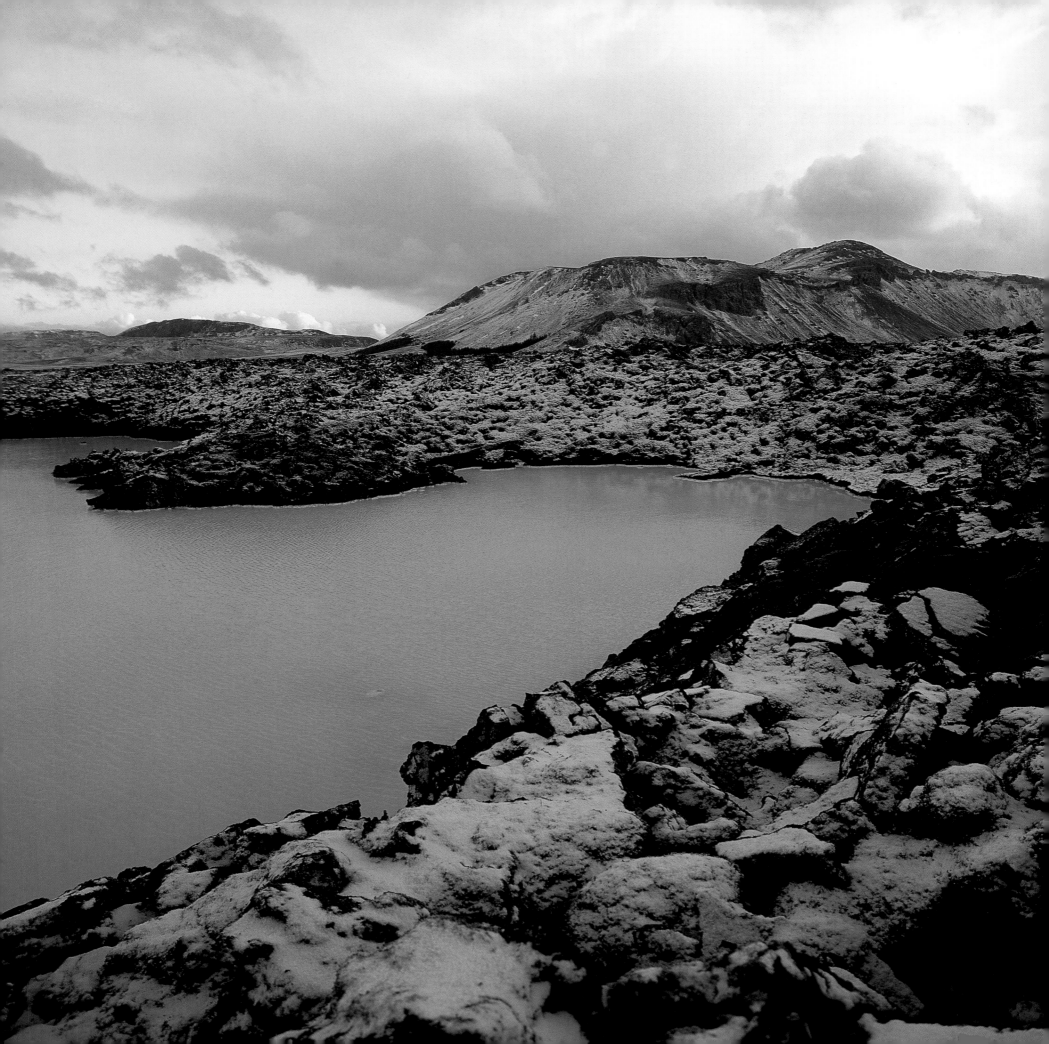

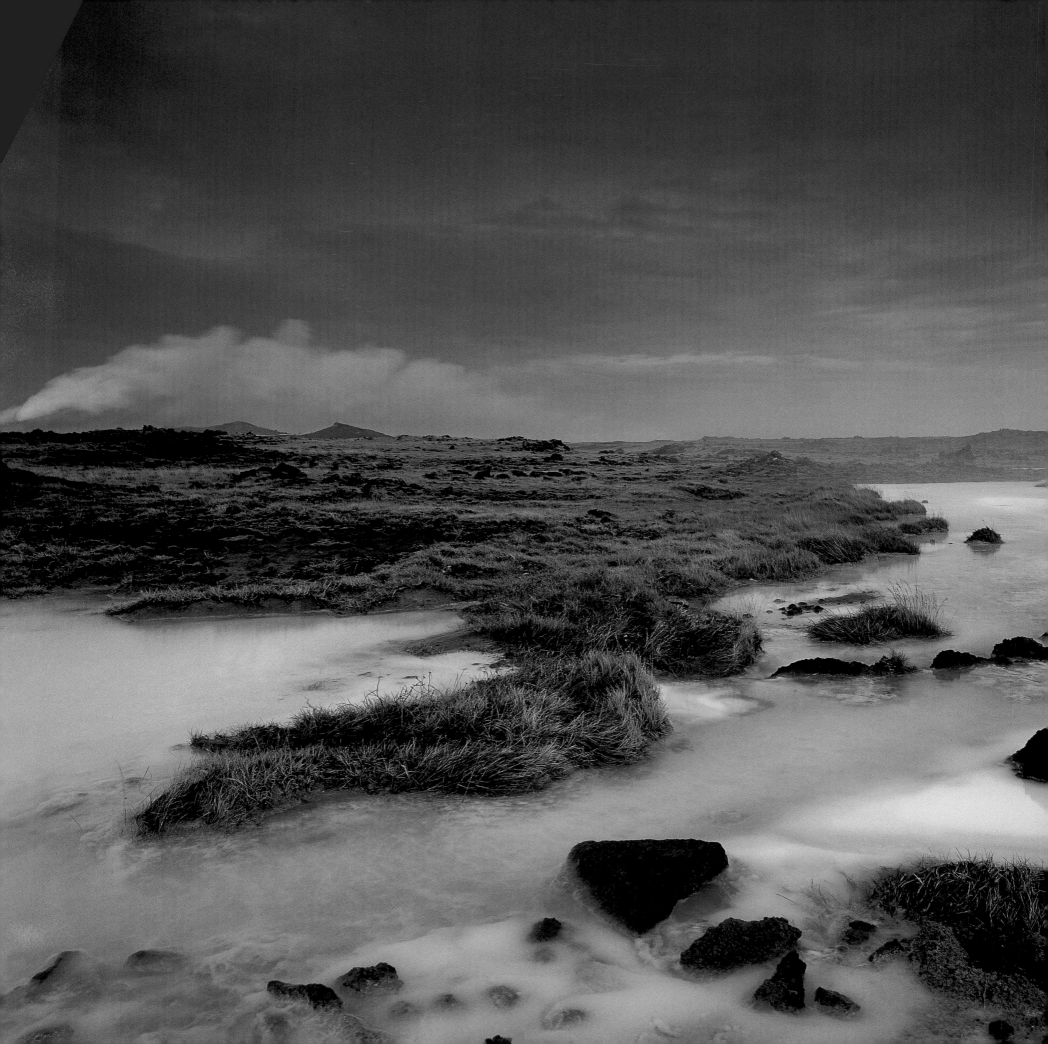

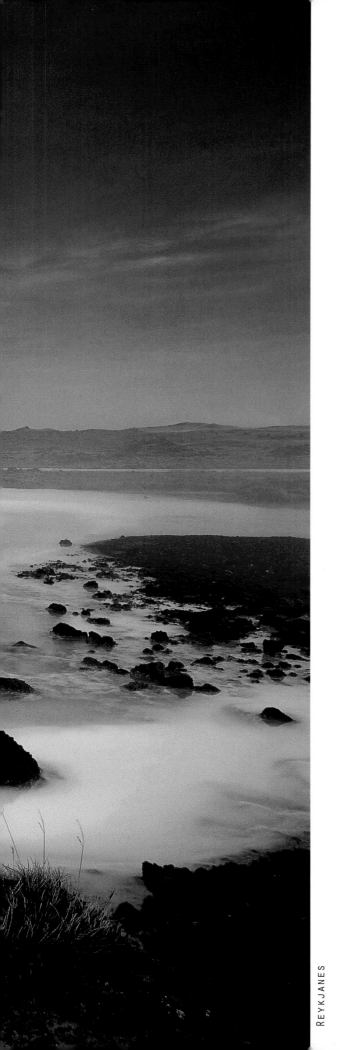

RENNANDI VATN,
Running water,

RISBLÁR DAGUR,
Blue day,

RADDLAUS NÓTT.
Voiceless night.

STEINN STEINAR, from *Tíminn og Vatnid*

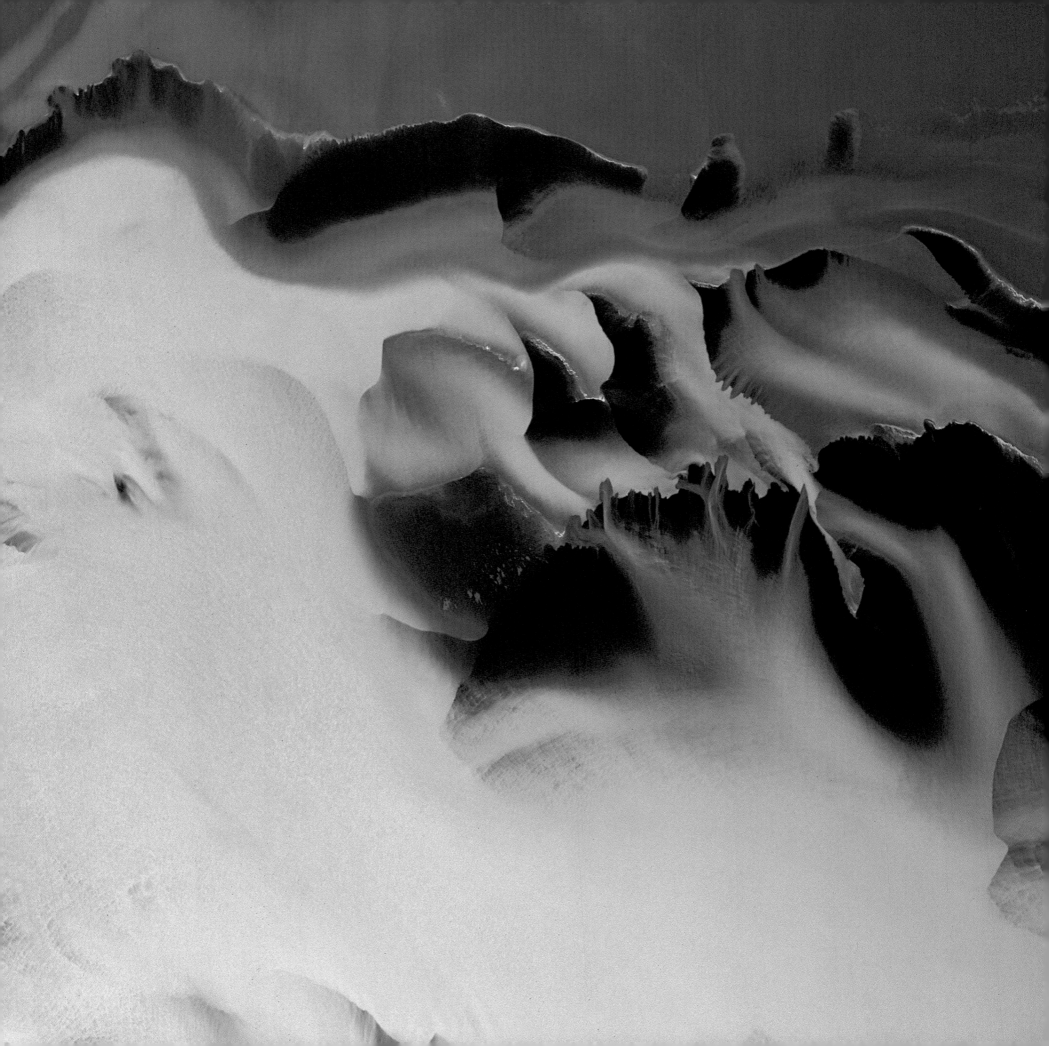

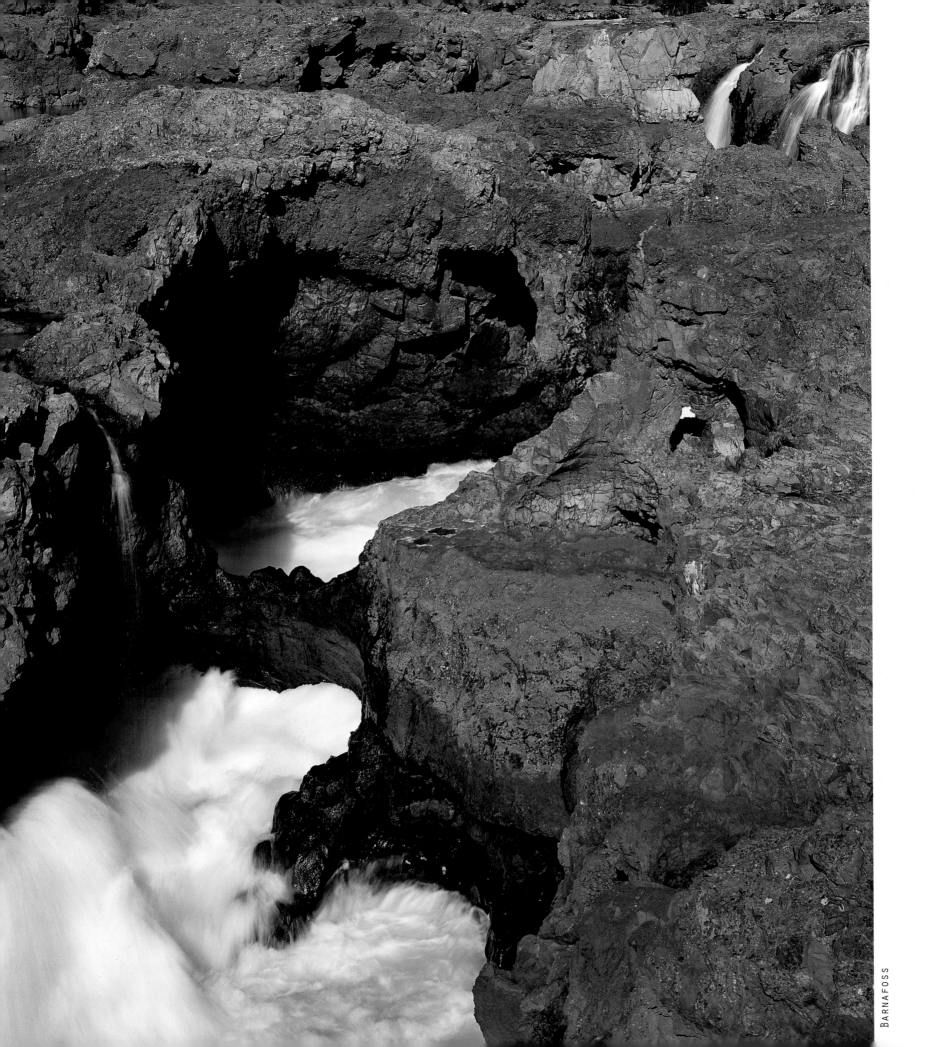

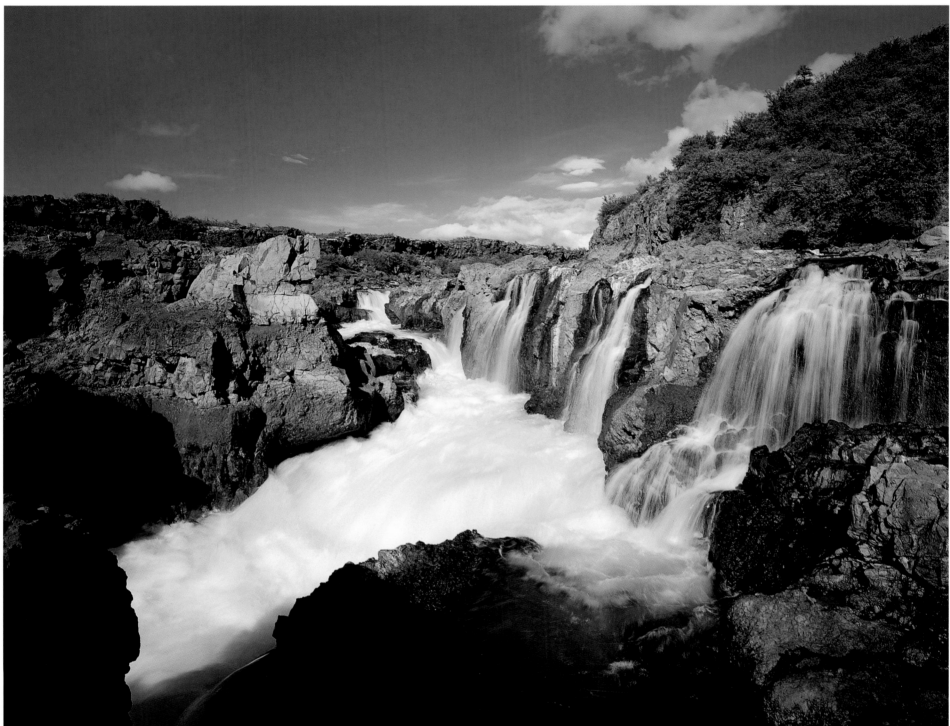

BARNAFOSS

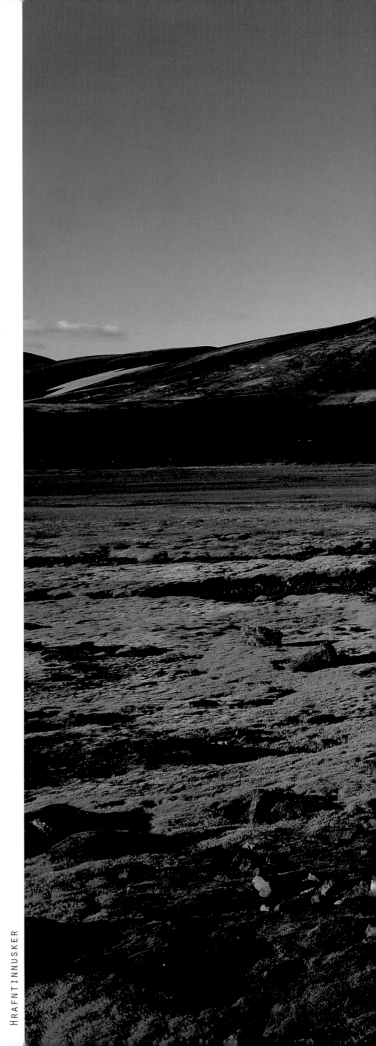

Fagurt var
It was beautiful

Hvað fyrr þú bar
Everywhere you looked

Á fjallinu því
From the mountain

FORN STEF

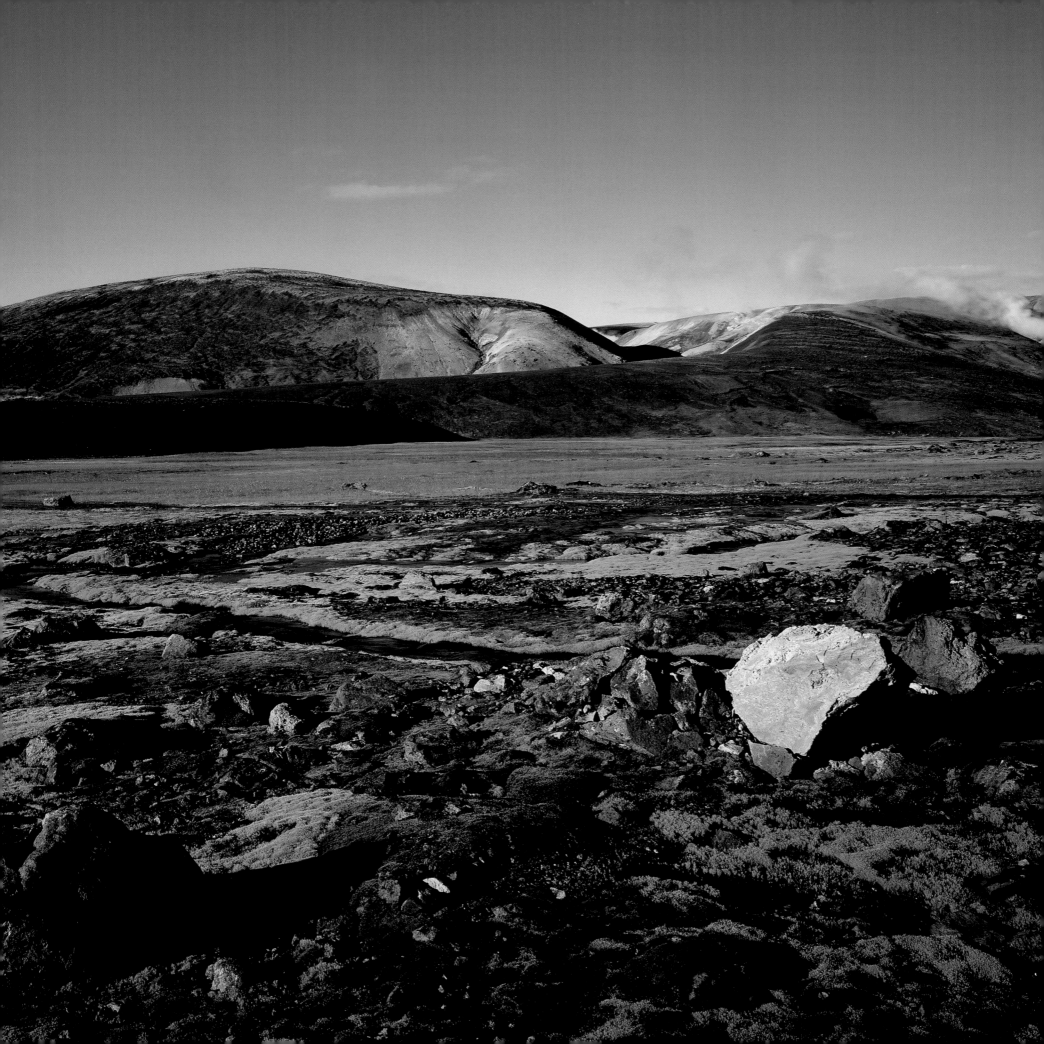

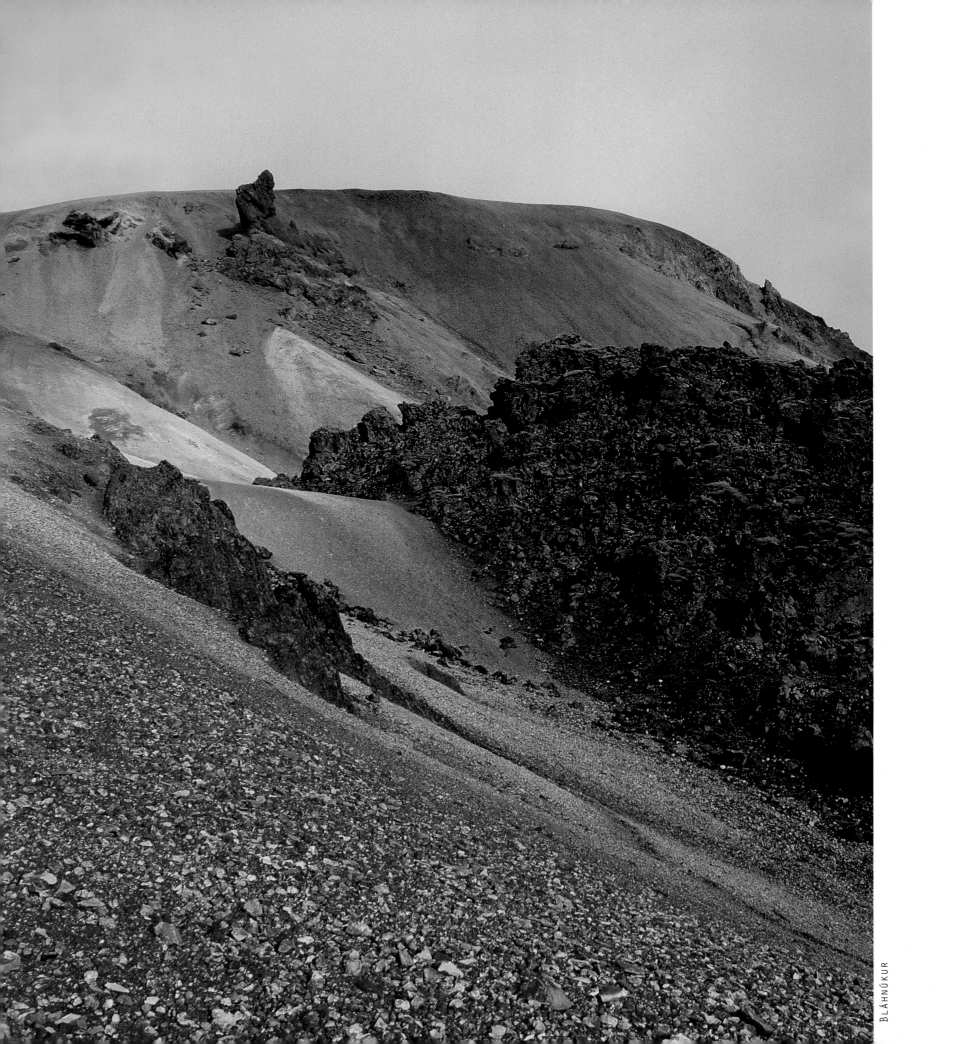

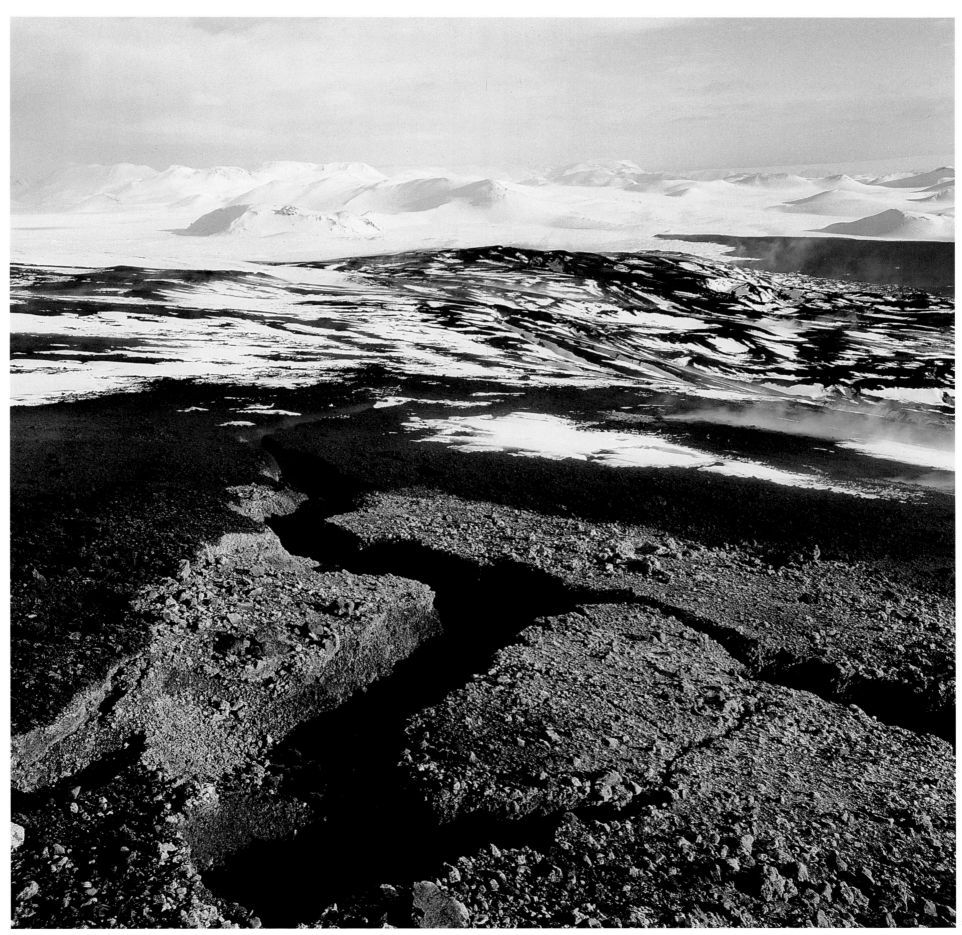

HEKLA

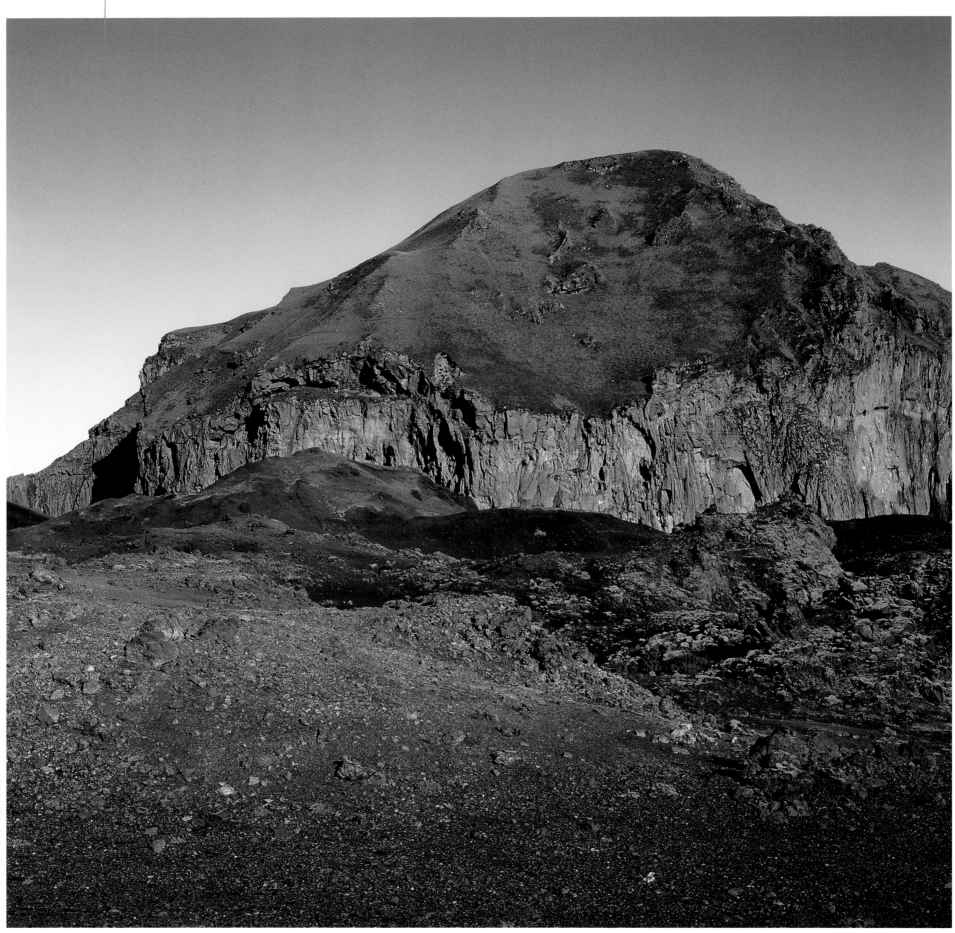

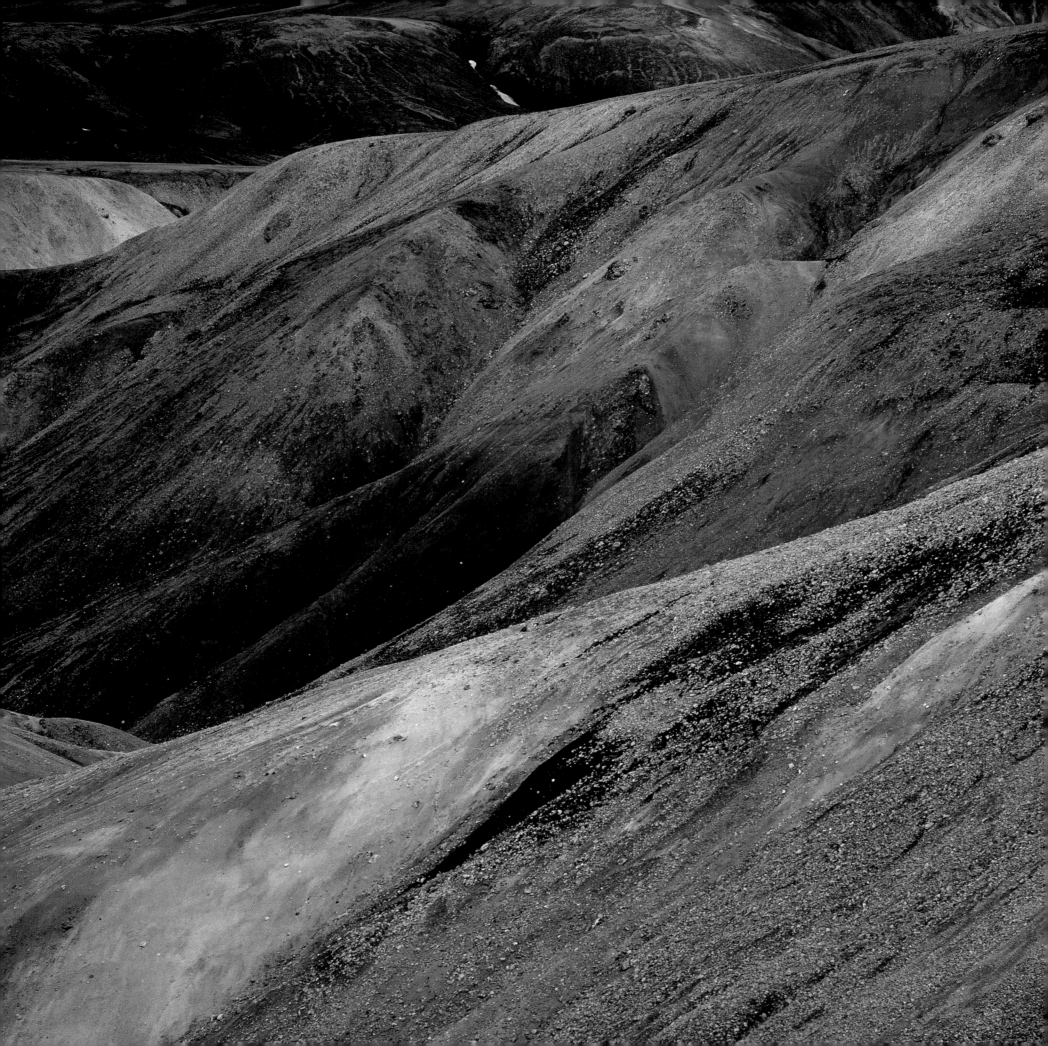

OG YFIR ÖLLU VAKIR ÞÖGNIN—ÞÖGNIN.

And above us reigns silence—silence.

STEINN STEINAR, from *Tunglskin*

LANDMANNALAUGAR

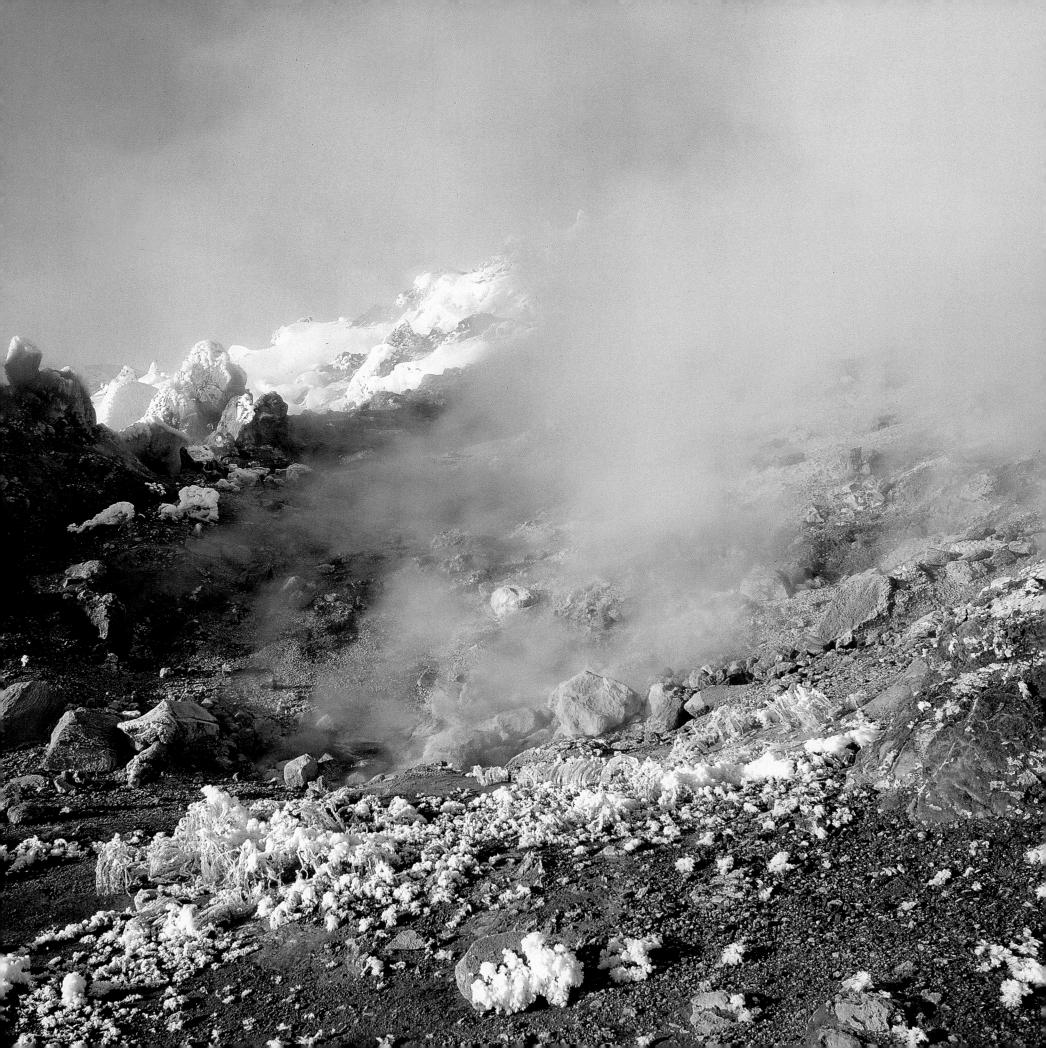

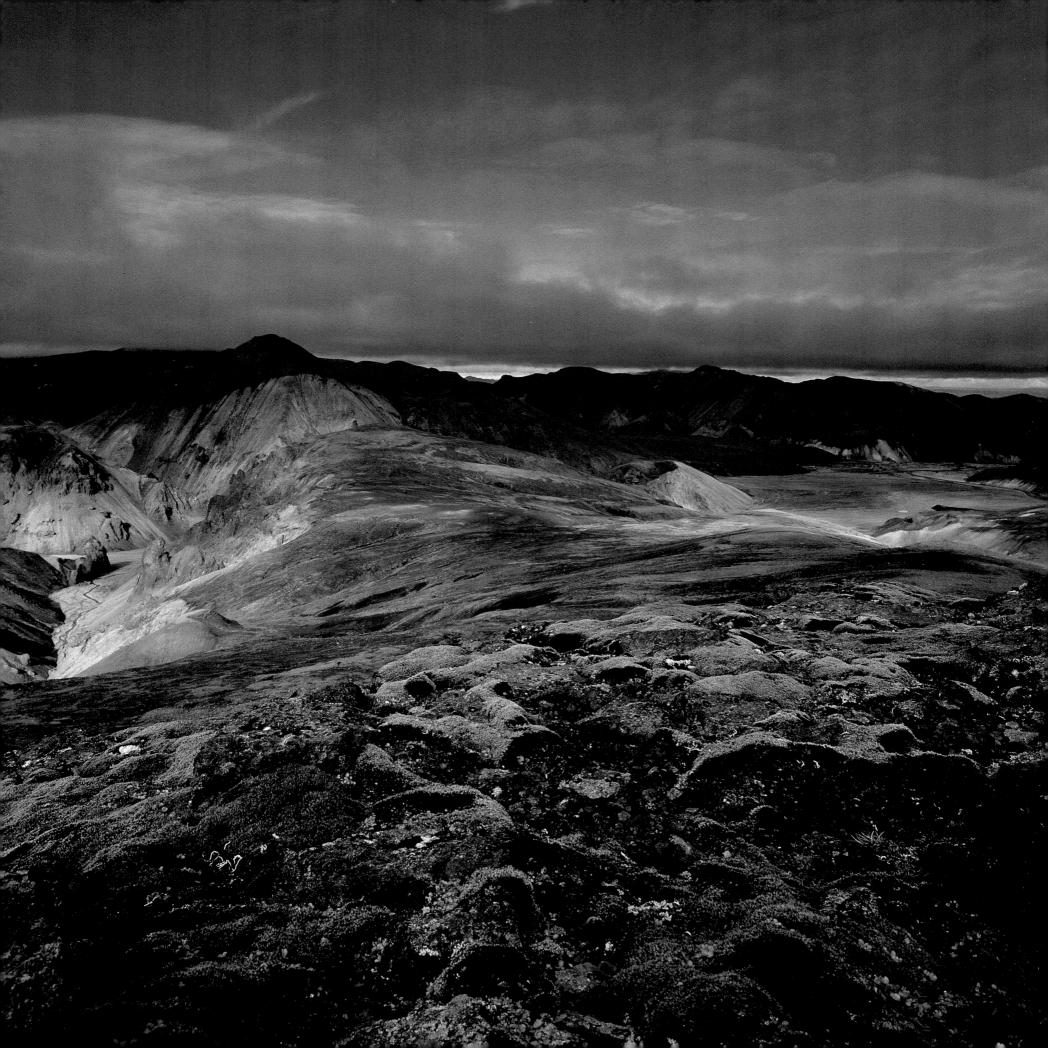

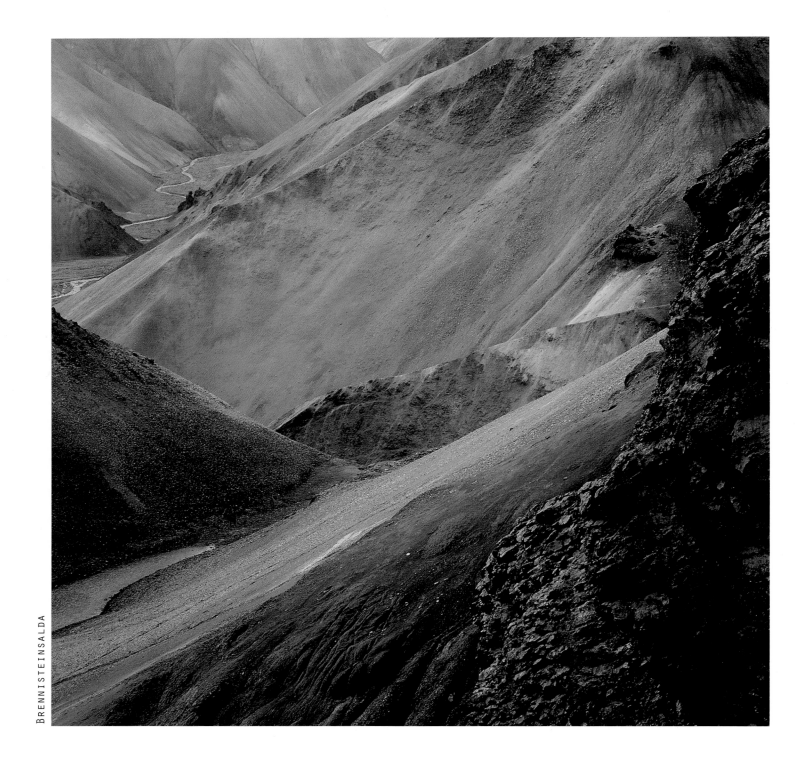

BRENNISTEINSALDA

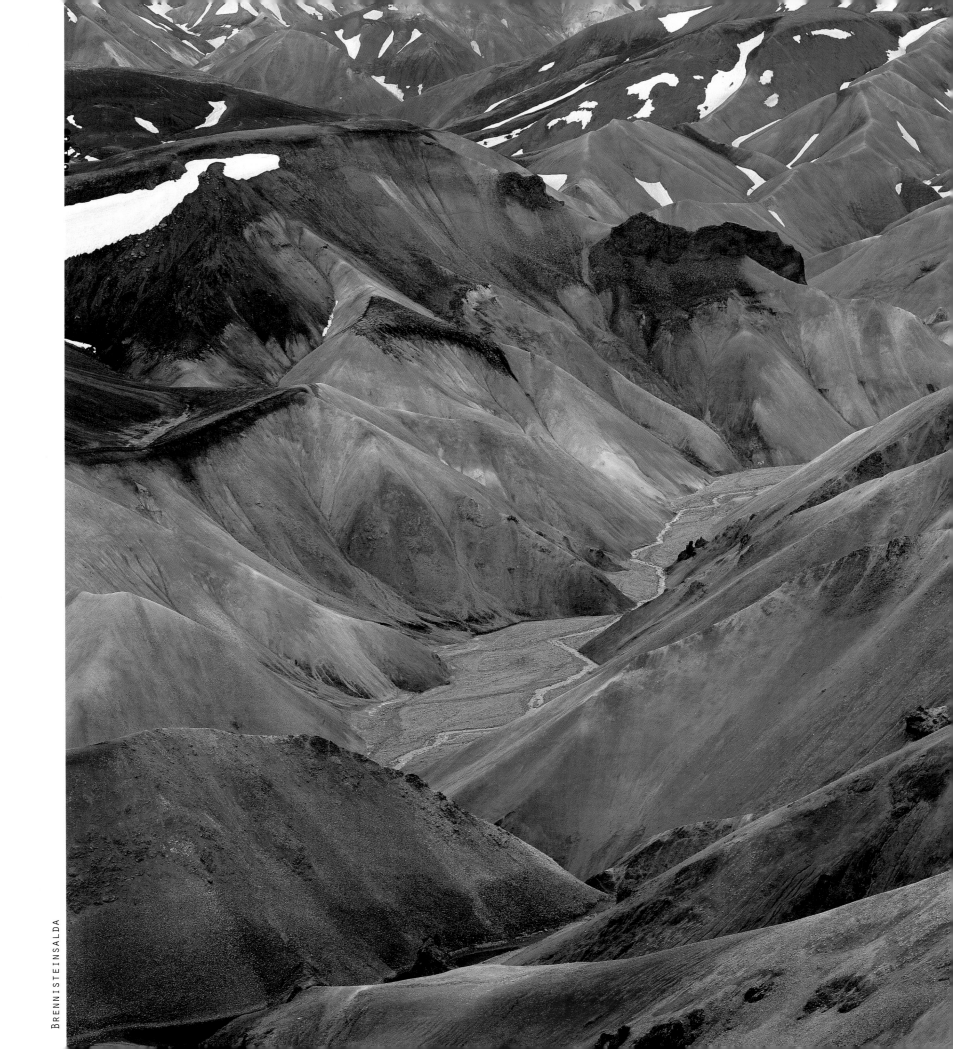

BRENNISTEINSALDA

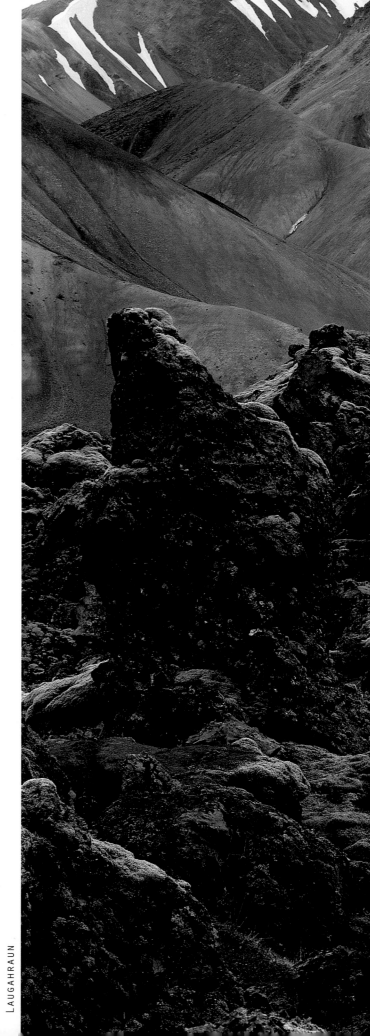

ÞAR ERU TRÖLL AÐ SYNGJA SÖNG

Over there the giants are singing a song

SVO AÐ FJÖLLIN HEYRA

So that the mountains can hear it

THORSTEINN ERLINGSSON

LAUGAHRAUN

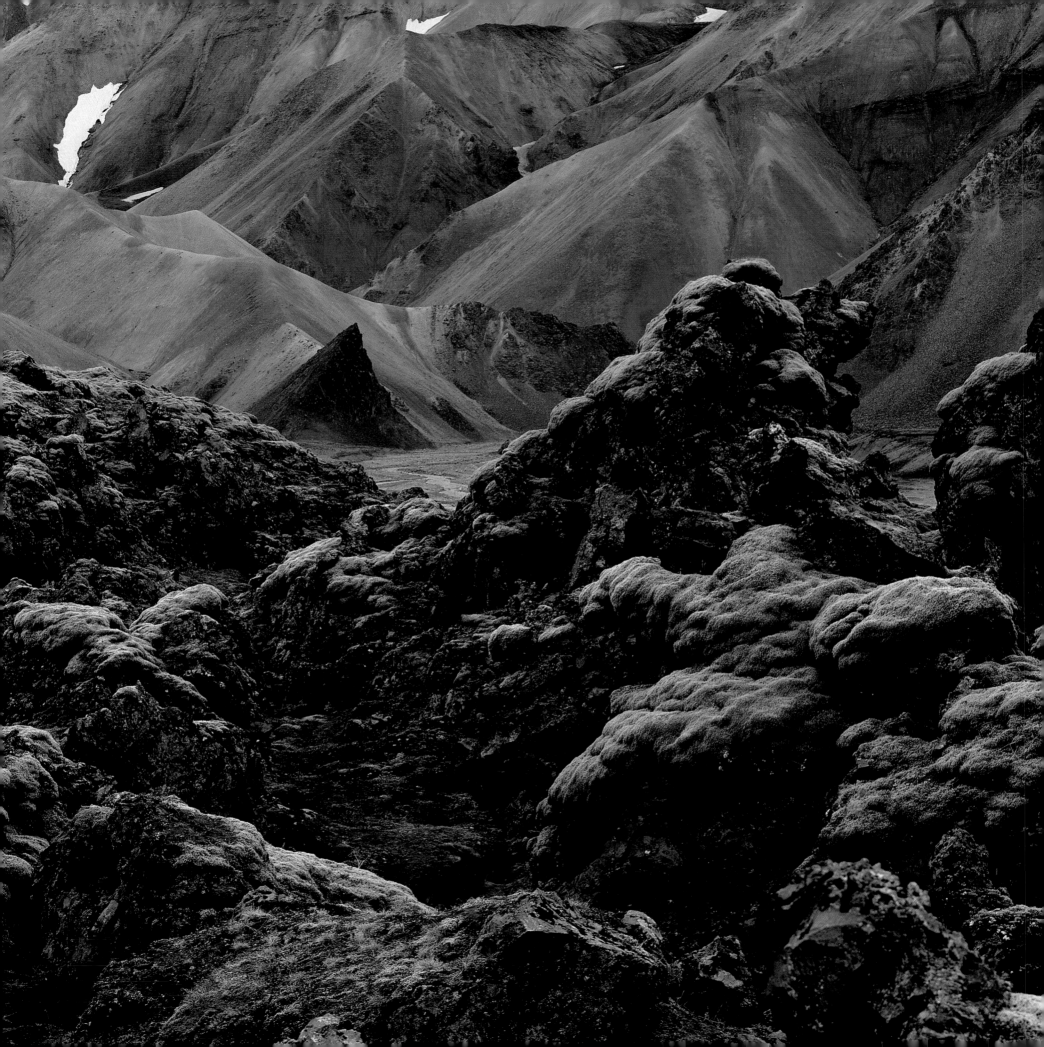

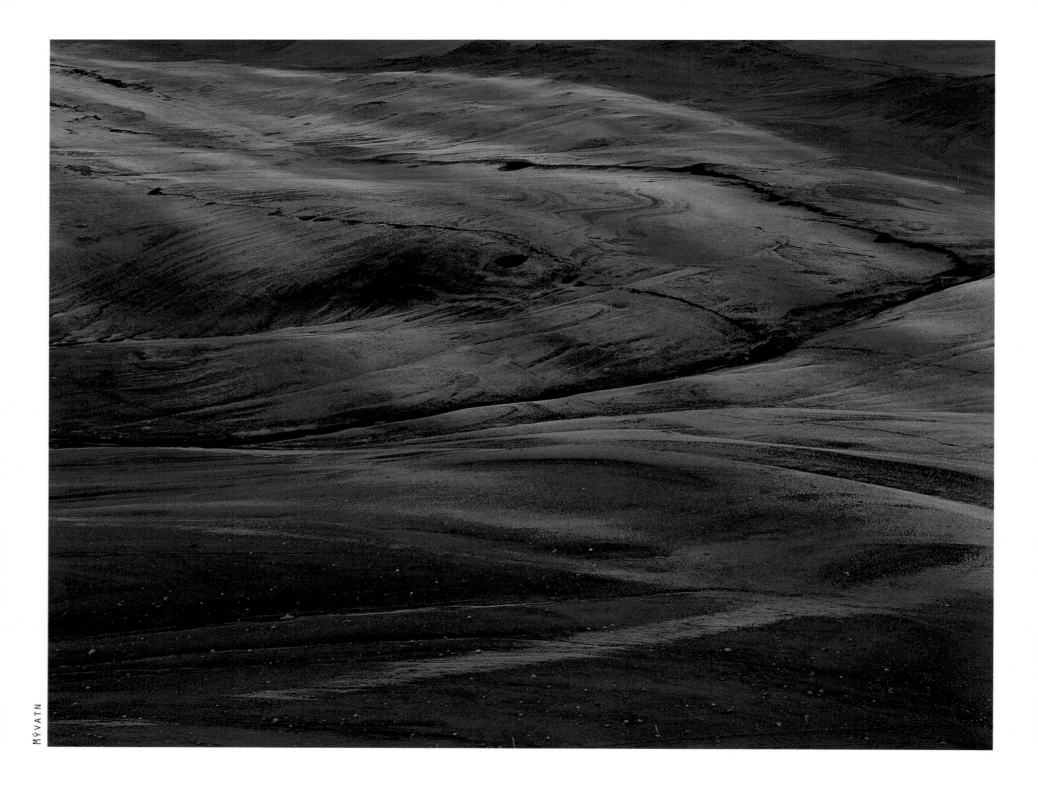

MÝVATN

MÆLIFELLSSANDUR

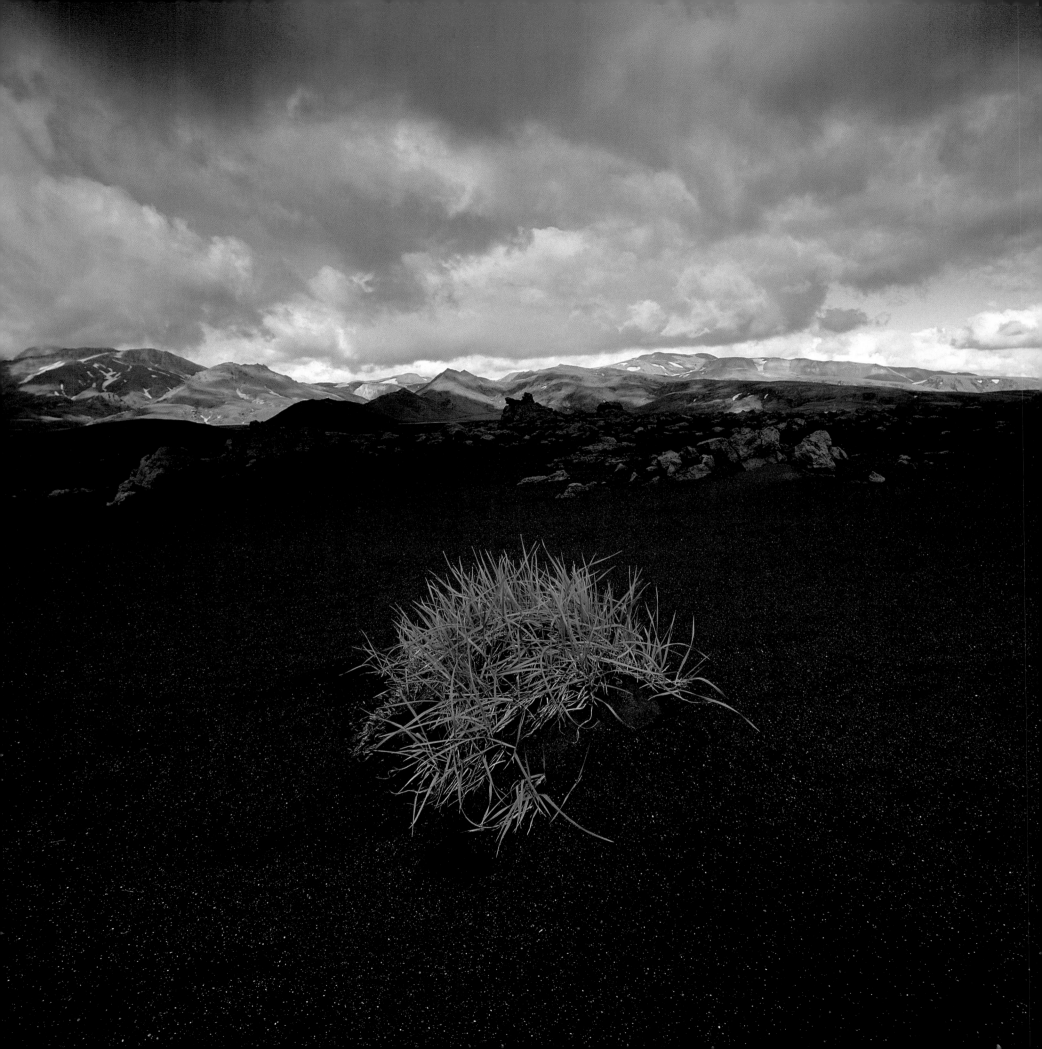

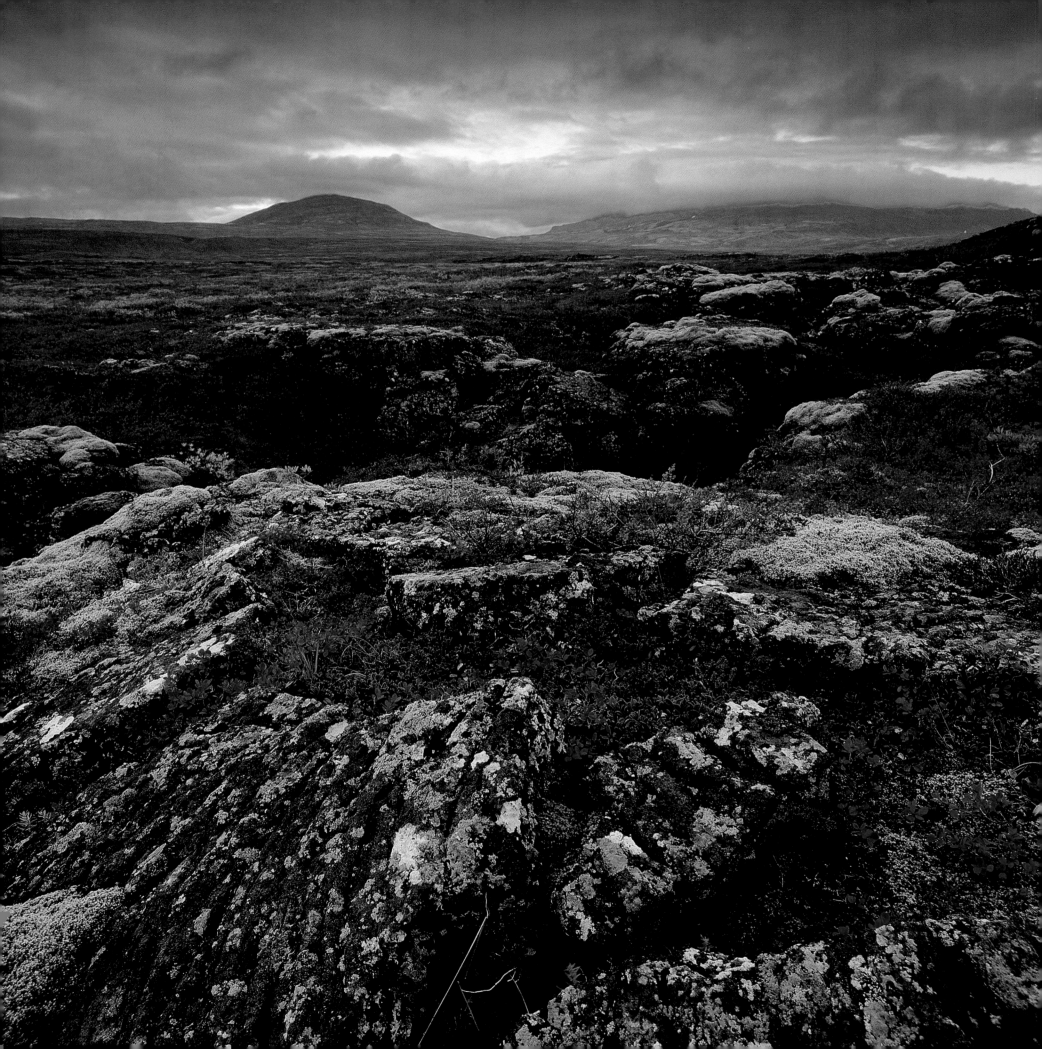

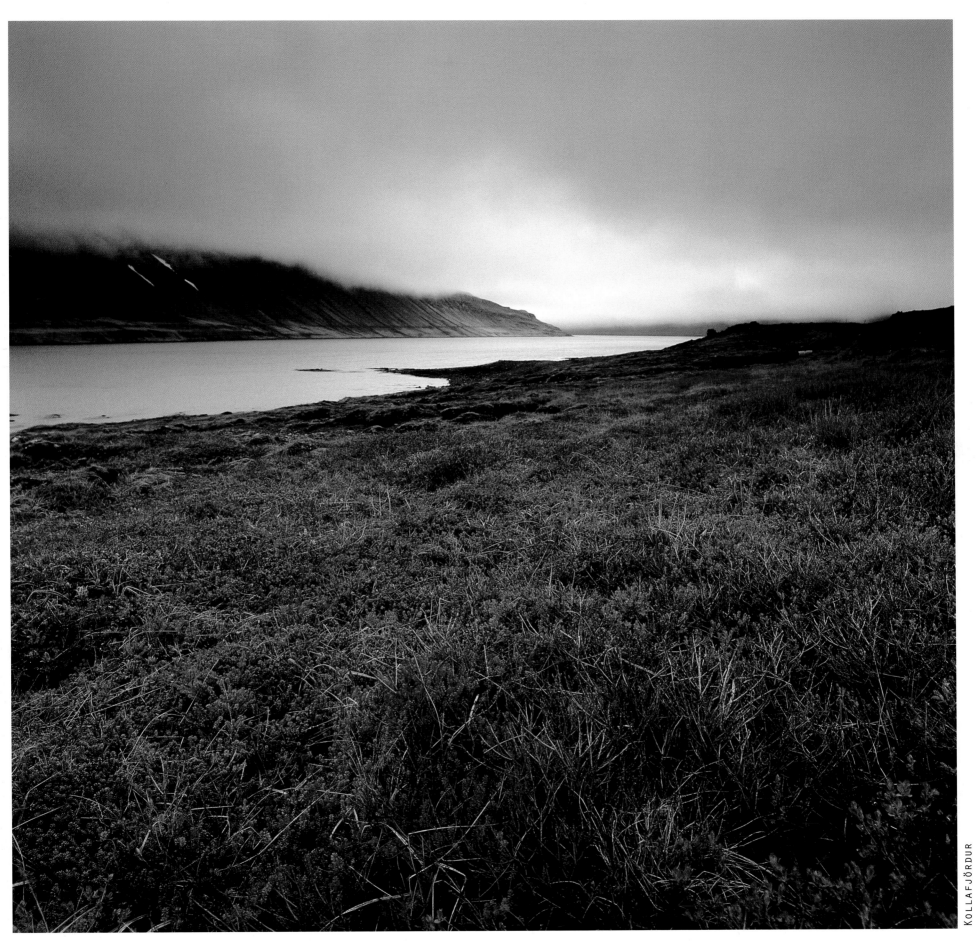

KOLLAFJÖRDUR

VEIZTU? ÞAÐ ERU VOR TÁR,

Do you know? It is our tear,

VOR TÁR,

Our tear,

SEM FALLA Í SVARTAN SANDINN

That falls on the black sand

OG SÉR ENGAN STAÐ.

And sees no place.

STEINN STEINAR, from *Gönguljód*

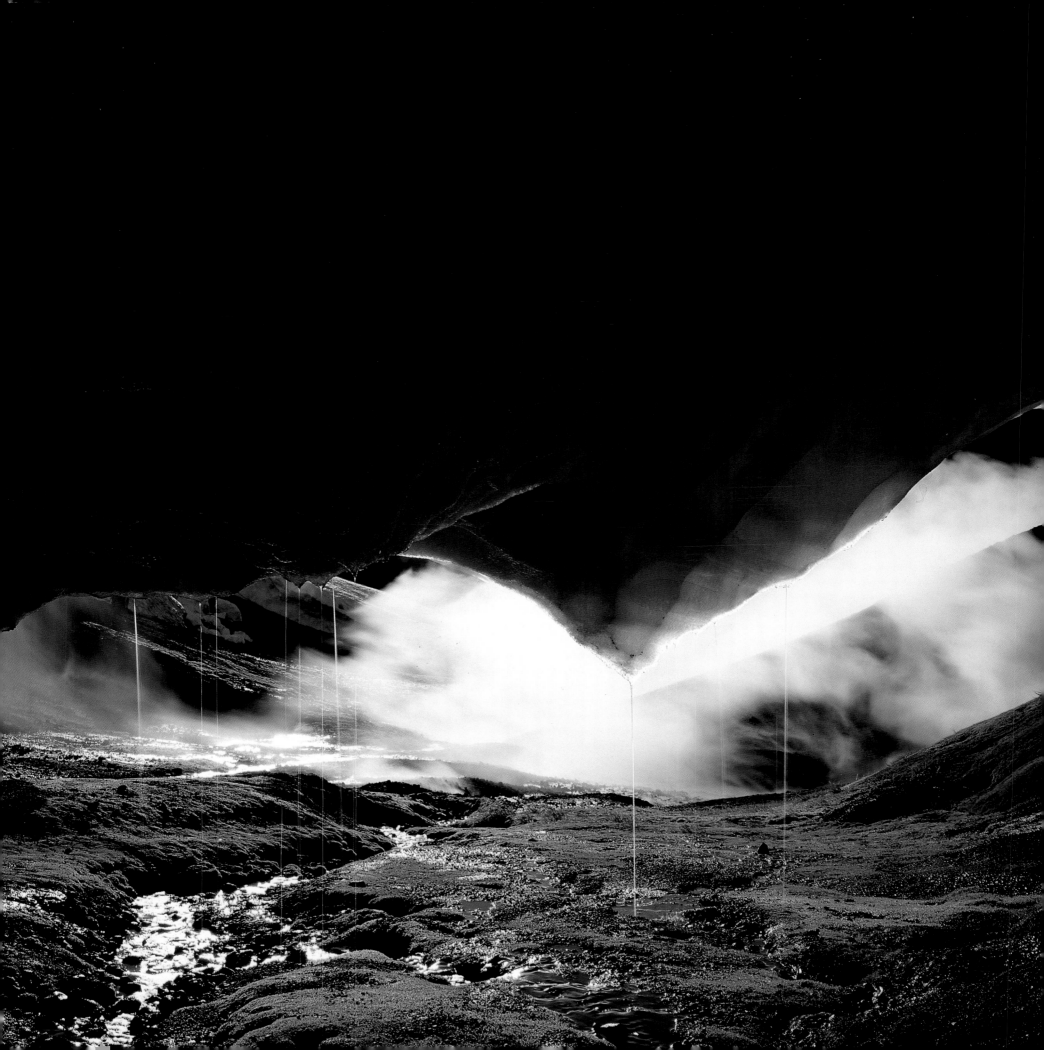

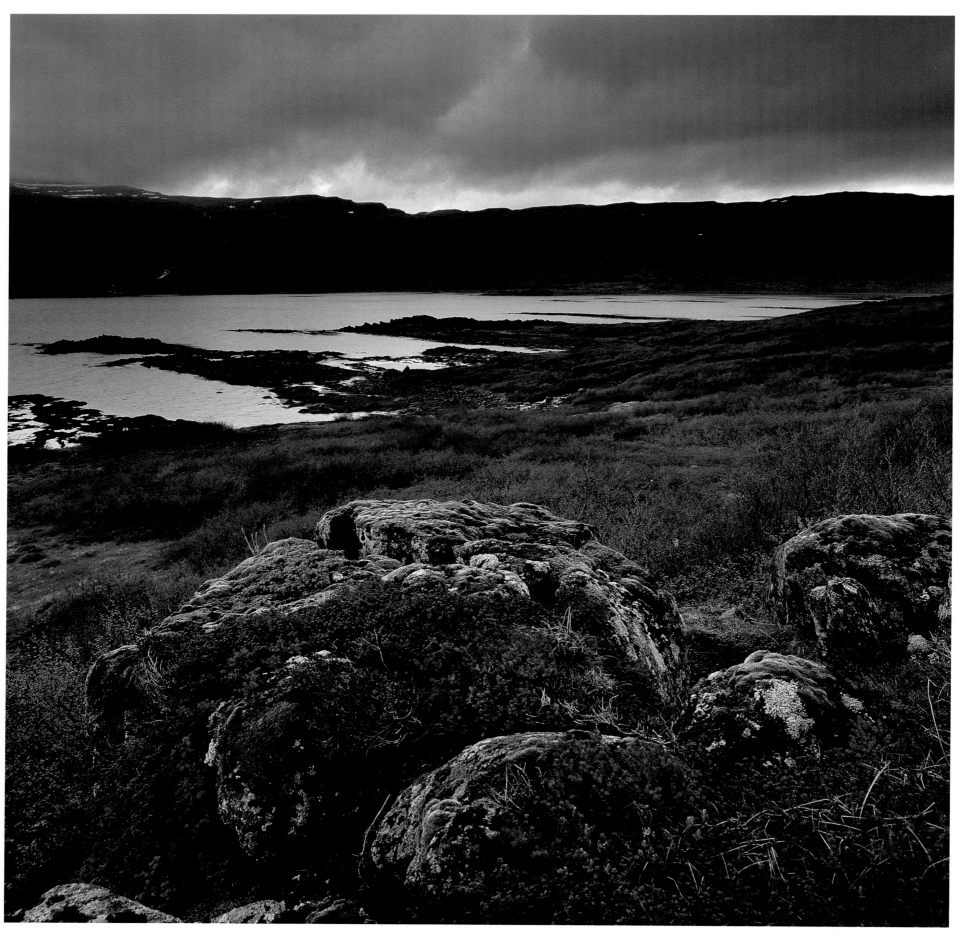

KOLLAFJÖRDUR

BLUE LAGOON

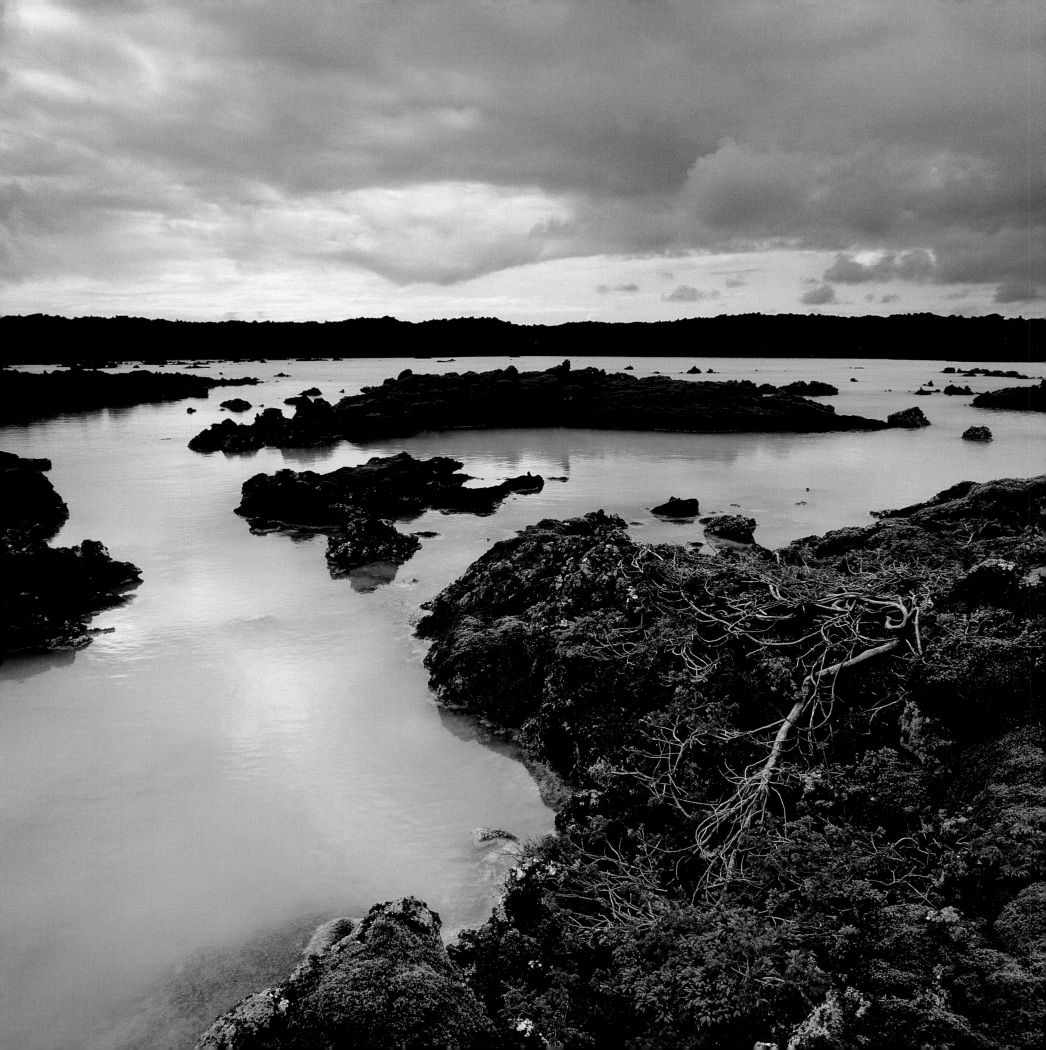

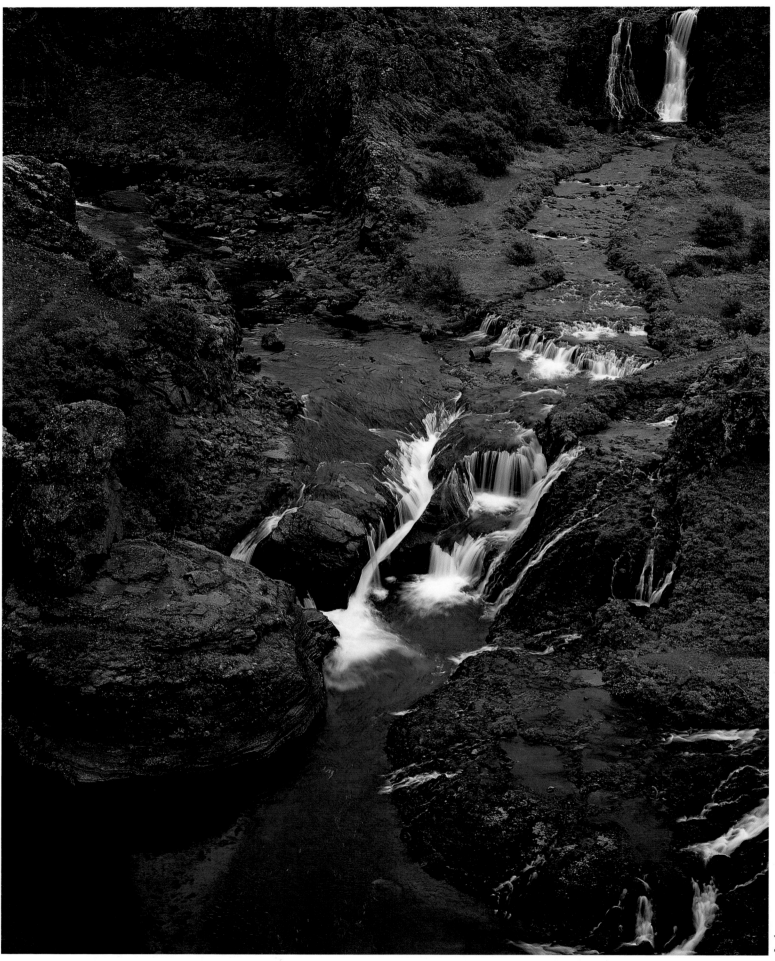

GJÁIN

EYSTRI-RANGÁ

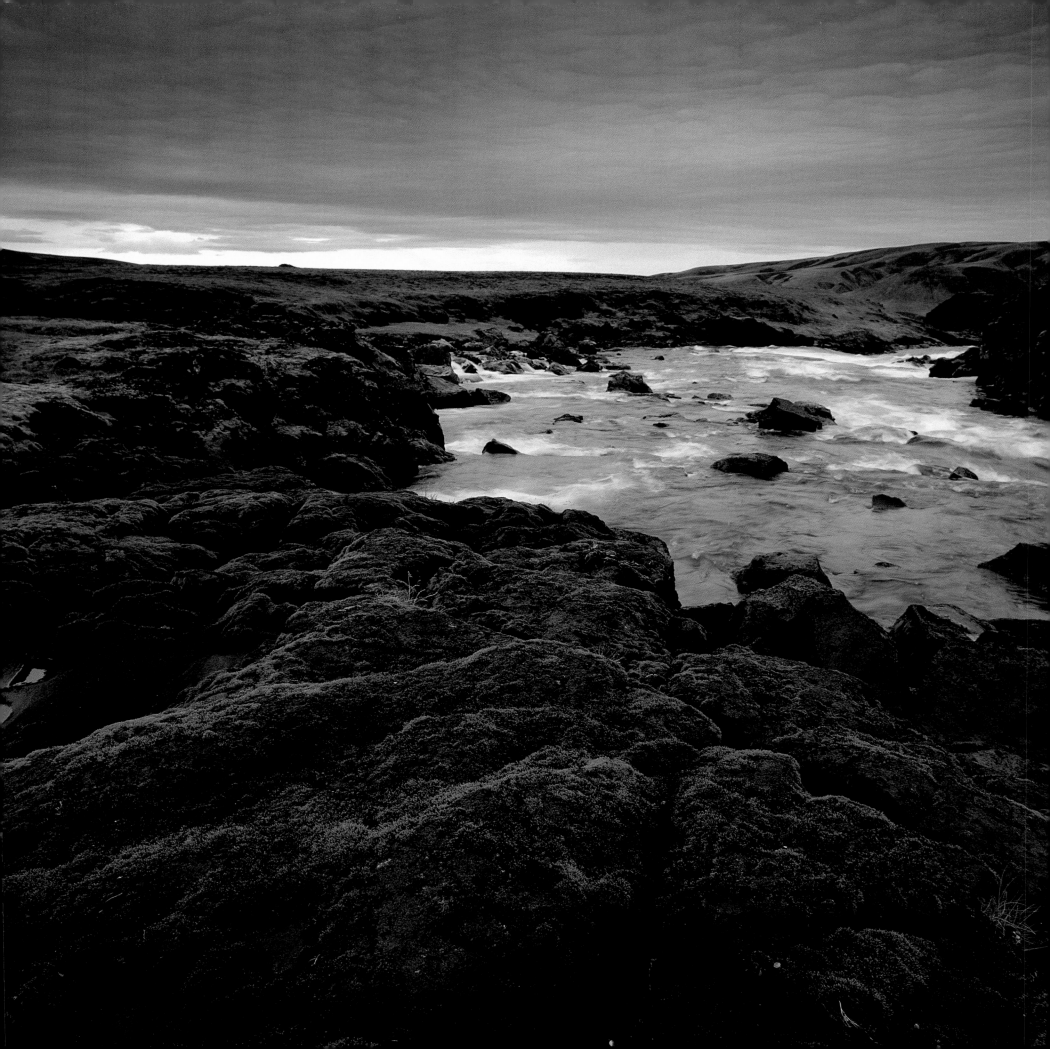

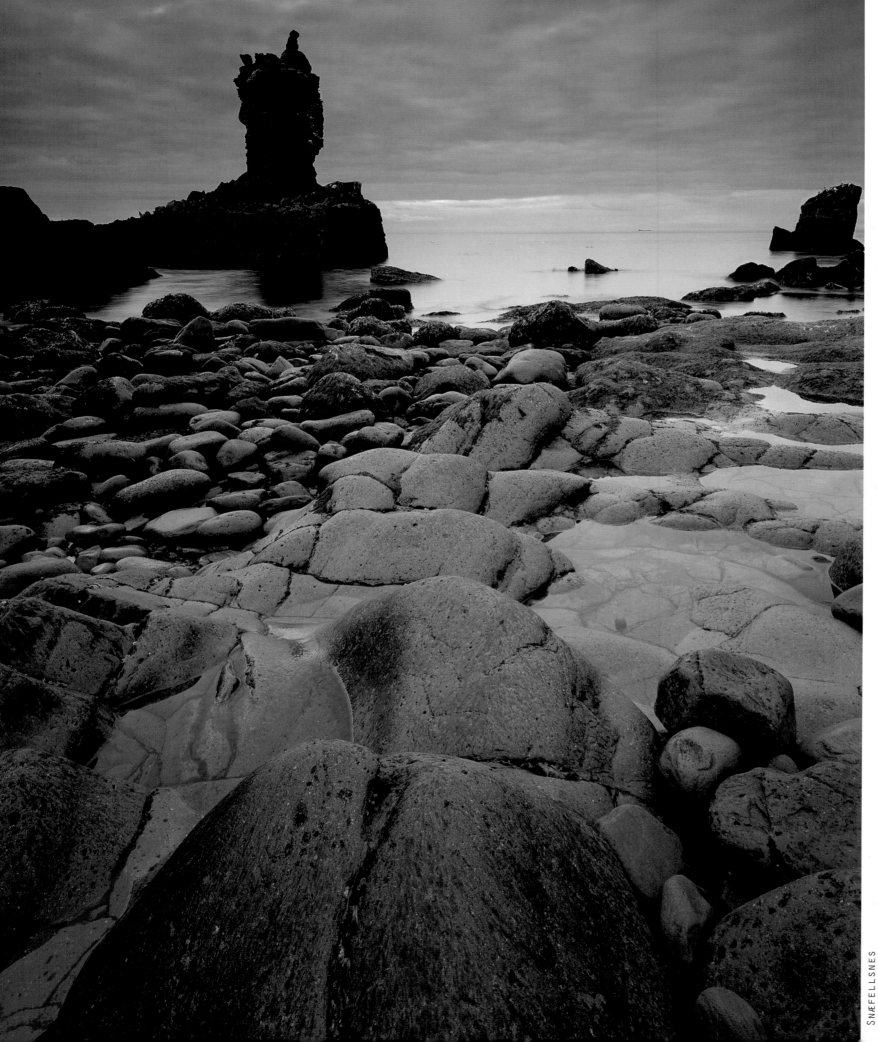

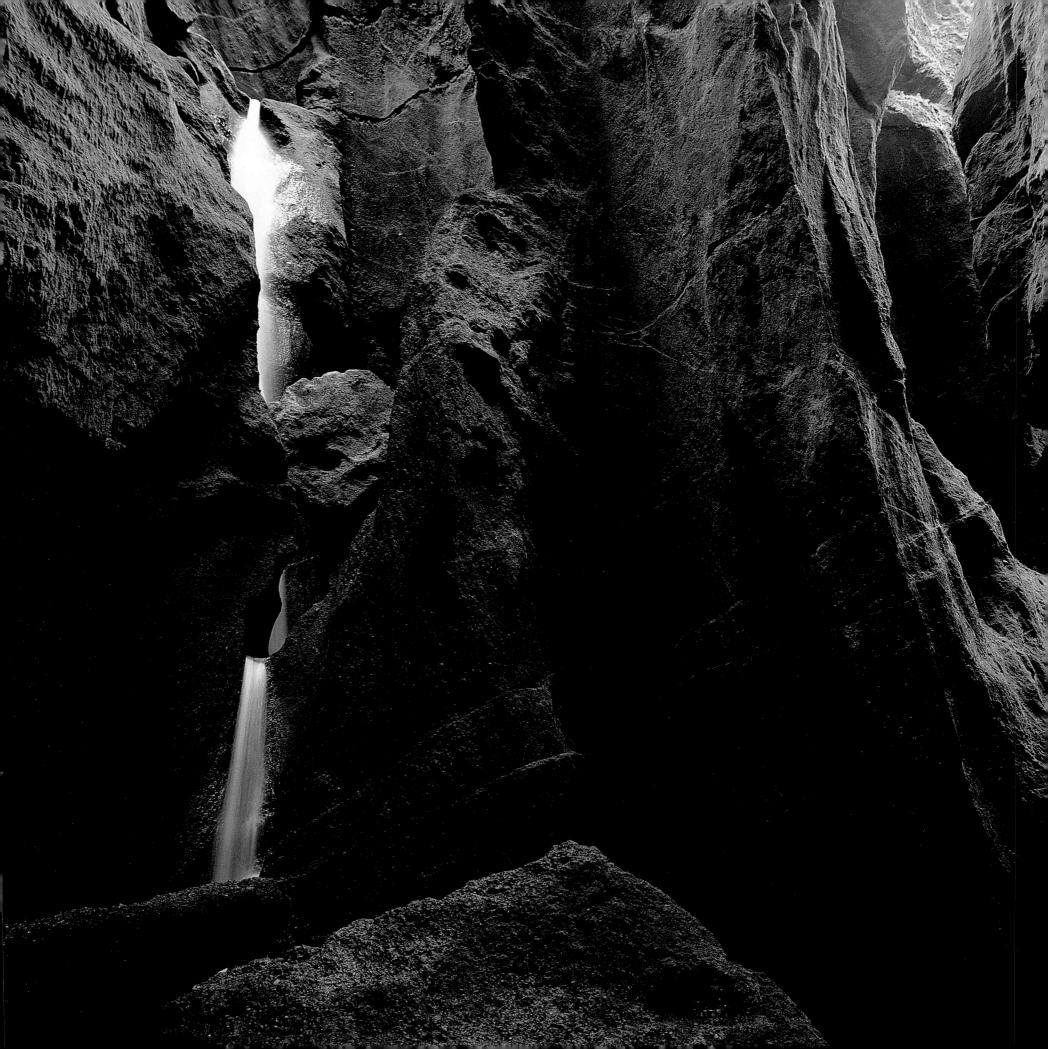

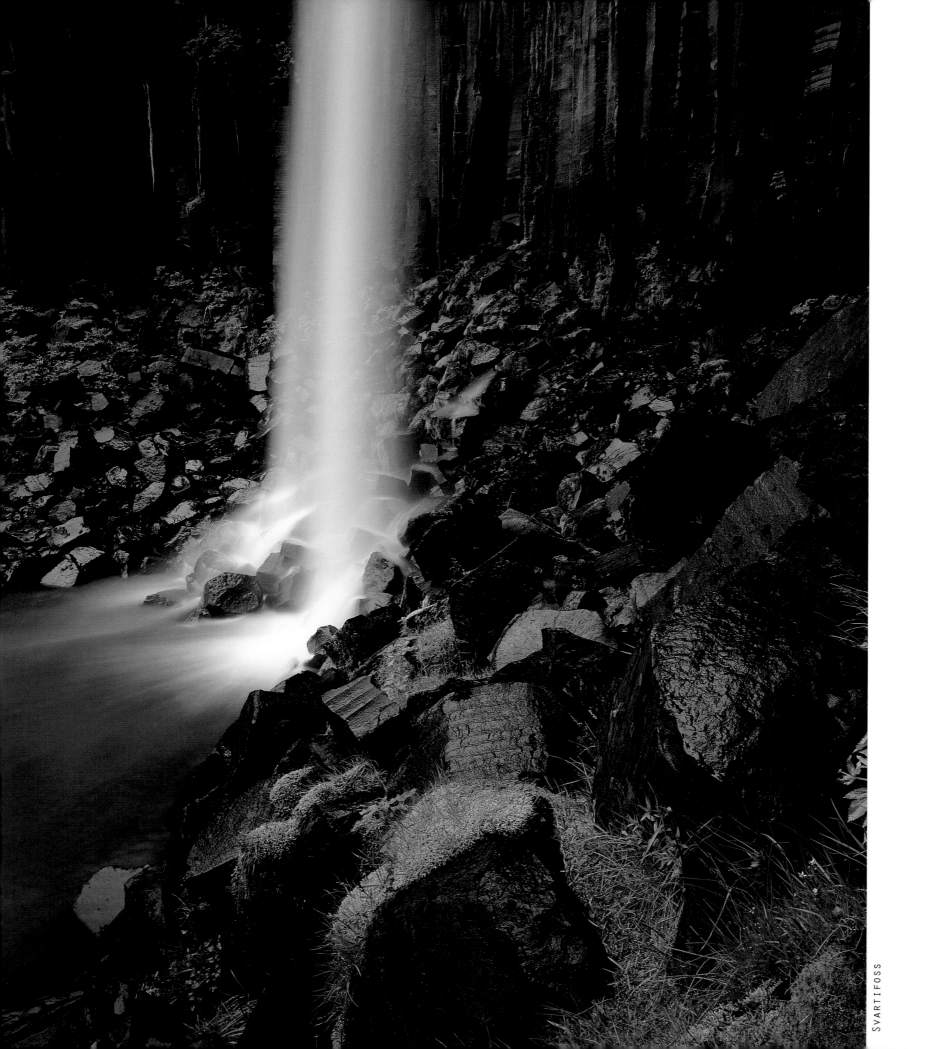

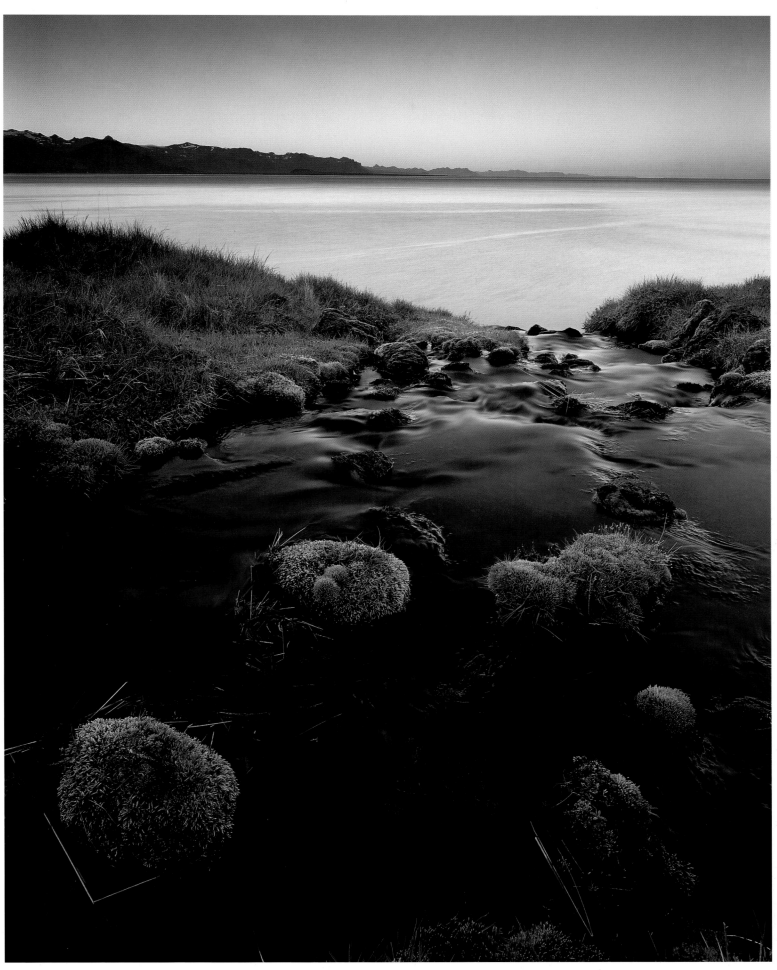

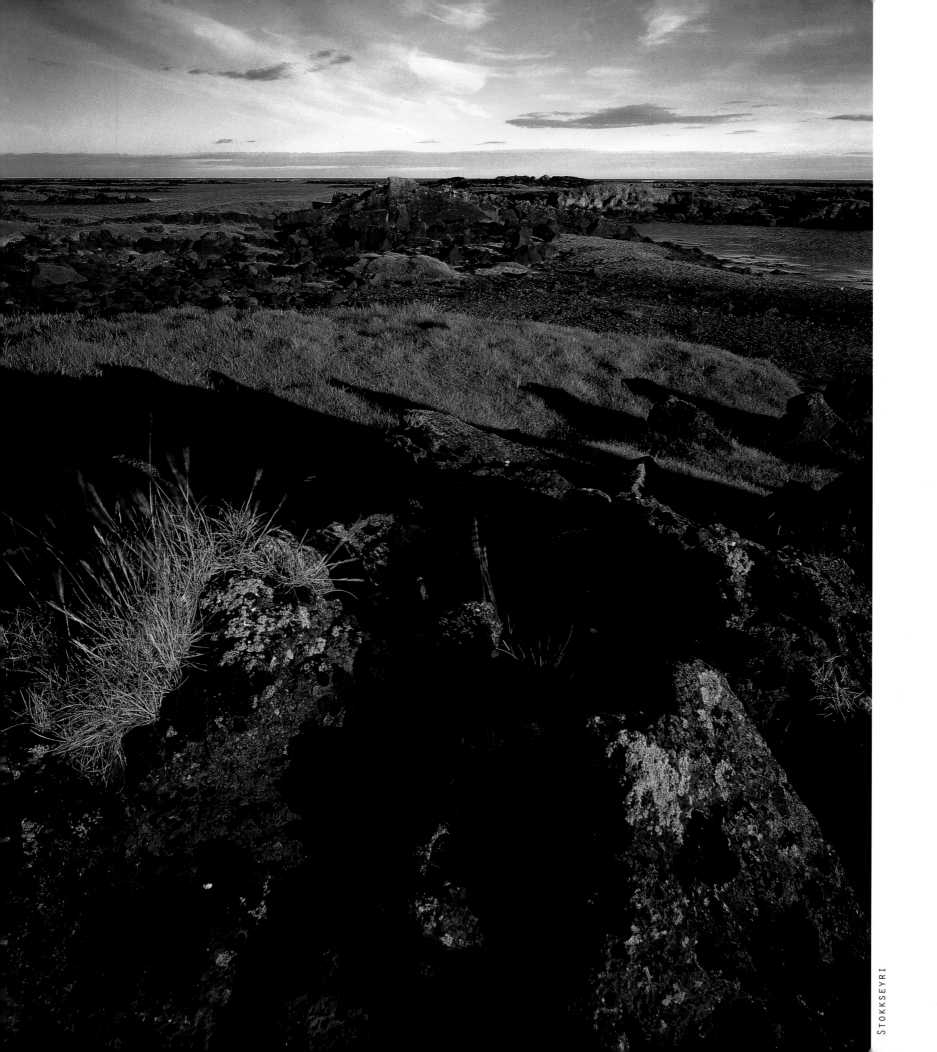

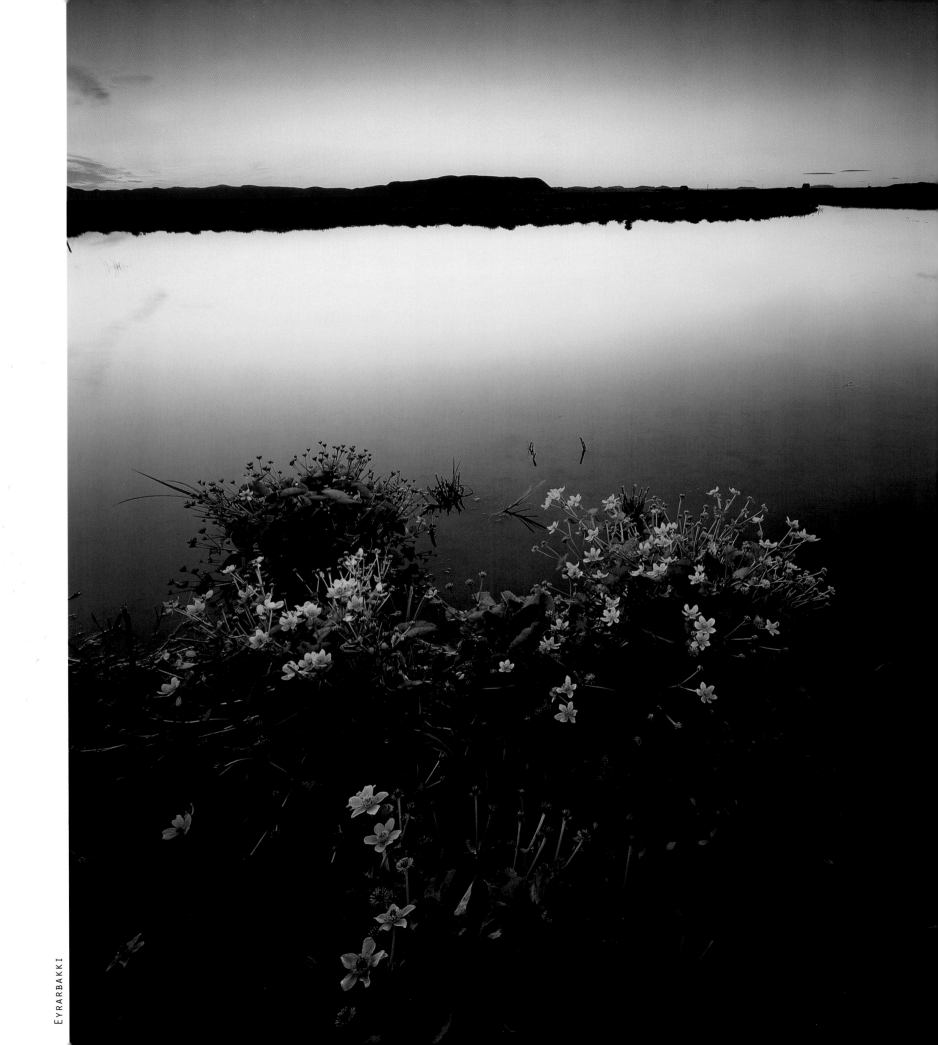

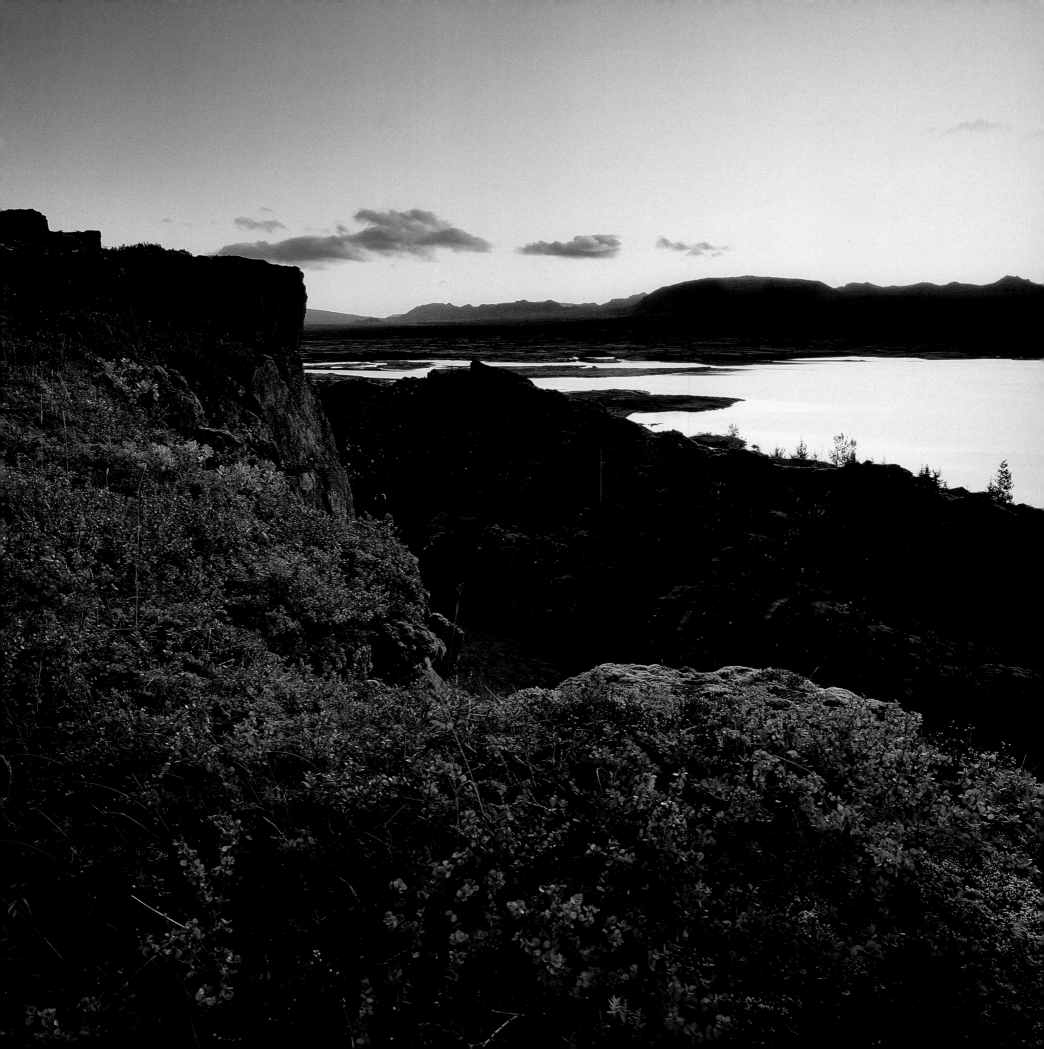

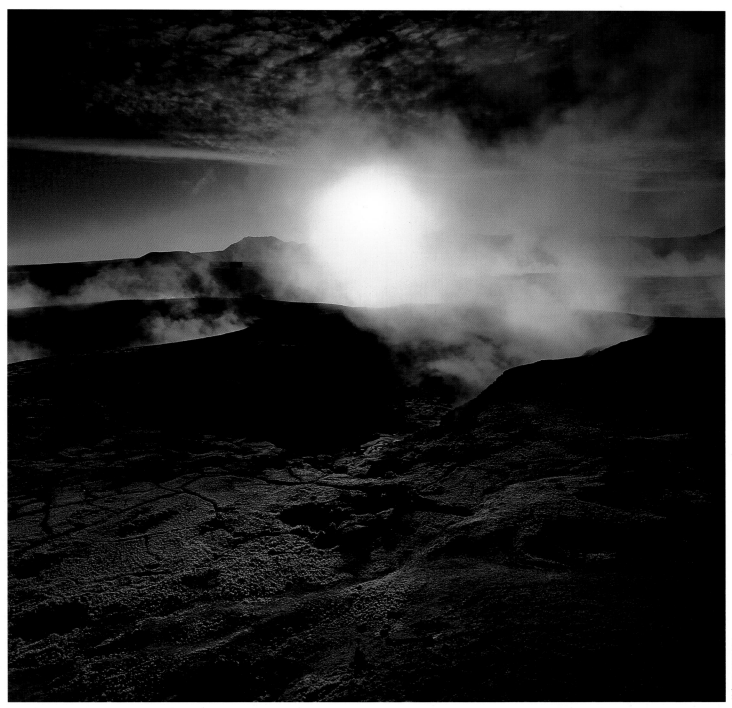

NÁMASKARD

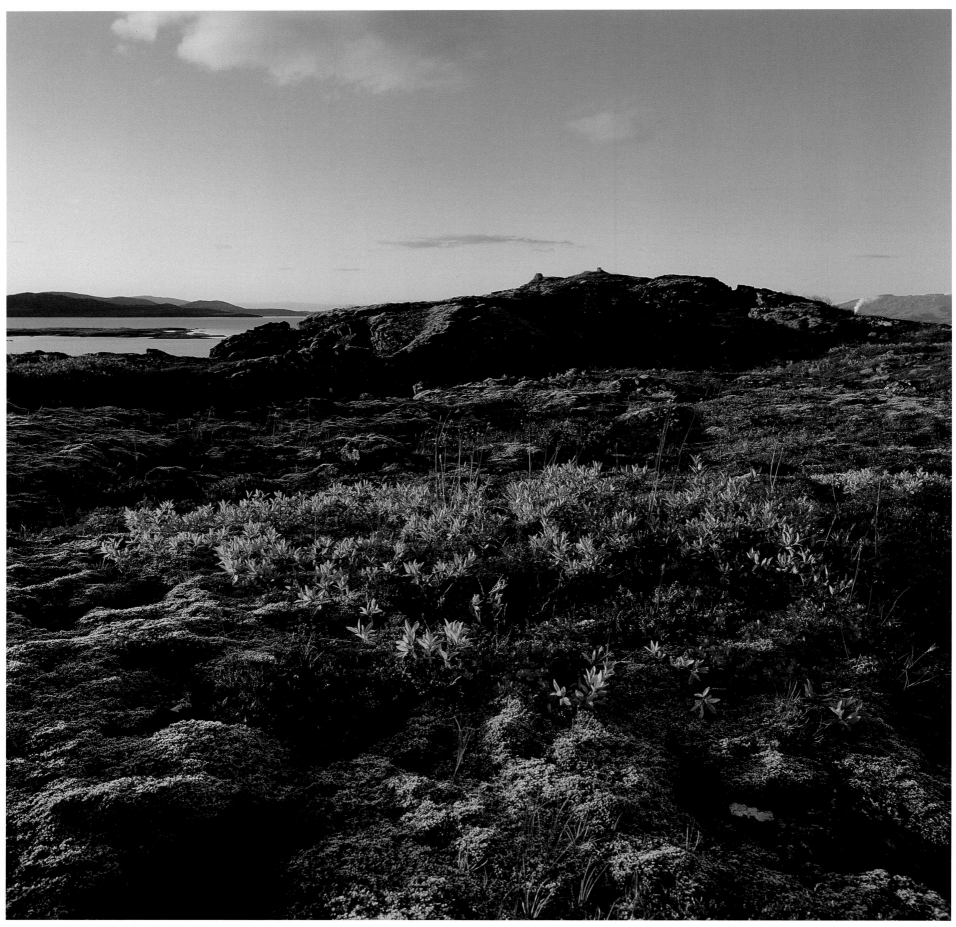

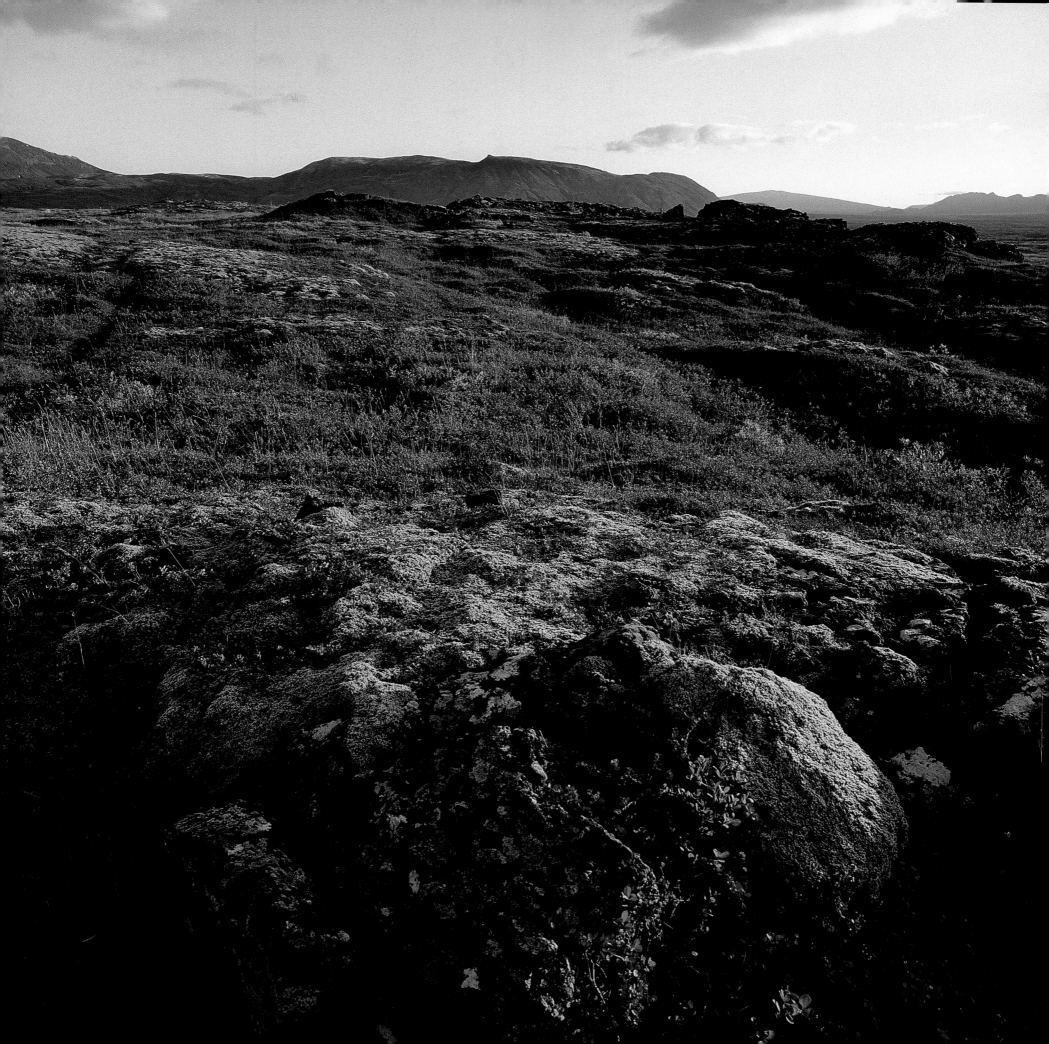

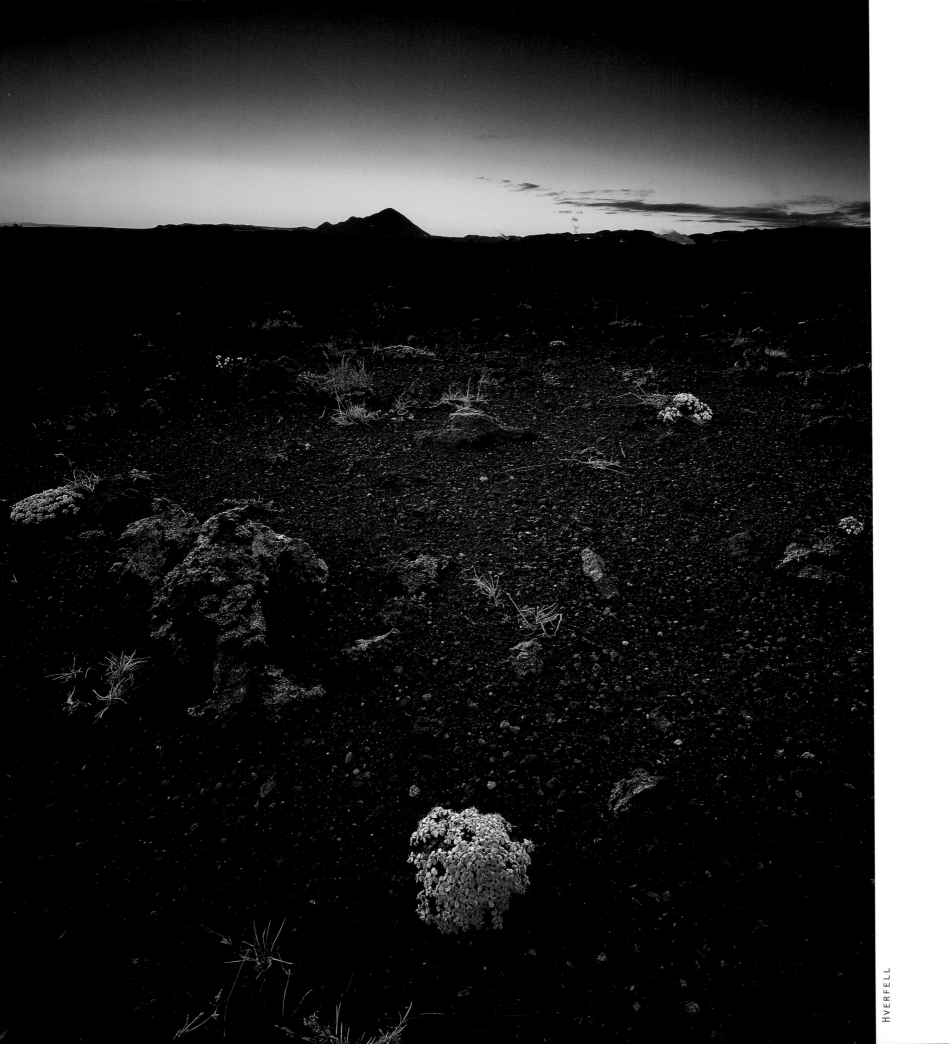

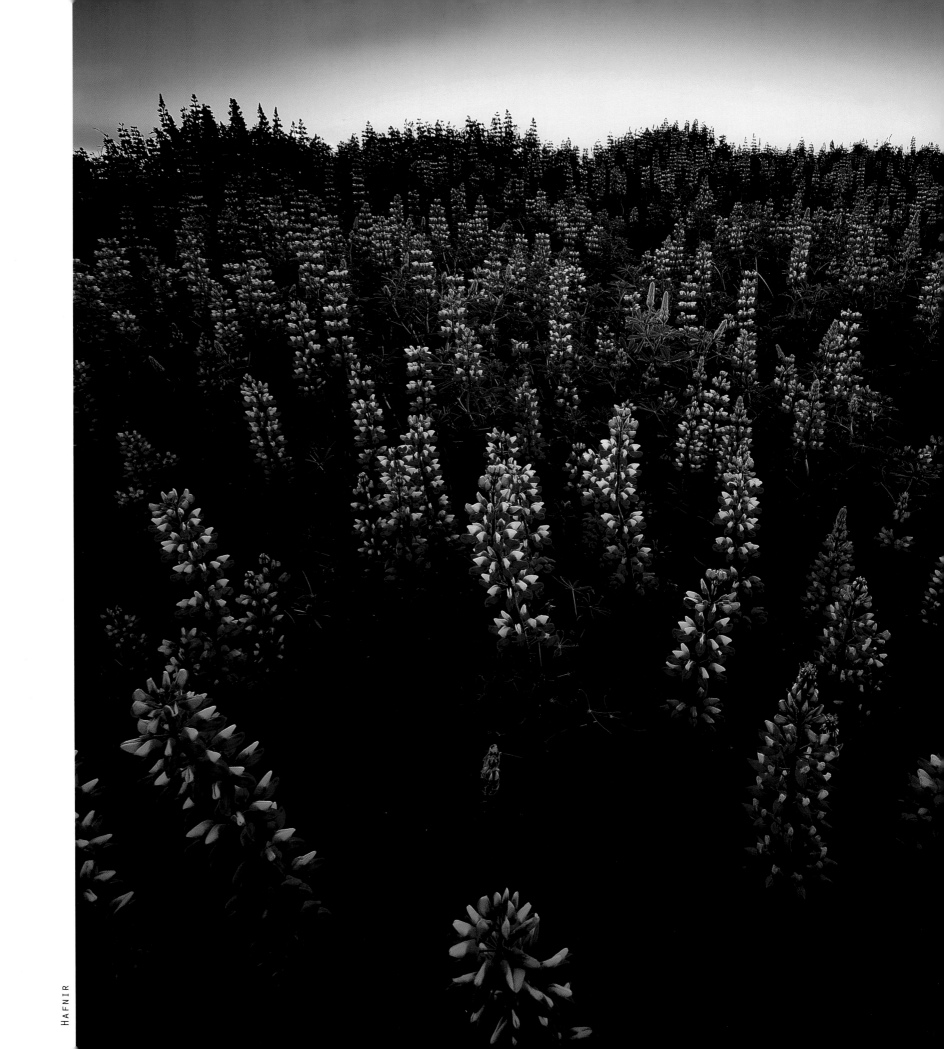

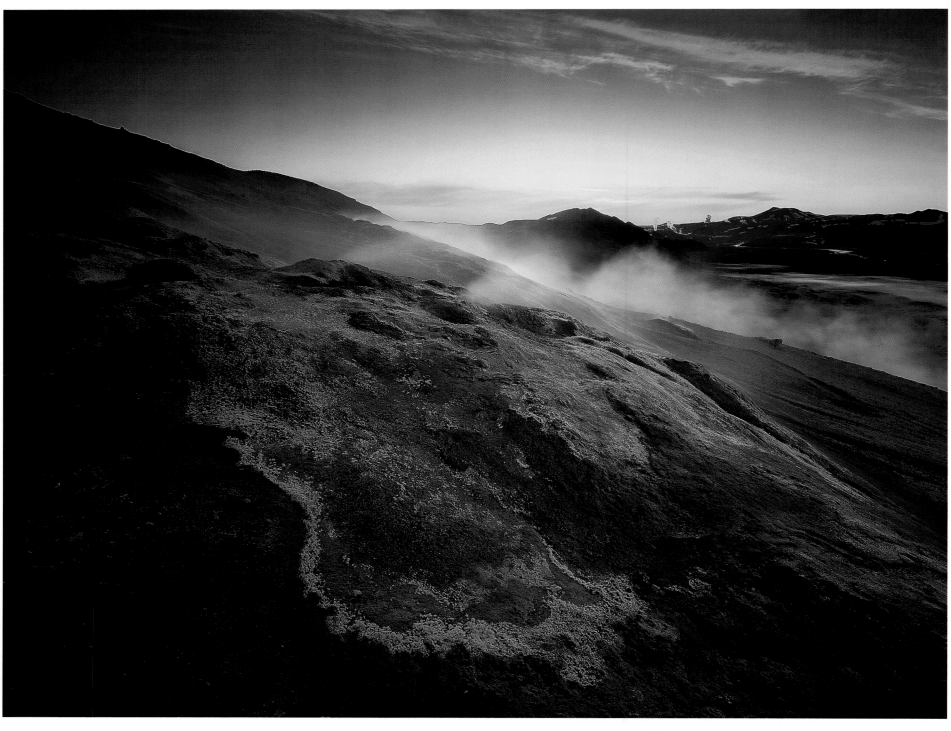

NÁMASKARÐ

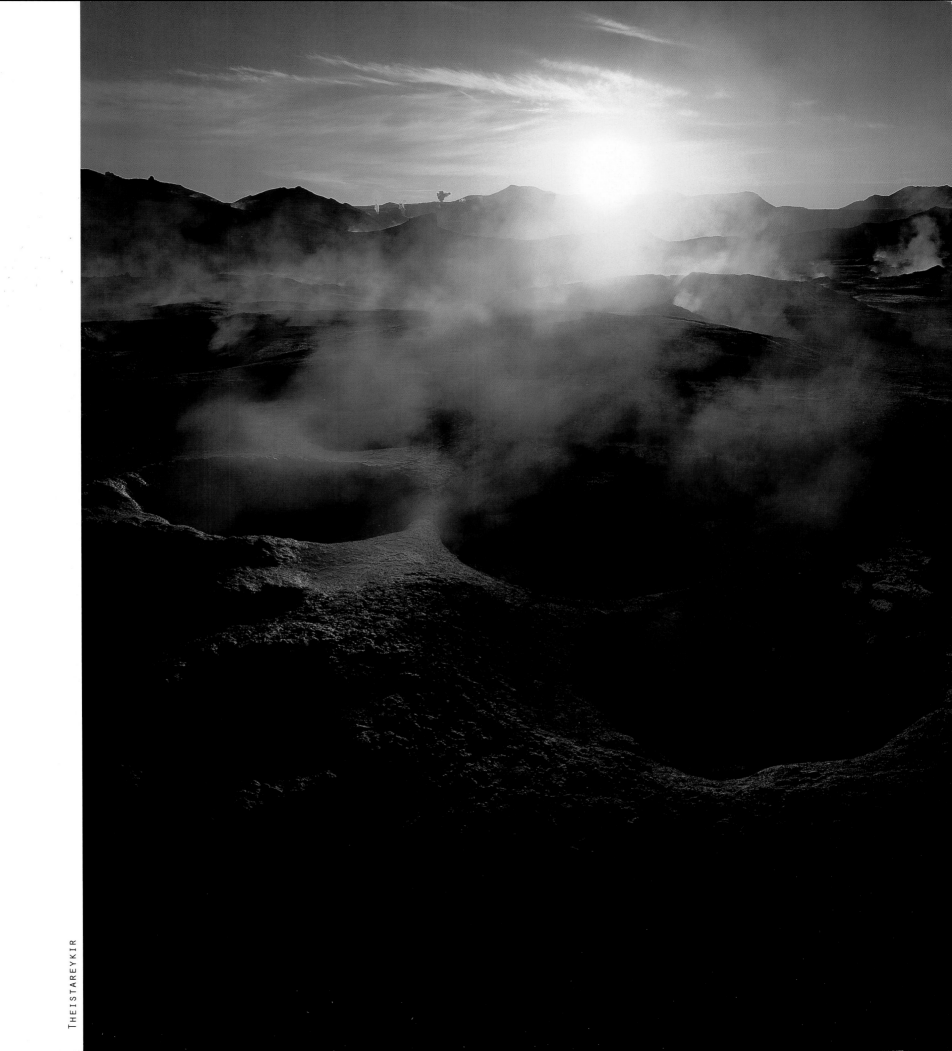

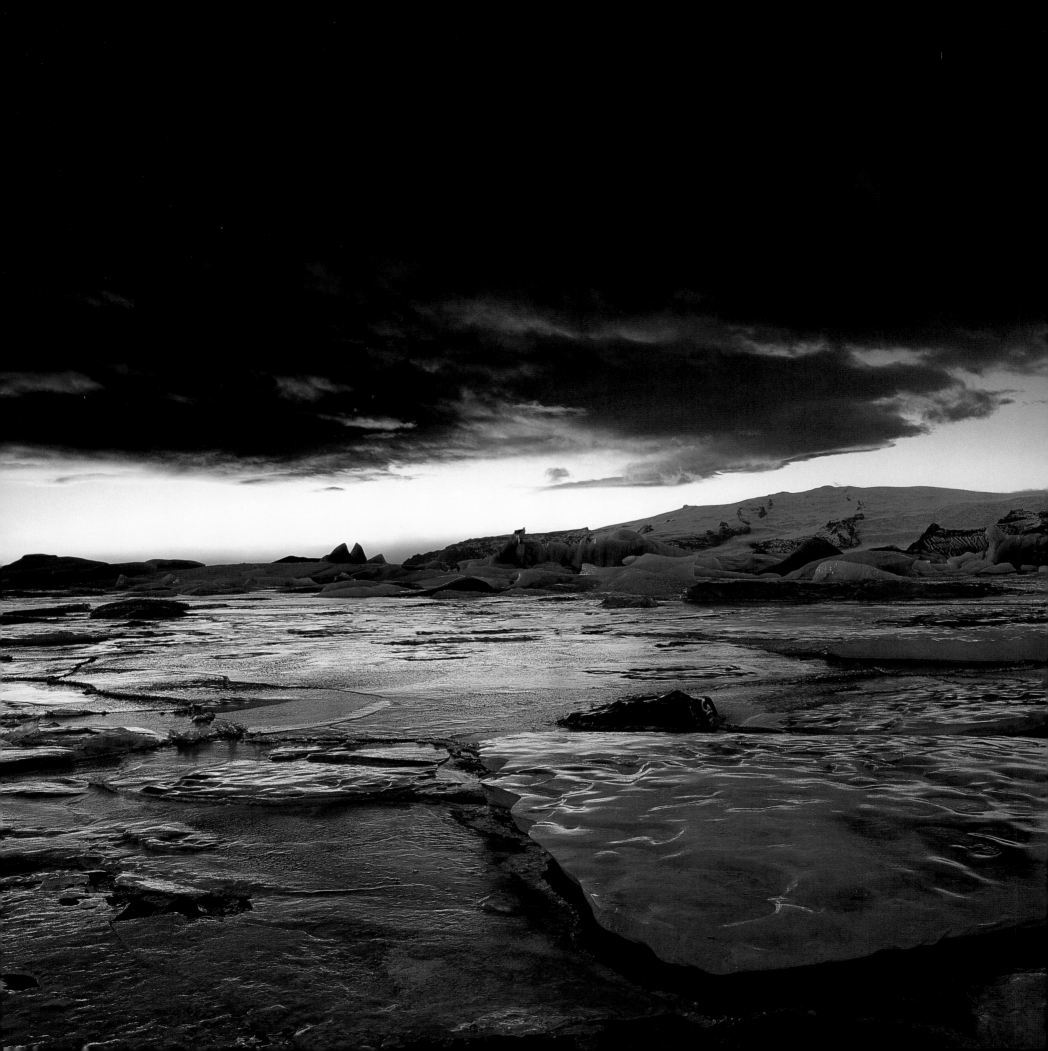

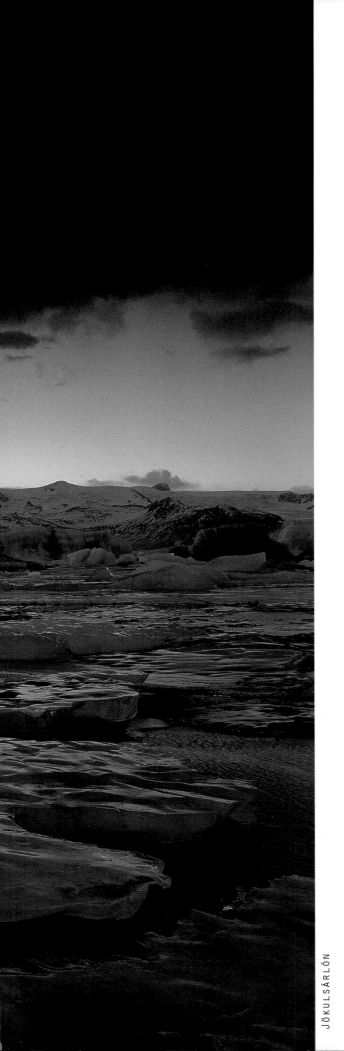

JÖKULSÁRLÓN

OG ÞAR SEM JÖKULINN BER VIÐ LOFT

HÆTTIR LANDIÐ AÐ VERA JARÐNESKT.

And there where the glacier touches the sky, the land ceases to be earthly.

HALLDÓR LAXNESS, from *Kristnihald undir Jökli*

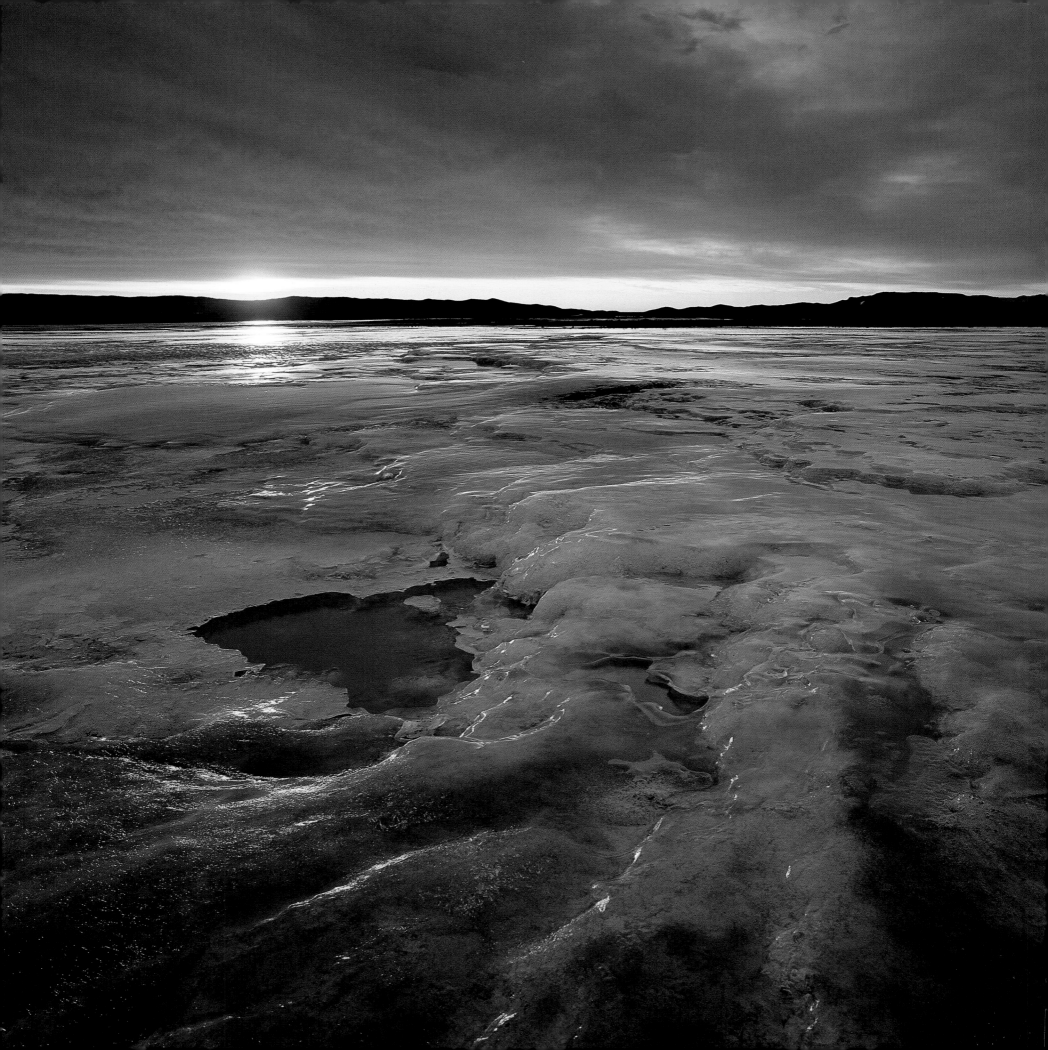

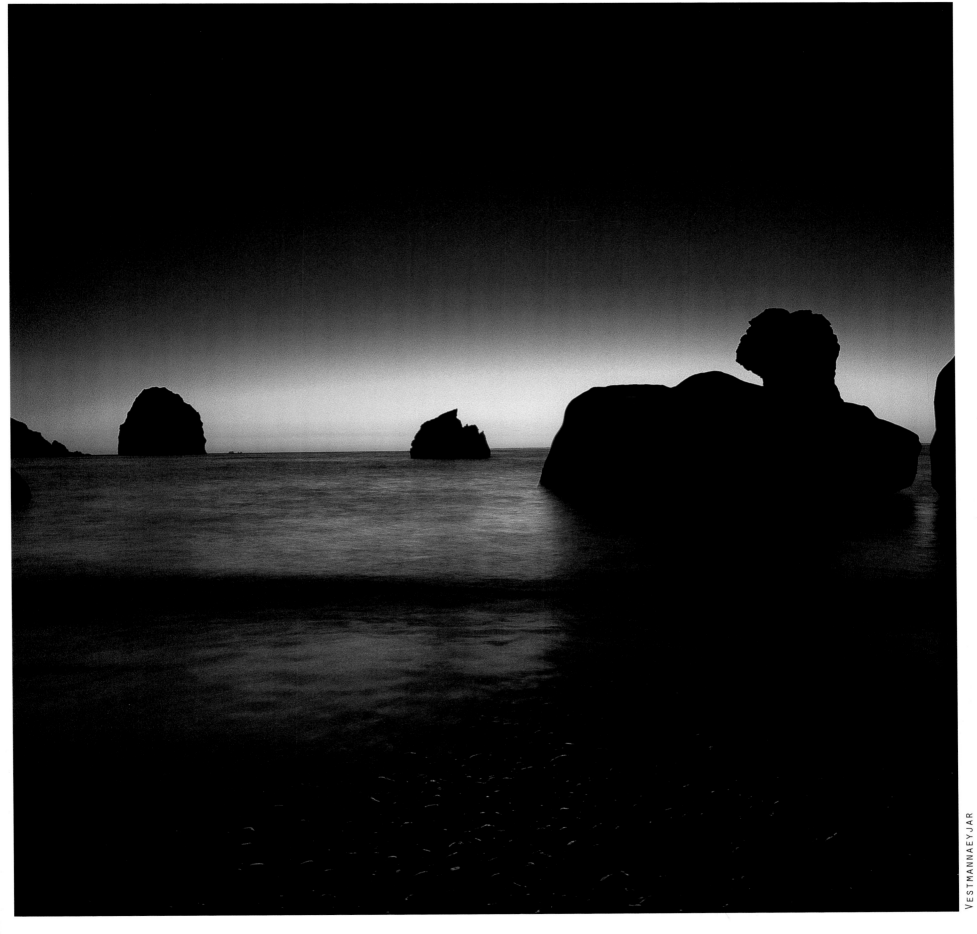

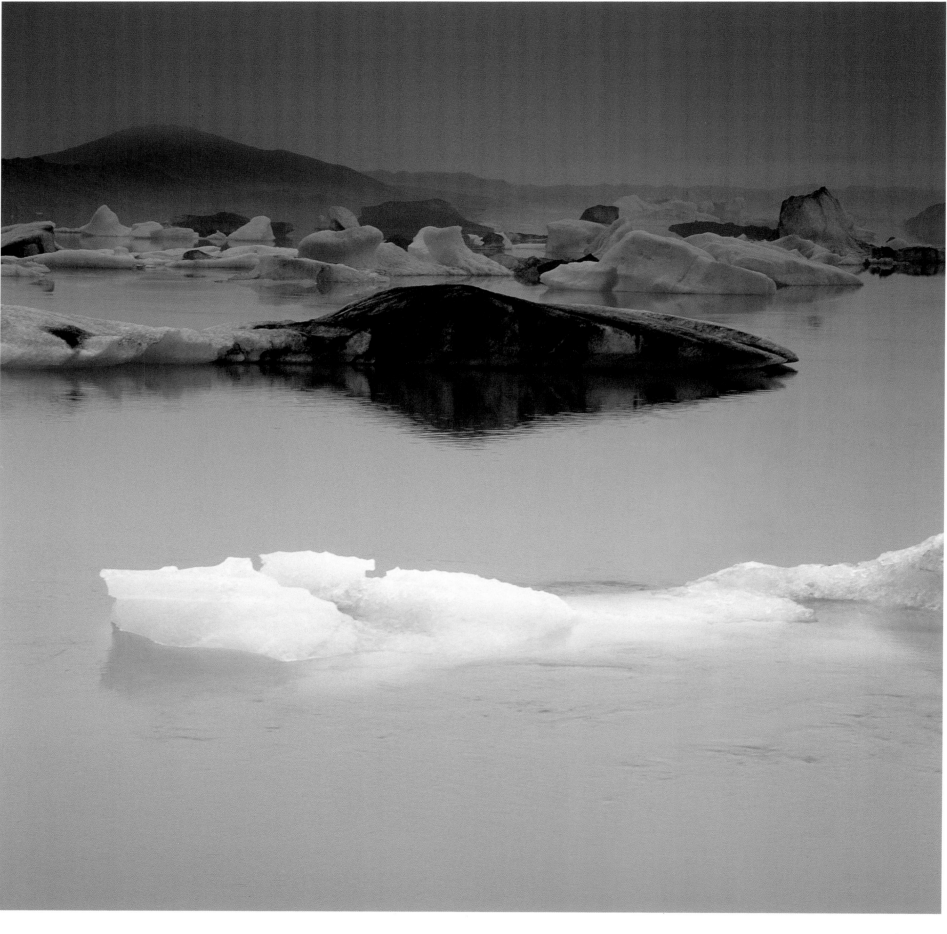

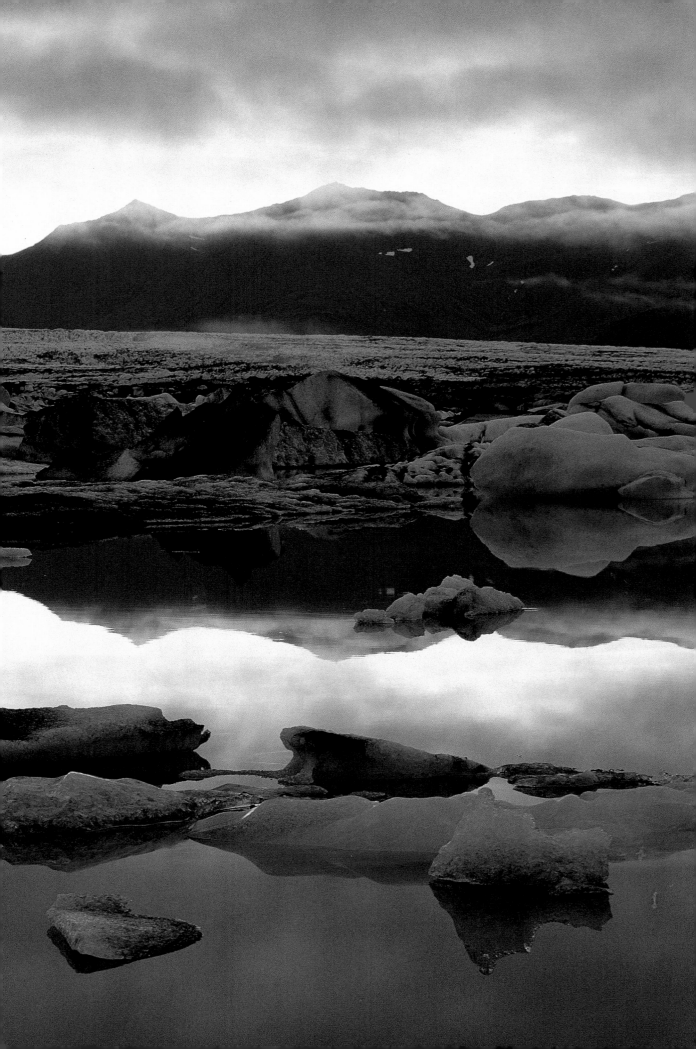

ÉG ER DJÚPIÐ SEM GEYMIR

I am the abyss that protects

ÞÆR DÝRMÆTU PERLUR

The precious pearls

ER ÞIG DREYMDI UM AÐ EIGNAST

You dreamt of having

STEINN STEINAR, from *Akvarell*

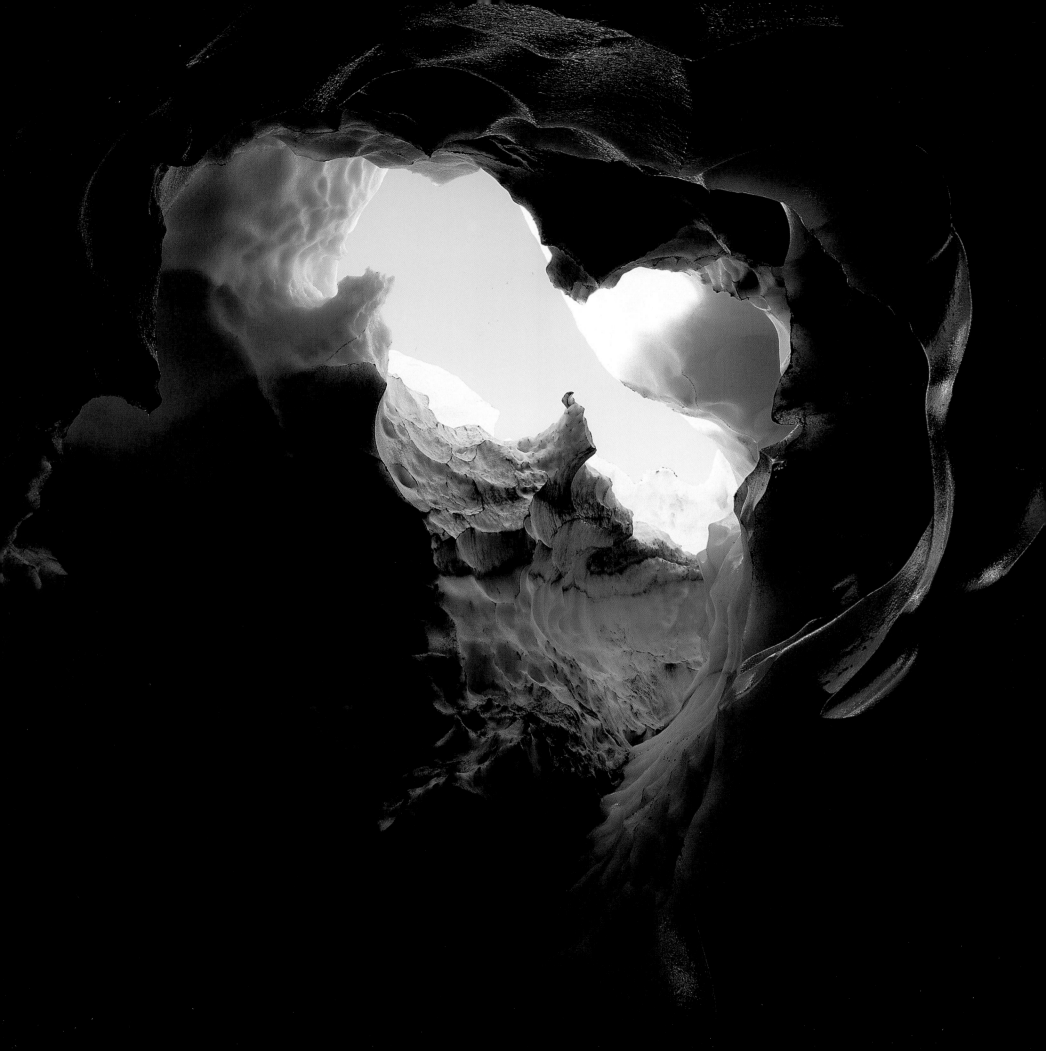

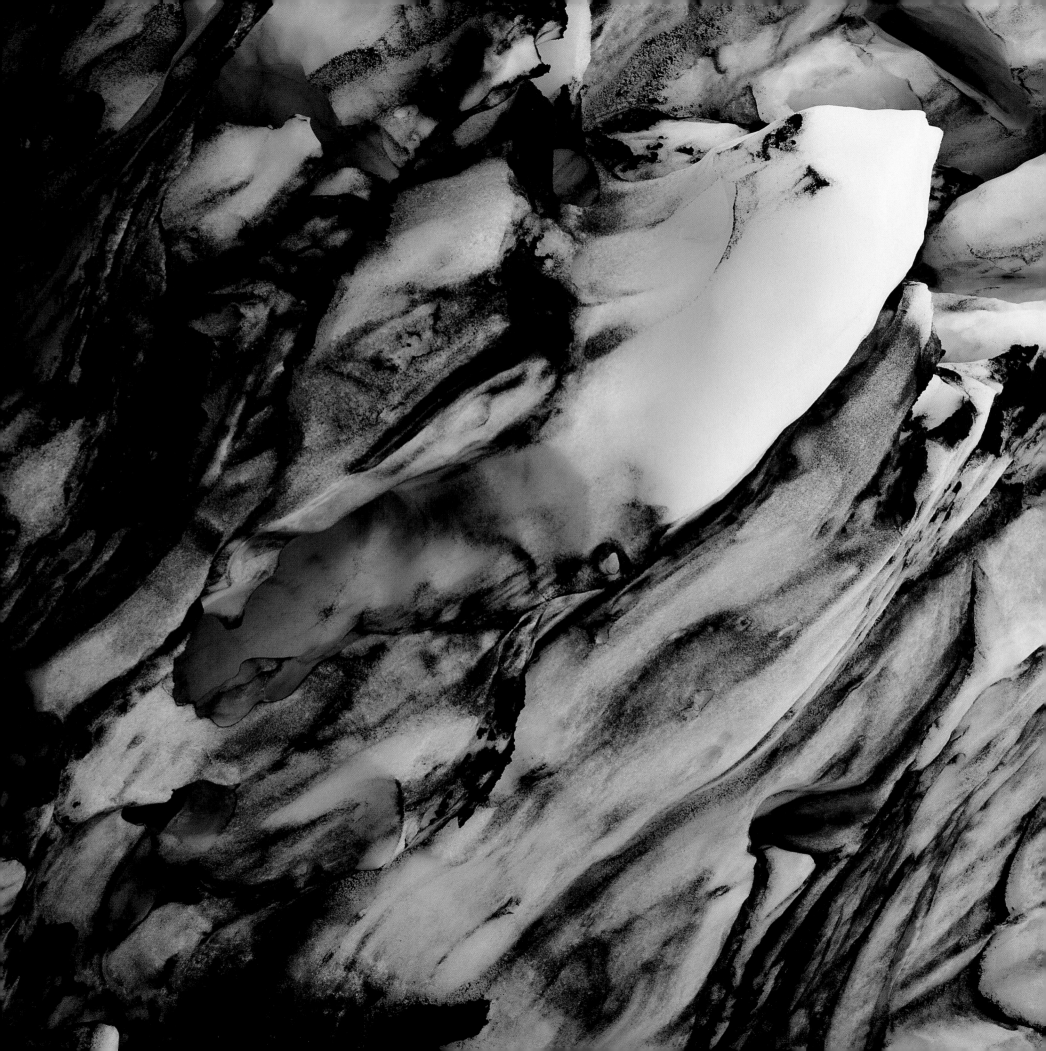

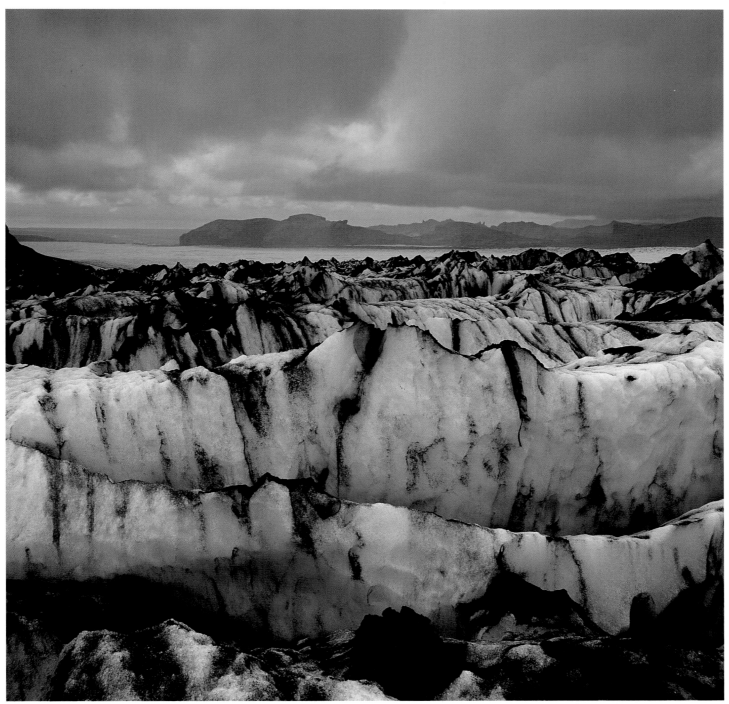

MÝRDALSJÖKULL

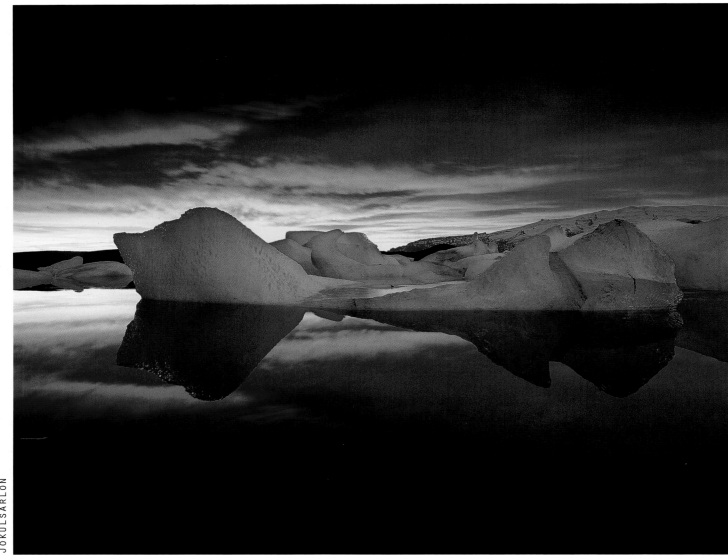

JÖKULSÁRLÓN

THE REGIONS
OF ICELAND

Twenty million years ago the human species was still evolving, but the Atlantic Ocean existed already. The continents that bordered it were a little closer together than they are today, and their coastlines were slightly different, but the ocean between them was vast and deep. At the heart of this immensity, there was nothing but water where Iceland is now.

One day, however, waves heated by innumerable underwater volcanic eruptions began to boil, signaling that a founding event was near. For hundreds of thousands of years, a chain of mountains created by the ceaseless welling up of magma from the earth's core had been rising from the ocean floor, and the summit of one of its highest peaks was about to break through the tormented surface of the waters.

Having observed this same process at work elsewhere, geologists know that the boiling suddenly gave way to violent explosions as a miniscule bit of rock appeared. It was thus that Iceland was born. Growing at the rate of an inch or two per year, the island today measures more than 248 miles from east to west and is still expanding. Its ground is constantly shaken by small earthquakes, and its volcanoes have been responsible for almost half of all the lava poured forth upon the surface of the earth during the past centuries. Still a geologically young and active land, Iceland has another distinctive trait: its geographical setting does not favor the development of a luxuriant plant cover. This has not made the life of the people colonizing the island any easier, but for scientific observers, it has been a marvelous stroke of luck. For them, the landscape can be read as if it were a great, open-air geology text.

The volcanic edifices in Iceland often appear newly created, although they are in fact thousands of years old. If we look closely, the images by Patrick Desgraupes, over and above their considerable beauty, can teach us a great deal about Iceland's past and its evolution. By focusing on a selection of them we will discover the principal facets of Icelandic geology, and we will see how this northern land serves as a link between our planet and the rest of the solar system.

THINGVELLIR

In the 1960s geologists the world over unanimously affirmed that Iceland was a protruding piece of the immense underwater mountain chain known as the Mid-Atlantic Ridge, which divides the Atlantic Ocean down the center. Even more interesting, geological data collected from all parts of the country, revealed a curious fact: the farther away from the center, the older the land. This chronological data brought another unusual fact to light: rock formations equidistant from each side of the central region were the same age. When correlated with measurements taken at the bottom of the Atlantic, these observations provided the foundation of the theory of continental drift, or, as geologists prefer to call it now, tectonic plate theory. In the model of the earth presented by tectonic plate theory, the surface of our planet is divided into vast slabs of rock of various sizes, known as tectonic plates, which are surrounded by areas of fault and fracture. Heat emanating from the center of the earth tends to escape through some of these fractures in the form of magma under pressure, which pushes upward as the plates

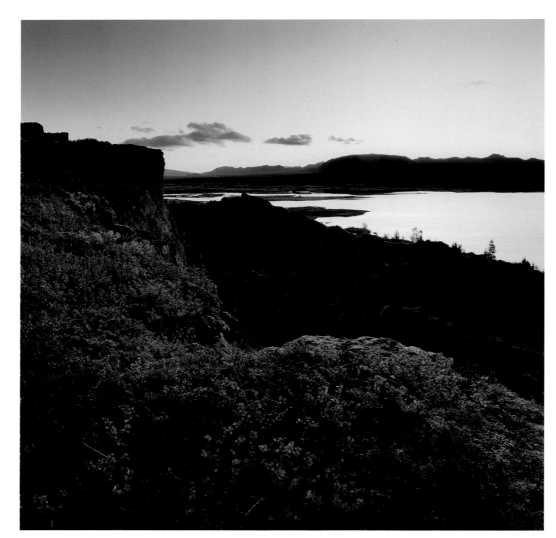

THINGVELLIR (P.140)

half of the country, and from south to north in the northern part. These great alignments of faults can be seen in the landscape.

Thingvellir, not far from the capital city of Reykjavík, is one of the most spectacular regions in all Iceland. Fractures and open pits where the earth has dropped down can be seen, dozens of yards wide and deep, and several miles long. The entire valley that lies at the foot of Thingvellir is striated with open fissures, and it also contains one of the largest lakes in Iceland, the Thingvallavatn. In clear weather, immense rents in the earth can also be seen on the other side of the valley. This entire landscape forms a small portion of what geologists refer to variously as a median valley, rift valley, or median graben—a graben being a block of the earth's crust that has dropped down between two fault systems. Highly fractured and bordered with steep, stepped cliffs, this median graben runs along the top of the entire Mid-Atlantic Ridge, and the majority of the magma extrusions and volcanic eruptions that occur along the ridge take place in it. Geologically, Thingvellir sits on the North American plate, while the other side of the valley—the other side of the median graben, just a few dozen miles to the east—belongs to the Eurasian plate.

The architectonic power of Thingvellir was not lost on the island's first settlers. Beginning in the year 930, they decided that the Althing, the first national parliament of Iceland, would convene there each spring. In the same way, planetologists, those scientists who work in a discipline combining astronomy and geology, immediately understood the

move apart. Since the area of the earth's surface is finite, the shifting plates must either slide under the plates adjoining them or collide with them, forcing upheavals that create mountain ranges such as the Alps or the Himalayas.

The Mid-Atlantic Ridge is one of the major magma-extruding areas on our planet. The plates that border it, bearing North America

and Eurasia in the north and South America and Africa in the south, draw apart by an average of one to one and one-half inches every year. Iceland, the portion of the ridge that emerges above the water surface, undergoes a comparable spreading movement, and the principal fissures that cross it run from the southwest to the northeast in the southern

importance of the region, for it testifies to the dynamics of a planet capable of creating and remodeling its surface through forces generated by its own internal heat. Looking elsewhere for similar formations, planetologists found them on Mars. Only a quarter of the size of Earth, the planet Mars has a long geological history and it presents features that are in many ways similar to those found in Iceland. In 2004, on the northern flank of the Martian volcano Olympus Mons—which is more than 85,000 feet high and the largest volcano in the solar system—the European space probe Mars Express photographed the region of the Acheron Fossae, a gigantic graben flanked by steep, stepped cliffs more than 5,000 feet in height—Thingvellir at ten times the scale! Yet this Martian rift valley seems not to have been formed by the pressure of extruding magma, as is the case with the opening of a ridge. It was more likely produced during the upthrow of Mars's crust that took place when the Olympus Mons was formed. As the pressure on the planet's surface grew stronger than its mechanical resistance, the crust would have developed fissures and partially collapsed. The same phenomenon seems to have opened up the Valles Marineris, an immense system of canyons that runs like a scar for almost 2,500 miles along the Martian equator.

THE SNÆFELLSNES PENINSULA

With an area of 40,000 square miles, Iceland is the largest of the exposed portions of the Mid-Atlantic Ridge. In the island's south, the median graben rises magnificently from the sea, surfacing as the peninsula of Reykjanes, which lies to the southwest of Reykjavík. In the north, it dives back into the abyss, where the mountainous crest bordering the Eurasian face of the rift plunges into the ocean, disappearing beneath the water in the bay of Öxarfjördur. In similar manner, the peninsula of Snæfellsnes, in the west of Iceland, can also be seen disappearing into the deep. The bluish ridge of Snæfellsnes is an important transform fault, that is, one that occurs where two tectonic plates slide laterally against each other, like the famous San Andreas Fault in California.

Snæfellsnes opens perpendicularly toward the median graben. On it lies the Snæfellsjökull volcano, where the protagonists in Jules Verne's *Journey to the Center of the Earth* began their underground adventure. Capped by the Snæfellsjökull glacier, the volcano rises to an altitude of 4,750 feet; although it has

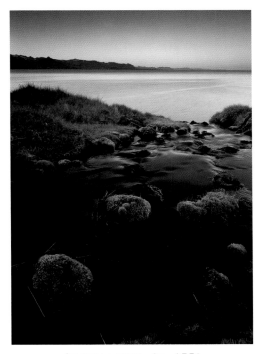

SNÆFELLSNES (P.135)

not erupted for the past two millennia, volcanologists consider it to be potentially active. Interestingly, Snæfellsnes is one of the rare places in Iceland where sedimentary layers and fossils can be found. The island composition is almost 99.9 percent volcanic rock; only 0.1 percent of the land comprises sedimentary deposits capable of preserving plant or animal fossils.

VATNAJÖKULL GLACIER

Once it was understood that Iceland was an exposed portion of the Mid-Atlantic Ridge, it remained to be explained why this particular part of the ridge had risen above the ocean surface, since so much of it lay thousands of feet under water. The answer came at the end of the twentieth century from an analysis of the underlying structure of the island. By measuring the speed at which seismic waves are propagated, scientists were able to discover the existence of a column of magmic upflow directly underneath Iceland. More than sixty-two miles in diameter, this column is approximately 400 degrees Fahrenheit warmer toward its center than at its periphery. It is thought to originate some 435 miles beneath the ocean's surface, far deeper than the usual springs of magma that feed the ridge. The upward force that propelled this section of the Mid-Atlantic Ridge into the open air would thus have been a hotspot, a sort of gigantic natural blowtorch of the type that created the volcanoes of Hawaii and the island of Réunion, east of Madagascar. Remarkably, lying above this hotspot on the surface is the Vatnajökull, the largest glacier in Europe. Here we have one of Iceland's magnificent paradoxes: that the strongest seismic activity and some of the most eruptive volcanoes on the island—

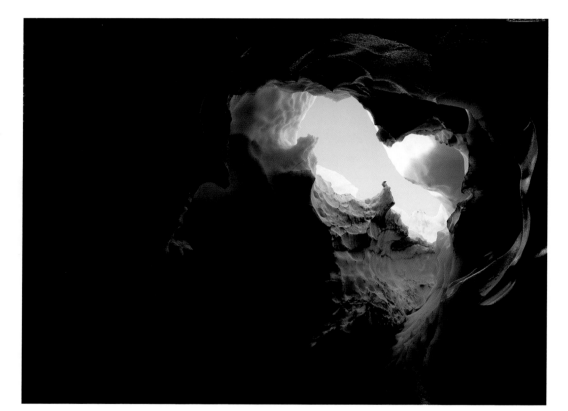

HRAFNTINNUSKER (P.155)

Grimsvötn, Kverkfjöll, and Öræfajökull—lie beneath the great Vatnajökull glacier. Virtually everywhere beneath its vast expanse, even between volcanic eruptions, powerful blasts of steam have hollowed out galleries and caverns in the ice. Touring these caverns is one of the most impressive—and oppressive—experiences that Iceland affords. Nothing is quite stable in these places, and the deep grinding and dry cracking sounds that sometimes drown out the quiet gurgling of the streams often causes visitors to fear the worst, and indeed, these visitors are usually happy indeed to see the light of day once again at the end of their foray through the ice galleries.

MÝRDALSJÖKULL GLACIER

Iceland's ice is dirty. Black streaks mark it everywhere, and the moraines along the glaciers' edges are as black and shiny as coal. Spewed forth by volcanoes and carried by the violent winds from the immense deserts at the center of the country, volcanic ash and dust are trapped year after year between fresh layers of snow that changes slowly into ice. Owing to their sheer number and size, glaciers play an essential role in Icelandic life. They influence the climate, of course, but they also augment the risks that certain volcanoes pose to the population, especially in the south of the country.

This photograph captures the blackened peaks before the moraines of the Mýrdalsjökull glacier, beneath which lurks Katla, one of the most dangerous volcanoes in Iceland. Its eruptions are always accompanied by a violent meltdown of part of the glacier, resulting in the cataclysmic mudslides known as lahars—*jökulhlaup* in Icelandic. Dragging along rocks and blocks of ice weighing dozens of tons, these colossally powerful mudslides hurtle toward the Atlantic Ocean, destroying everything in their path. The *jökulhlaup* resulting from the eruption of Katla in 1918 had a mass flow rate rivaling that of the Amazon River—some 203,000 cubic yards per second! Several small fishing ports are nestled along the coast to the south of the Mýrdalsjökull, and so Katla is closely monitored; and even the smallest shift in its mood is signaled.

Hidden away beneath the Vatnajökull, the Grimsvötn volcano is even more active than Katla, having erupted some thirty times since the arrival of the first colonists in the ninth century. During a period of its activity in 1996, it melted the largest glacier in Iceland to a depth of thousands of feet along an impressive erupting fissure. Though initially restrained by a natural barrier of rocks and ice, the melted water ended up finding a passageway to the south, and the pressure it exerted was powerful enough to raise the glacier itself in several areas. Ripping off the front of the Skeidarárjökull glacier, which extends to the Vatnajökull to the south, and sweeping along its moraines, the *jökulhlaup* hurtled across the Skeidarársandur plains at a flow rate of more than 54,000 cubic yards per second for several hours—the equivalent of the Congo River, or

regions on our planet. All of this activity is concentrated directly on the median graben or in its immediate proximity, where the earth's crust is the thinnest and where the force of the magma beneath most often opens fissures that extend to the surface. Hekla occupies a choice spot among Iceland's most active volcanoes. More than forty-six miles to the east of Thingvellir, it sits on the Eurasian side of the median graben. Hekla is a strato volcano, a type not particularly well represented in Iceland, where its principal examplars are Snæfellsjökull and a series of volcanic edifices buried beneath the ice of the Vatnajökull: Dyngjufjöll, Öræfajökoll, and Eyjafjallajökull. Active for several millennia—its oldest known lava flows date from 6,600 years ago—Hekla awakes periodically, alternating between two types of eruptions. Some are purely explosive, with a projection of ash but no lava flow. In others, the initial explosion is followed by massive lava flows such as the one visible here. In spite of this regular activity, Hekla does not have a particularly high elevation,

peaking at 4,900 feet. The explanation is that its outflows of magma don't always follow the same passageways. Rather, new fissures open up with almost every eruption, which does not favor vertical buildup. The explosive phase of Hekla's events is dangerous largely because of the nature of the materials it disgorges into the atmosphere. On the evening of May 5, 1970, after twenty-three years of calm, Hekla began to erupt, sending a mixture of steam and rock fragments more than 24,000 feet into the air. Borne to the northeast by winds, the cinders reached the northern coast of the island at midnight, resulting in the death of thousands of sheep, who ate the cinders while they were grazing and were poisoned by the fluorine they contained. Hekla awoke without serious consequences in 1980–1981, 1991, and 2000, and it is thus one of the most closely monitored volcanoes in the country, all the more so in that it rises near some of Iceland's most densely populated regions.

Ljótipollur Crater

Along the trail from Hekla to the massif of Landmannalaugar, shortly before arriving in that region of sumptuously colored mountains, a path splits off that leads to an impressive natural formation: the explosive crater, or *maar*, of Ljótipollur. Ljótipollur is one of a chain of craters that extend northward for about thirty miles along the axis of the median graben. Measuring one mile in length by more than 300 feet deep, its oval-shaped cup contains a beautiful lake. Ljótipollur was born from a long-ago encounter of a column of magma with a layer of ground water. When such a meeting takes place, the magma turns

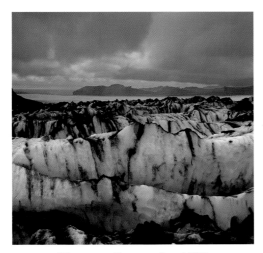

MÝRDALSJÖKULL (P.157)

more than twenty times the Rhone. After the worst was over, immense blocks of ice more than thirty feet tall were strewn across the coastal plain, giving the barren expanse a completely surreal air.

In the images sent back from the Martian probe, a great many traces of such devastating flows can still be seen despite years of wind erosion. Up until a fairly recent time—a few million or several tens of millions of years—magmatic activity seems to have provoked violent melting of the frozen water that had been locked in the Martian soil for billions of years. A number of the flow traces discovered on Mars were created by these means rather than by the slow and prolonged action of a normal river, though there are several considerable river systems as well dating from the early ages of the planet, a time when its atmosphere was denser and warmer than it is today.

Hekla Volcano

Averaging a major eruption every five years, Iceland is one of the most active volcanic

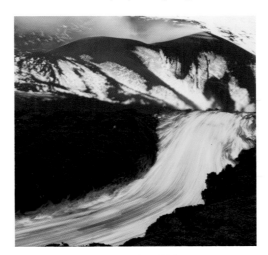

HEKLA (P.64)

LJÓTIPOLLUR (P.68)

the water to steam, and the resulting pressure in the layer gradually builds until the rock walls encasing it can no longer withstand the pressure's force. One or more cataclysmic explosions follow, blasting out everything in their path and propelling clouds of steam and rock fragments both horizontally and vertically at speeds of hundreds of yards per second and up to several miles in altitude. The lip of the Ljótipollur crater bears witness to this violence: the gray strata of ancient lava flows are buckled and twisted toward the top, and fragments that break off slide and roll down steep slopes covered with deep red cinder. A few yellow mosses cling precariously to the surface.

No crater of Ljótipollur's type has yet been identified for certain on Mars, but planetologists would not be surprised to find one there. The composition of the Martian subsoil, a mixture of rock and frozen water, would have lent itself to the very sort of explosive encounter that formed Ljótipollur during the era when magma still rose to the planet's surface. This type of crater is generally rather

small, however, and searching for one through the hundreds of thousands of high-resolution images gathered by the probes is a truly monastic task. Since the Martian surface has now cooled to the great depth of more than 200 miles, it would be unlikely that the magma beneath the crust could exert enough pressure to break through it. Scientists therefore think it unlikely that new volcanic events can occur on the planet.

Landmannalaugar

Dark, angular basalts can be seen everywhere in the Icelandic landscape. In fact, over ninety percent of the volcanic rock on the island is basalt of one kind or another. The most ancient basaltic flows, those that go back to the origin of Iceland some twenty million years ago, formed massive accumulations estimated to be more than six miles thick. Water and ice have patiently gnawed and scraped away at them, sculpting the vast plateaus that can be admired all over the country, notably in the east and west, where they are incised with fjords whose walls are often dizzyingly steep. The most recent basaltic flows, those which survive in human memory since the colonization of Iceland, are barely eroded and wear only a downy coat of dense, thick moss, all the greener for being moist. But there are other volcanic rocks in Iceland, notably rhyolites, an acidic rock that embellishes the country's austere and immense expanses with little massifs in delicate pastel shades. Some of the most beautiful of these rhyolite formations are found in the interior region of Landmannalaugar, where they seem to form a peaceful haven of soft and voluptuous forms surrounded by aggressive basalt citadels.

Formed during eruptions that occurred beneath the Torfajökull glacier at a time when it was much vaster than it is today, the hills of Landmannalaugar are among the marvels of Iceland. Hollowed out by water and wreathed in sulfurous fumes from the overheated earth below, they are streaked with color from materials that have disintegrated and oxidized. At the heart of the massif, a small flow of obsidian sometimes sparkles in the sun, a jet black streak lost in the center of this autumnal universe. With a sheen like crows' wings, the obsidians found here are perfectly pure, but their sharp, broken edges can cut like glass. The whole of the Landmannalaugar region is crossed by rivers fed by the melting of mini-glaciers that persist on some of the summits and in some of the deep gorges. White plumes of steam visible everywhere testify to intense geothermal activity, and care must be taken with the rivers: seemingly harmless, some of them are heated to more than 120 degrees Fahrenheit. Judging by the colors and the odor of hydrogen sulfide—like rotten eggs!—which regularly invades the atmosphere, we could easily be on Io, one of the principal moons of Jupiter. But the surface of that far-off celestial body is characterized by volcanic activity so incessant and sulfur fumes so dense that Landmannalaugar is a paradise on earth in comparison.

Eldgjá and Lakagígar

To the east of Landmannalaugar lies a region that still bears traces of two extraordinary eruptions: that of the Eldgjá fissure system, which happened over a thousand years ago, and that of a row of craters nearby, Lakagígar, in 1783. Measuring almost twenty-five miles in

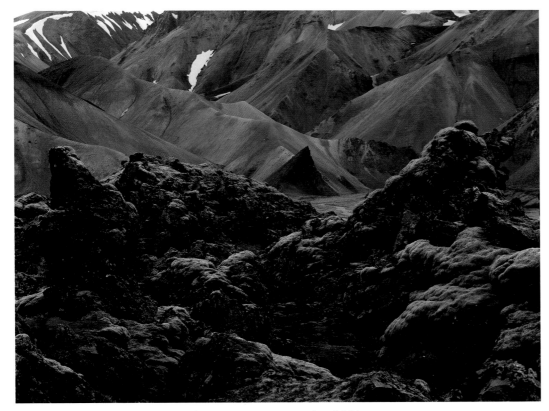

LANDMANNALAUGAR (P.118)

during the years that followed it, played a significant role in setting off the French Revolution. In Iceland, almost a quarter of the population died between 1783 and 1786, mostly owing to the famine. The livestock was also devastated, with 200,000 sheep, 11,000 head of cattle, and 28,000 horses killed by clouds of poisonous fluorine gas.

KRAFLA VOLCANO AND THE FIELD OF THEISTAREYKIR

Although not as devastating as the Lakagígar catastrophe, the multiple eruptions of the Krafla volcano between 1975 and 1984 undoubtedly gave observers a good idea of what the fires of that event must have been like two centuries earlier. Krafla is in the north of Iceland, at the heart of the north-south segment of the median graben. Like Lakagígar, Krafla is not a single volcanic mountain with a central cone through which lava wells up, but is rather a line of many fissures that have opened up one after the other and along which strings of cones have developed. The entire region some fifty miles to the north and south of Krafla has been affected by this

length, up to 1,640 feet wide, and 460 feet deep, Eldgjá is the largest volcanic fissure on the planet. It begins beneath the Mýrdalsjökull glacier and extends to the northeast toward the foothills of the Vatnajökull glacier.

However great the eruption of Eldgjá was a thousand years ago, the lava poured forth during that event was almost entirely covered by the new flow of lava produced during the eighteenth-century eruption of Lakagígar. The fissure system of Lakagígar looks like a prolongation of Eldgjá shifted a couple of miles to the east. More than fifteen miles in length, it centered on the volcano Laki, seen in this image. Nearly one hundred craters of all sizes, from a

few yards to a few hundred yards in diameter, have been counted in Lakagígar's crater row. Their fires have spewed almost three cubic miles of lava over an area of 226 square miles, more than fives times the surface area of Paris. It has been estimated that during the first days of the eruption in 1783 the mass flow rate exceeded 6,700 cubic yards per second, twice that of the Rhine river at its mouth. The volume of gasses and ash propelled into the upper atmosphere was enormous, and the resulting climatic effects were felt in Europe, Africa, and all the way to Asia. Historians have suggested that this cataclysmic eruption, which caused poor harvests and famines throughout Europe

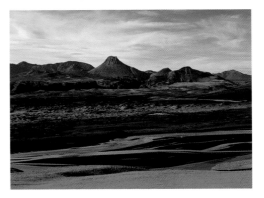

LAKI (P.42)

recent seismic episode, which began at the end of December in 1975 and is in all likelihood still not over. Geothermic activity, already strong before 1975, is currently intense, and there are numerous fields of fumaroles and solfataras. The field of Theistareykir, illustrated here, is located to the north of Krafla. In the distance, toward the south, plumes of steam can be seen rising from the Krafla Power Plant, which uses geothermal energy to generate electricity. Constructed between 1975 and 1978, it harnesses the heat that rises through a system of deep wells drilled into the earth throughout the region. In September of 1977 one of these wells, which was more than 3,700 feet deep, provided a convenient channel for an upsurge of magma to reach the surface. Fortunately, the volume of this particular upflow was not particularly great!

The entire Krafla region is a life-size illustration of the theory of plate tectonics and the expansion of the ocean floor. A ridge is not thrown up continuously, as though it were on a conveyor belt moving along an inch or two per year. Instead, tensions build up for months, years, and even centuries. Then they release their power in one or more seismic episodes, shifting the plates by a few yards. Between 1975 and 1990, the faults in the region of Krafla opened more than twenty-six feet in an east-west direction, which is to say, perpendicularly to the axis of the median graben. Since the last major seismic activity in the region had occurred between 1724 and 1729, we can estimate that these twenty-six feet correspond to a portion of the tensions

accumulated over almost two and a half centuries along this segment of the rift valley.

A good way of following the evolution of tensions accumulating underground is to measure swelling at certain characteristic points. Since 1975, the height of Krafla has been continuously monitored as a way of estimating the mounting pressure in the vast chamber of magma below. The measurements revealed that immediately following the 1975 eruption, the volcano sank by more than six and one-half feet, confirming the drop in pressure that resulted from the emptying of a part of the magmatic chamber below. Since 1976, despite a series of eruptions, as well as seismic movements that did not result in eruptions but rather diffused magma through various underground fissures, Katla has steadily increased in height. It is currently more than three feet taller that it was at the end of December, 1975, just before the first eruption of that time, which leads geologists

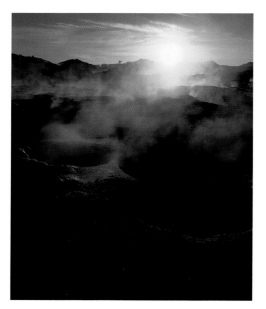

THEISTAREYKIR (P.147)

to think that another eruptive episode may be brewing. Yet, though its eruptions are spectacular and could possibly imperil nearby geothermal industries, Katla is not considered to be a dangerous volcano, for it does not emit gasses or anything else that is toxic to humans and animals, nor will it trigger a *jökulhlaup*, one of the giant mudslides that have caused so much destruction in Iceland's history.

When the fissures begin to erupt, the pressure is so great that fountains of magma shoot dozens of yards into the air. Some of the fissures that opened up during the September 1984 eruption are five to six miles long. One can only imagine the splendor of the incandescent curtains formed by fountains of fiery magma shooting skyward all along these terrestrial scars. Indeed, the jets of magma were so numerous that they turned the sky red, and their light could be seen from as far away as Reykjavík, almost 200 miles away. For planetologists, a similarly extraordinary event was an eruption that they observed on Io, the first moon of Jupiter, in November of 1999. The American space probe Galileo flew over Io several times, during which the moon displayed numerous active volcanoes, among them one which boasted a magnificent fissural eruption more than eighteen miles long. Between Galileo's flight over Io of November 26, 1999, and that of February 22, 2000, this fissure had ceased its activity, but another—more than thirty-one miles across—had opened nearby and was shooting magma and gasses thousands of feet into space. Since Io is much less massive than the earth, its gravity is correspondingly weaker; as a result, erupting

magma and gasses can be projected much farther. During its flights over Io, Galileo photographed a plume of gas that reached almost 186 miles in height before falling back to the surface like a gigantic, evanescent umbrella.

NÁMASKARD AND THEISTAREYKIR

If we look at a map of geothermal activity in Iceland, we see immediately that points representing hot water springs are scattered across the entire country. Some regions are more densely supplied with them than others, but there is hot water almost everywhere. In contrast, zones where water, water steam, or gasses are found at extremely high temperatures are located exclusively along the median graben. In the northern half of the country, they are perfectly aligned south-north, between the volcanoes Kverkfjöll and Krafla, and they indicate a magmatic presence near the surface. Geothermic activity can be seen in hot springs, fumaroles, solfataras, boiling mudpots, and, more rarely, geysers. Some of the most beautiful fields of fumaroles and solfataras are distributed around Krafla, notably at Námaskard and at Theistareykir, which appear in these photographs. Gasses such as methane, carbon dioxide, ammonia, and hydrogen sulfide mingle with steam to send forth distinctive odors, and not always agreeable ones, to the solfataran fields. When hydrochloric or sulfuric acid are present, they accelerate the natural erosion of the rock in the area, and transform it into clay. Thus the rock ultimately dissolves in the rainwater that percolates into the soil, forming potholes or mudpots. Depending on the quantity of water and the temperature of

NÁMASKARD (P. 54)

the vapors that pass through it, these cavities may contain mud that is more or less viscous and boiling. While caution dictates viewing them from a reasonable distance, since the weakened earth can give way at any moment beneath one's feet, the spectacle, and especially the sounds, produced by these formations are a delight, calling to mind pots full of thick, bubbling jam or childhood memories of splashing about in the mud.

Before the earth has changed enough to produce mudpots, solfataras form magnificent deposits of yellow sulfur, which is all the brighter for being hot. Here, conditions approach those of the surface of Jupiter's first moon, Io. More or less the same size as the earth's moon, Io is prey to angry volcanic activity induced by the tidal forces of its ruling planet, Jupiter, and of Europa, Jupiter's second moon. For reasons yet to be discov-

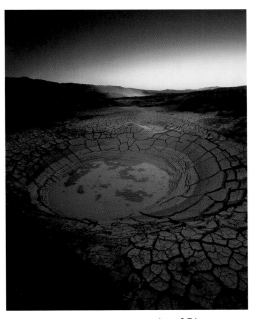

THEISTAREYKIR (P. 67)

ered, the lava thrown up by Io's volcanoes is extremely rich in sulfur. Depending on their temperature, these lava deposits display colors ranging from white through yellow, orange, red, and on to deep brown. Eruptions on Io are so numerous and regular that its entire surface is colored by these sulfurous deposits, which have prompted astronomers to nickname Io "the pizza."

HVERAVELLIR

Bláhver is a basin filled with water at 190 degrees Fahrenheit and crowned with whitish, siliceous deposits called geyserite. The water's distinctive color (*bláhver* means "blue spring") comes from the microscopic particles of silica it holds in suspension, which diffract entering light. Slightly more than twenty-six feet in diameter, Bláhver is the largest blue basin in Iceland, and it adds a welcome patch of color

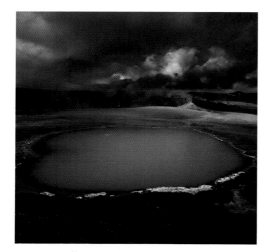

HVERAVELLIR (P. 78)

to the barren and glacial site of Hveravellir. Wedged between the glaciers of Langjökull and Hofsjökull, on the western edge of the median graben, Hveravellir has a high concentration of extremely hot thermal springs. Thirty or so basins ringed with geyserite, together with fumaroles, solfataras spangled with sulfur, and a small river of very hot water share the region with Bláhver. Farther to the south, in the valley of Haukadalur, other boiling basins—including one shaped like an almond and colored a spectacular ultramarine blue—surround the famous geysers Strokkur and Stóri-Geysir on the site of Geysir itself, which gave its name to the phenomenon of hot springs that intermittently send up columns of water and steam.

The existence of geysers is intimately connected to an area's seismic activity. In order for geysers to form and to continue erupting, there must be fissures in the area that allow rainwater or runoff water to come into contact with very hot vapors. A high rate of activity, however, eventually brings about a geyser's extinction: The more active it is, the more

mineral-rich water it sends shooting toward the sky. The more water shooting toward the sky, the more water falls back to earth, where the minerals it leaves behind as it cools and evaporates eventually build up a deposit large enough to block the geyser's opening, preventing any further eruption. A study of the silica deposits around Stóri-Geysir, which can send its plume of water more than 260 feet into the air, shows that its first eruptions date from more than 7,000 years ago. Stóri-Geysir must have experienced long periods of dormancy, however, for only from the thirteenth century on do we find it mentioned in the chronicles. Blocked several times, and revived several times by earthquakes, this imposing geyser is currently dozing. The same cannot be said for its neighbor Strokkur, which erupts almost every five minutes, shooting its plume of water between sixty-five and one hundred feet into the air. But Strokkur could not have accomplished this without some human help. Toward the beginning of the 1960s, its conduit was bored to a depth of more than 130 feet.

There are other geysers on earth, some more impressive and more spectacular than those of Geysir, but none can rival the phenomena viewed in 1989 on Triton, one of the natural satellites of Neptune. Triton is smaller than the earth's moon—1,677 miles in diameter as opposed to 2,155 miles—and it orbits around a planet situated some 2.8 billion miles from the sun. We might well imagine, then, that it must be perpetually cold and dark, no matter what its geological composition. Yet information relayed back by the American space probe Voyager 2 in August 1989 proved

once again that the natural world encompasses greater variety than most of us think. In the case of Triton, the gigantic gravitational force exerted by Neptune—a planet seventeen times more massive than the earth—is so enormous that Triton is affected by a titanic tidal draw. This immense and constant pull agitates Triton's core, heating it; the energy thus liberated presses against Triton's fabric and forces its way up to the surface—a thick layer of nitrogen and methane frozen to –393 degrees Fahrenheit. Planetologists hypothesize that conditions on Triton may produce cryovolcanism, a state in which frozen nitrogen, warmed to –148 degrees Fahrenheit in the planet's interior, wells up and is extruded through fissures in the frozen crust. This is exactly the same process that occurs in Iceland, except that in Iceland's case what is pressed upward to the surface is magma.

Another unusual feature of Triton's frozen environment seems to be the formation of gas and dust plumes. Measuring several hundred yards in diameter at the base, they rise in Triton's thin nitrogen atmosphere to a height of around five miles before stretching out for more than sixty miles in the direction of the prevailing wind. On the images sent back by

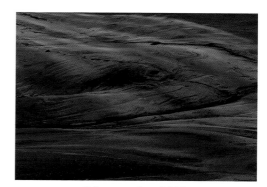

MÝVATN (P. 120)

Voyager 2, researchers counted four of these columns of nitrogen vapor mixed with ice crystals and dark carbon compounds, but numerous elongated traces on the Triton crust suggest deposits left by other such columns. These may be a form of geyser produced by pockets of nitrogen that have been heated up beneath the frozen crust. It is thought that when the pressure reaches a level high enough to break through the ice, a plume of gas and dust is shot up to a very high altitude, since the gravity of Triton is very weak. No probe is presently scheduled to revisit Neptune, and Triton is too small for its surface to be observed by telescope from earth, so the mysteries of its geysers and its cryovolcanism will probably not be solved for some decades to come. We can, however, compare these observations with the discoveries made on Titan, the largest moon of Saturn, by the European probe Huygens in January 2005. An analysis of the measurements taken by instruments on the probe is thought to prove the existence of cryovolcanism in the region where the probe landed. On Titan, the phenomenon may be produced not by frozen nitrogen, as on Triton, but by frozen ammonia and, as in the glaciers of Iceland, frozen water.

Mývatn Lake

When the first settlers arrived in Iceland a little more than a thousand years ago, forest covered nearly one quarter of the island. Today, less than one percent of the island is forested. Felled for construction and for heat, the trees also suffered from the voracious appetites of grazing sheep, which played a significant role in the desertification of much of the land.

Aware of this problem, Icelanders several years ago began the slow work of reforestation and of stabilizing barren regions. Long swaths of sparsely planted growth have thus become a fairly common sight in desert areas. The photograph here illustrates tests undertaken near the lake of Mývatn, in the north of the country. Seeds of *elymus arenarius,* a type of wild rye, are sown by airplane. Able to survive in extremely poor soil, this grain formed part of the diet of the first inhabitants of Iceland. Once the *elymus* has established itself and its roots have checked the erosion of the soil, it becomes possible to sow fodder plants, whose decaying will gradually build up a layer of humus rich enough to sustain still other plants that will continue the process. Elsewhere, in those regions that are well sheltered from the wind, and where the principal reason for soil

erosion is grazing, the Icelandic government is now overseeing the planting of tens of millions of young trees—mostly pine, larch, aspen, and birch. A fifty-year program of such plantings is planned, which should permit a part of the Icelandic forest to be reestablished.

Svartifoss and Barnafoss

If there is one element that all Iceland has in common, it would surely be water—water not only in the form of glaciers, but also of lakes, streams, rivers, and waterfalls. With an annual rainfall that can reach more than 160 inches in the southeast of the island, water often leaves its mark on the landscape. Taking advantage of extinct volcanic fissures, it gouges out canyons that seem to have been carried here from the imagination of Dante. Running off ancient basaltic plateaus, water also takes to the air in

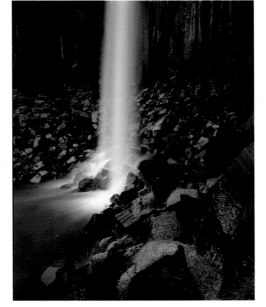

SVARTIFOSS (P.134)

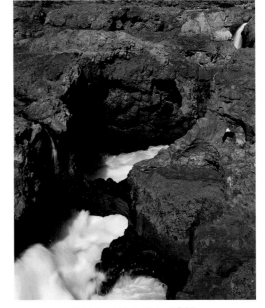

BARNAFOSS (P.102)

the form of sumptuous waterfalls that plummet in one breathtaking leap or cascade down flights of ledges. Fusing with the fronts of glaciers, it spreads out in braided webs. Sweeping the sands, cleaning the rocks, it everywhere sets off the geometric forms created by lava flows: great basalt organs as in Svartifoss, in the national park of Skaftafell, south of the Vatnajökull; potholes dug into strings of craters as at Barnafoss, in the desert of Kaldidalur, to the southwest of the glacier Langjökull; a lava arch, now collapsed, at Ófærufoss, in the Eldgjá fault. Recurrent in Iceland, prismatic formations arise primarily in basalt flows, but other kinds of volcanic rock can also produce them, such as phonolite or ignimbrite. The hexagonal prisms always rise perpendicularly to the cooling surface, and the slower the cooling, the more beautiful and regular they are.

THE PENINSULA OF SNÆFELLSNES

As if echoing human efforts to reintroduce diverse and abundant plant life to Iceland, nature proves that, given a chance, she will

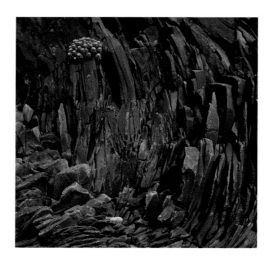

SNÆFELLSNES (P. 113)

cling to the least bit of humus and attempt to establish her claim. On the peninsula of Snæfellsnes, an imposing pier facing thousands of miles of ocean, ancient basalt flows battered by waves and broken by winter freezing from what would seem to be an extremely hostile environment. And yet a few specs of dust blown into the crevices were all the encouragement plants needed to begin colonizing the region. Human history is not so different on this island out of Genesis, suspended from the Arctic Circle and regularly shaken by the spasms of a too-thin terrestrial crust. People are not numerous; they have settled where conditions were the least unfavorable, and they take advantage of what the country has to offer, all the while knowing that nature could brutally set about remodeling the landscape at any moment, putting their very lives in danger.

JÖKULSÁRLÓN

Icelanders do not have a confidence in the future nourished by an immemorial past, as continental populations can have. However dimly, they know they are perpetually on some sort of probation in this fragile and brutal environment. This may perhaps explain their unconventional way of looking at certain natural phenomena. For example, when a luminous curtain sets the sky aglow—as here over the glacial tongue of Breidamerkurjökull, which branches off from the tongue of Jökulsárlón—men, women, and children pretend to think of it as a magical event, a spray of light sent skyward by the elves that inhabit every nook and cranny of the island. Or perhaps the Icelanders are not entirely pretending. And why need

they? Why not imagine that, if elves exist, these marvelous beings would toy with the currents of matter that bathe our planet. For in fact these luminescent apparitions really do reflect forces that transcend us, that surpass our senses, and that act on the scale of the sun and the planets, even on the scale of the solar system. These strange glimmerings appear when the sun has sunk low enough beneath the horizon for the vault of heaven to unveil its loveliest stars. At first, there is nothing, nothing but the night blue of the sky and the diamond flashings of the constellations. Quietly, a faint new nodule of light is born and draws our gaze, often over the northwest horizon. Little by little, this nodule sends out pale tentacles and grows brighter, taking on greenish tints barely perceptible to the naked eye, but which photography reveals magnificently. And then, suddenly, the spectacle begins. Waves of light invade the sky, undulating like a great curtain teased by the wind. The edging of this phosphorescent veil is crisscrossed by streaks and serpentine ribbons, which quiver like the surface of a lake skimmed by the breeze. The green hues intensify, sometimes pierced by rays of red and violet. The aurora borealis reaches its height, and whether it lasts a few minutes or the entire night depends on the strength of the solar storm that engendered it.

If observing a polar aurora—we speak of aurora borealis in the northern hemisphere and aurora australis in the southern hemisphere, but they are the same phenomenon—is a treat for the eyes, it is also the sole way of seeing materialize the fantastic currents of

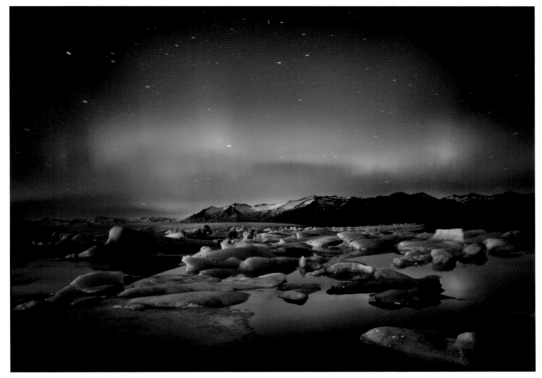

JÖKULSÁRLÓN (P.84)

matter that bathe our planet. Our limited senses cannot perceive the movements of infinitely small particles or the deformation of the lines of force of the earth's magnetic field. Throughout the year, the earth is subjected to a veritable deluge from the sun, which does not content itself with lavishing light and energy upon us, but also sends a myriad of electrons and ionized atoms of hydrogen and helium shooting into space. These create what scientists call the solar wind, a wind made of particles that radiate from the sun at speeds of 250 miles per second.

Luckily for life on earth, which would not survive such a bombardment for long, the rotation of our planet on its axis generates a strong magnetic field that deflects the solar wind just as a reef parts a flow of water. Sometimes, however, this interplanetary wind is so violent that the lines of force of the earth's magnetic field are crushed on the side facing the sun, and some of them open onto space. They allow solar particles to pierce the atmosphere and hurl themselves greedily on the magnetic poles to the north and south. Speeding up to tens of thousands of miles per second during their trajectory across earth's magnetosphere, these particles collide with atoms and molecules in their paths. At more than 600 miles in altitude, the atmosphere of our planet is principally made up of neutral gasses and atoms of oxygen, which are excited by the energy they pick up during these collisions. After a short lapse of time, they release

this energy by emitting a feeble glow. Multiplied millions of times, these infinitely small emissions finally result in the dazzling lights of the auroras. The process is comparable to what takes place in the streetlights that illuminate most highways, where electrical energy passed through sodium vapor enclosed in a tube causes the vapor to emit a characteristic orange color. If the energy of the solar particles entering our atmosphere is high enough, they can reach into its denser layers, where they collide with molecules and atoms of nitrogen and oxygen. These emit a much more intense and colored light: blue and purple for molecular nitrogen, blue and red for atomic nitrogen, green for atoms of oxygen. Thus, simply viewing the colors of a polar aurora with the naked eye allows us to judge the size and energy of the wave of solar ions and electrons bombarding the earth. Under normal circumstances, chances of seeing the aurora borealis are far greater near the pole than in the tropics. In fact, the lights are concentrated in two bands that ring the northern and southern magnetic poles between 65 and 75 degrees latitude. In the northern hemisphere, all year round, the auroral zone covers parts of Alaska, Canada, Greenland, Iceland, Norway, Finland, and the northern fringe of Russia. In the southern hemisphere, auroras normally appear only over Antarctica. Iceland thus occupies a privileged place on the terrestrial globe, offering visitors a superb front-row view of this almost supernaturally outsized and opulent spectacle.

—GUILLAUME CANNAT

INDEX

MAP

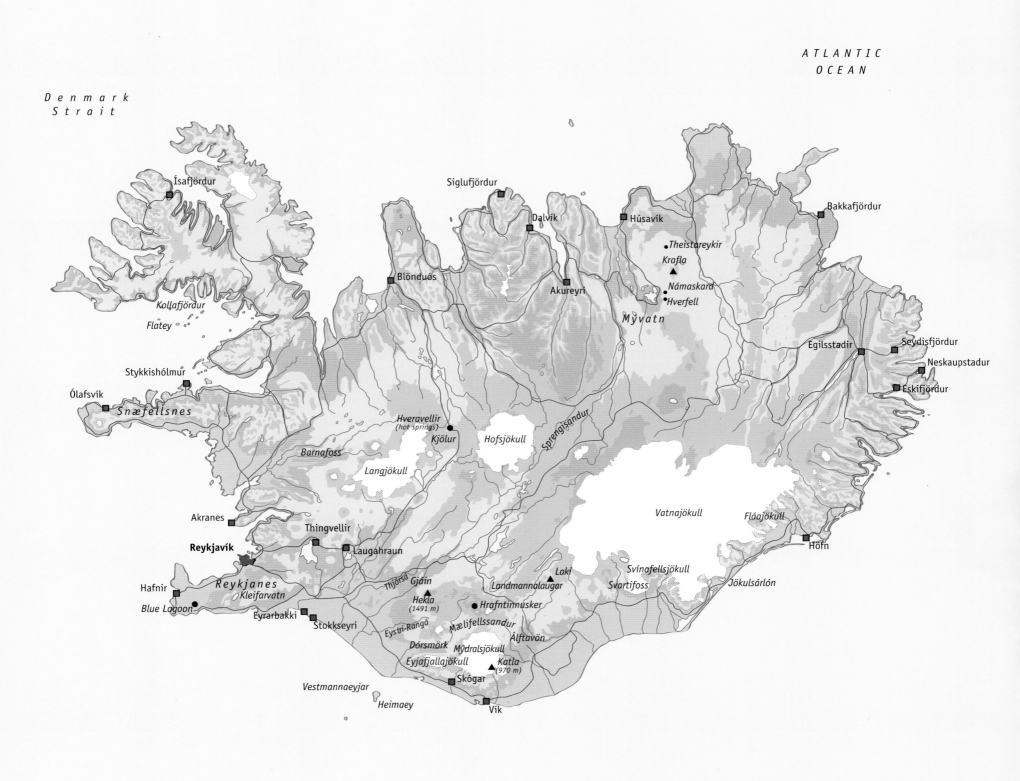

ATLANTIC
OCEAN

*Denmark
Strait*

Ísafjördur

Siglufjördur

Dalvík

Húsavík

Bakkafjördur

● *Theistareykir*

Krafla ▲

Kollafjördur

Blönduós

Akureyri

● *Námaskard*

● *Hverfell*

Mývatn

Flatey

Egilsstadir

Seydisfjördur

Stykkishólmur

Neskaupstadur

Ólafsvík

Eskifjördur

Snæfellsnes

Hveravellir
(hot springs)

Kjölur

Hofsjökull

Sprengisandur

Barnafoss

Langjökull

Vatnajökull

Fláajökull

Akranes

Thingvellir

Svínafellsjökull

Höfn

Reykjavík

Laugahraun

Laki

Svartifoss

Jökulsárlón

Hafnir

Reykjanes

Kleifarvatn

Thjórsá *Gjáin*

Landmannalaugar

Hekla
(1491 m)

● *Hrafntinnusker*

Blue Lagoon

Eyrarbakki

Stokkseyri

Eystri-Rangá

Mælifellssandur

Álftavön

Dórsmörk

Mýdralsjökull

Eyjafjallajökull

Katla
(970 m) ▲

Vestmannaeyjar

Skógar

Heimaey

Vík

ATLANTIC
OCEAN

3000 m
2000 m
1000 m
500 m
200 m
0 m

N

0 50 100 km

ACKNOWLEDGMENTS

This book is dedicated to traveling companions who have become lifelong friends.

In Iceland, I would like to thank Bertrand Jouanne, my friend and heart's brother, who showed me so many marvelous places, and so much more besides; Thorbjörg R. Hákonardóttir, my Icelandic sister, who always believed in me; Magnús Ásgeirsson, for his generosity and his visionary spirit, to whom I owe so much; Bryndís Ívarsdóttir and Hólmgeir Hermannsson, for their warm welcome; and Philippe Patay and Sigrídur Arnardóttir, who helped so much in my early years.

I owe thanks as well to Vilhjálmur Sigurdsson, Benedikt Bragason, Jónína Sigurjónsdóttir, Oli T. Óskarsson, Ingibjörg Pétursdóttir, Christine Blin, Thórunn Óskarsdóttir, Koen Van de Putte, Aurora Fridriksdóttir, Sighvatur Bjarnason, Nicole Chène, Jón Benediktsson, Ása Kolka Haraldsdóttir, Bergthór Njáll Kárason, Pétur Pétursson, Einar Torfi Finnsson, Sveinn Helgi Sverrisson, Victor Melsted, Óli Adolfsson, Anna Krístin Ásbjörnsdóttir, and Gadar Vilhjálmsson.

In Paris I would like to thank the entire staff of Comptoir d'Islande, especially Marc Maillet, a friend from the beginning who always supported this project; Franck Lemaître, without whom many of these photographs would never have been made.

I also wish to thank the entire staff of Icelandair, and especially Helgi Björgvinsson and Elisabeth Steffann, for their enthusiasm and assistance; Sébastien Faucher, traveling companion and brother in affection, with whom I have gone down so many paths; Jean Marie del Moral, for his generosity and his visionary spirit, which inspired and energized me; Hervé Katé, for having put his talent in the service of my images; Nicole and Michel Faucher, for their help and their support at all times; Eric Dessons, for his help over the years; and Olivier Joly and Carole Lefrancois, for their generosity.

Thanks as well to Olga Antonio, Richard Bride, Jean-Yves Courageux, Elias, Adeline Guerlain, Daniel Grutteau, Guy and Maury Guillon, Bruno and Ann Jarret, Alberto Ricci, Jean Marc Salembié, Virgo, the Faucher, Fourni, and Moro families, and my parents.

A huge thank-you to the entire staff at Hermé, and especially to Anne Serroy, Agnès Busière, Christine Dodos-Ungerer, and Marie-Hélène Lafin, for the kindness, professionalism, enthusiasm, and efficiency they displayed throughout our collaboration. My thanks also to Point 4 for the quality of the photoengraving.

And finally, thanks to Catherine Guerlain and Laurance N'Kaoua, warmhearted and witty women, who have given me more than they know.

TECHNICAL NOTES

Tripod by Gitzo
View camera by K.B. Canham
Lenses by Schneider-Kreuznach
Light meter and spot meter by Minolta
Films by Fuji (Provia and Velvia)

Editor, English-language edition: **Elaine M. Stainton**

Design coordinator, English-language edition: **Shawn Dahl**

Jacket design, English-language edition: **Eric J. Diloné**

Production coordinator, English-language edition: **Steve Baker**

The fragments of Icelandic poems included in the central portion of this work were kindly

translated into French by Bertrand Jouanne.

Library of Congress Cataloging-in-Publication Data

Desgraupes, Patrick.

[*Island: Le Sublime et l'Imaginaire*. English]

 Iceland / photographs by Patrick Desgraupes ; essays by Einar Már Jónsson and Guillaume Cannat; translated

from the French by Mark Getlein.

 p. cm.

 Includes index.

 ISBN 0–8109–5948–8 (hardcover : alk. paper)

1. Iceland—Pictorial works. I. Jónsson, Einar Már. II. Cannat, Guillaume. III. Title.

 DL315.D47 2005

 949.12′0022′2—dc22

 2005012385

Published in 2005 by Harry N. Abrams, Incorporated, New York.

Printed and bound in China

10 9 8 7 6 5 4 3 2 1

Harry N. Abrams, Inc.

100 Fifth Avenue

New York, NY 10011

www.abramsbooks.com

Abrams is a subsidiary of

LA MARTINIÈRE
GROUPE

ADDITIONAL CAPTIONS

p. 50: Basalt, Snæfellsnes
p. 51: Rhyolitic massif, Landmannalaugar
p. 58: Ice, Svínafellsjökull
p. 59: Mountain of sublimate deposits,
 Theistareykir
p. 76: Ice at sunrise, Fláajökull
p. 77: Obsidian, Landmannalaugar
p. 100: Basalt, Snæfellsnes
p. 101: Aerial view of the Thjórsá River
p. 114: Sublimates, Krafla
p. 115: Clay, Námaskard
p. 130: Solfatara mud, Reykjanes
p. 131: Basalt, Snæfellsnes
p. 138: Wild flowers, Stokkseyri
p. 139: Wild flowers, Stokkseyri